Minolta
sᴿT Manual

Minolta
sr T Manual

John Neubauer
Robert Moeser

AMPHOTO

American Photographic Book Publishing Co., Inc.

NEW YORK

Acknowledgments

The authors wish to extend their appreciation to Ted Kato and Ted Rosenberg of the Minolta Camera Co., Ltd., for their painstaking diligence in gathering and verifying information essential to this book.

Contents

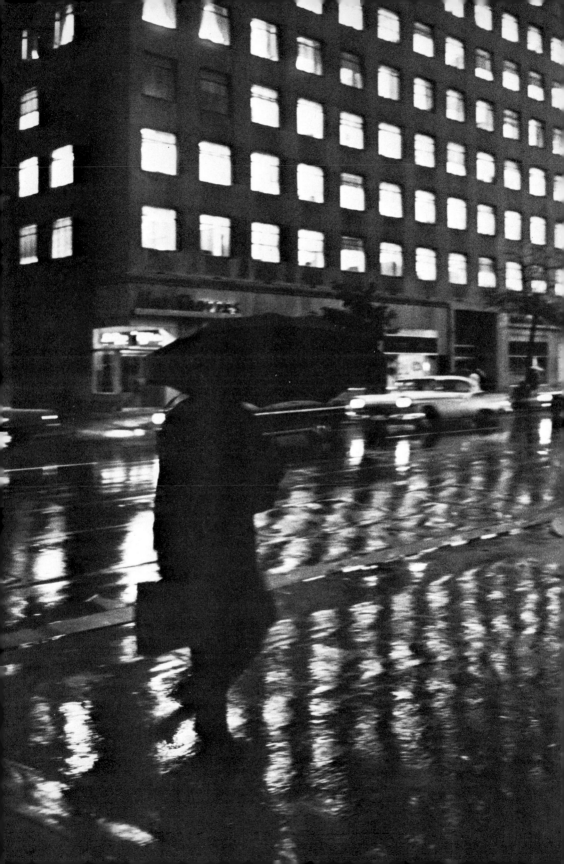

1

The Minolta Story

Although the 35mm single-lens reflex camera had its origins in Germany in 1936, it owes much of its contemporary popularity, look, feel, and rapid operating characteristics to Japanese engineering ingenuity. Those early SLR's made use of waist-level viewfinders that showed a reversed field of view; their mirrors stayed in the up position after an exposure was made and did not return to the viewing position until the shutter was cocked again. The instant-return mirror and the pentaprism housing, which shows a correct right to left image, are products of Japanese engineering skill and are found on all major makes of 35mm single-lens reflex cameras today.

Work on the first Minolta SLR camera began in 1953, and any complete history of the single-lens reflex camera would discuss the achievements in research and development of the Minolta Camera Co., Ltd. When the first Minolta single-lens reflex, the SR-2, was introduced in October, 1958, it included unexpected new advances in the SLR field. It was the first SLR ever to have, in one camera body, a quick-return mirror, a built-in self timer, and a single-axis, nonrotating shutter speed dial. What's more, its lens, the $f/1.8$ Rokkor, had semi-automatic diaphragm operation: It remained open at its widest aperture until the exact moment of exposure, when it closed down automatically to the correct, preselected aperture and then reopened to the widest aperture, ready for the next exposure, as the combination film advance–shutter wind lever was advanced. Until that time, lenses for single-lens reflex cameras were generally of the so-called preset diaphragm type, and had three rings: one for focusing, a second for setting the desired aperture, and a third for opening the lens from the desired aperture setting to the wide-open position for better viewing and focusing. The third ring had to be turned just before exposure to stop down the lens to the correct aperture. The whole procedure was a slow one, and there was always the risk that the photographer would fail to turn the ring, or not turn it enough, resulting in badly exposed pictures.

The most important of Minolta's achievements in the single-lens reflex field came in July, 1962, with its introduction of the Minolta SR-7, which

featured the first built-in cadmium sulfide (CdS) exposure meter on any camera. This development of the tiny CdS cell and the ability of Minolta's engineers to build it into a camera body made possible the revolution in through-the-lens exposure metering.

The Minolta Camera Co., Ltd., had its beginnings in 1928 when Kazuo Tashima, a pioneering businessman, manufacturer, and photography enthusiast, built a camera manufacturing plant in Tokyo's industrial environs. That first plant operated under the name of Nichidoku Shashin Shokai, which was translated into English as Japan–Germany Photographic Mercantile Co.—a reflection of the influence and the dominant position Germany then held in the world photographic market. That position, of course, has changed. So, too, has the name Nichidoku Shashin Shokai. It underwent a series of changes, in fact, the first of them occurring in 1931 when the Japan–Germany Photographic Mercantile Co. became the Molta Co. Also in 1931, the trademark Minolta was first registered. The company name was changed again in 1937 to Chiyoda Kogaku Seiko K. K. Finally, in 1962, the company incorporated under the name Minolta Camera Co., Ltd., the name it has used ever since.

THE SR-2 TO THE SR-7

Since it first began manufacturing cameras, the Minolta Camera Co., Ltd., has produced well over ten million cameras, including folding cameras, twin-lens reflexes, rangefinders, and its most sophisticated single-lens reflex cameras—the Minolta SR-T 101, the Minolta SR-M, and the Minolta SR-T 100.

The SR series of Minolta single-lens reflex cameras began with the SR-2, which made its debut in 1958. Less than a year later, a more popularly priced version, the SR-1, which had a 55mm $f/2$ Rokkor lens, appeared on the market. The SR-3 was introduced in August, 1960. Its principal features were a 55mm $f/1.8$ semi-automatic diaphragm Rokkor lens and a clip-on exposure meter, which coupled to the shutter speed dial. An improved version of the SR-3 was brought out in August, 1961. The improvements included minor internal changes, fully automatic diaphragm operation, and a fast 58mm $f/1.4$ Auto Rokkor lens. Like the first SR-3, this model had a coupled, clip-on exposure meter.

Minolta next introduced the SR-7 with a remarkable innovation—a built-in cadmium sulfide (CdS) exposure meter, so small that its inclusion in the design of the SR body, basically unchanged since 1958, did not require any alteration in the appearance of the camera. Need for the accessory shoe that allowed the SR-3 and SR-1 models to accept the clip-on exposure meter was eliminated.

The exposure meter of the SR-7 was a small circular window, with the direct reading exposure scale on the top, lefthand deck of the camera body. To permit an accurate expanded scale, Minolta designed it as a two-stage meter with a linear scale. It had a normal range for determining exposures under general photographic conditions, as well as a low range for more criti-

cal exposure situations, such as picture taking under low-light conditions. When the low-range button was pushed, it shifted a masking bar from one set of *f*/stop numbers to another. At the same time, a compensating change took place in the CdS cell window. Because the photo-resistor circuit in the SR-7 was so sensitive, a plate with a tiny aperture was placed in front of the cell to admit the proper amount of light under normal conditions. When the low-range button was pressed, the plate pivoted out of the way, allowing all available light to strike the cell. A later version of the SR-7 featured a more compact body—0.5mm thinner, 9.5mm shorter, and 136 grams lighter.

THE SR-T TO THE SR-M

Minolta's research and development technicians plunged forward in the search for an even more advanced and sophisticated camera; it arrived in May, 1966. The introduction of the Minolta SR-T 101 was major news in photographic circles around the world. Here was the first Minolta single-lens reflex with a totally new—and more accurate—way of measuring exposure—through the lens—by measuring only the light entering the lens. With the clip-on meter of the SR-3 and the external, albeit built-in, meter of the SR-7, the angle cov-

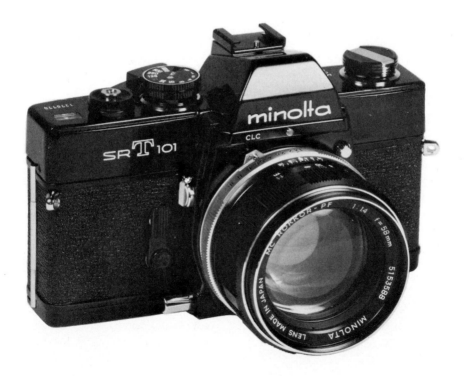

Fig. 1-1. The Minolta SR-T 101, black body version.

11

ered is 30°, regardless of which lens is used. With through-the-lens metering, compensation for the actual angle of view of a lens is automatic.

The SR-T 101 introduced a new term into the language of metering—*Contrast Light Compensator (CLC)*. Until the introduction of the SR-T 101, there were two basic methods of measuring exposure through the lens—spot and averaging. The spot method provides a reading of a restricted central portion of the total picture area. This is accurate where there is little contrast or when the reflectance of the primary subject happens to coincide with that of the limited area being spot read. But this type of shooting situation is not always possible. In averaging systems, the meter reads the entire picture area and then provides an arithmetically averaged aperture setting. An average setting, however, is not accurate for pictures with a wide contrast range or for backlighted subjects.

The CLC exposure system combines the advantages of spot and averaging metering. It reads both highlight and shadow areas and exposes for the dominant area in the scene covered by the camera lens, while allowing some consideration for the area of secondary importance. (For a more detailed discussion of the CLC exposure metering system, see Chapter 3.)

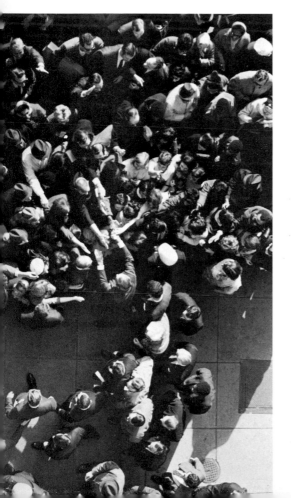

Fig. 1-2. This unique view of President Johnson was made as he entered the National Press Building in Washington, D. C., for his final official appearance at the National Press Club. For this view, probably the only one like it of President Johnson, the photographer positioned himself at a ninth floor window directly over the building entrance. The lens he used was the MC Auto Rokkor 100mm $f/2.5$. Photograph by John Neubauer.

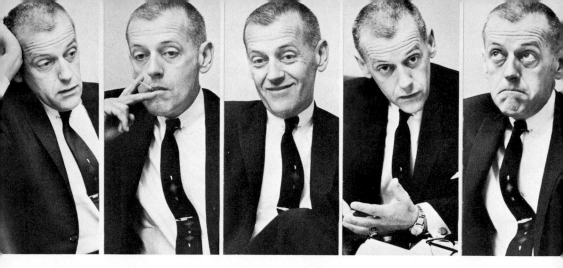

Fig. 1-3. For the photojournalist, the ability to shoot rapidly to capture a variety of expressions is essential if he is to produce photographs that will help sum up the personality of the subject, as in this excellent sequence of Mike Galligan, former head of the Army and Air Force Exchange Service. The photographer used an 85mm lens and Tri-X film, which was rated at ASA 1000 and developed in Acufine. Sequence by John Neubauer.

In 1970, Minolta responded to the professional photographer's demands for a motor drive camera and introduced the Minolta SR-M. Like so many other Minolta products, the SR-M incorporated a "first"—the first power rewind in a motor drive camera. Providing the SR-M with a power rewind was logical; after all, if the photographer intends to work with a camera that lets him shoot rapidly, he should also be able to rewind his exposed film quickly in order to reload faster and get on with his shooting.

In 1971, Minolta introduced the SR-T 100, a less expensive version of the SR-T 101. This new camera can be used with the entire range of lenses and accessories that make up the Minolta system.

Since its introduction in the mid-1930's, the 35mm single-lens reflex has become the most popular camera among professional and advanced amateur photographers. Its popularity is based on many considerations, but if one sentence could sum it up, it would be: "It's all in the viewing."

The single-lens reflex camera offers an enormous advantage over other types of camera, which simply show the photographer the area of coverage within a bright line frame. For example, the SLR presents no problem with parallax, which is the difference between what the eye sees when looking through the viewfinder and what the film will actually record. (On range-finder cameras, the viewfinder is to one side and slightly above the lens. Hence, what the eye sees and what the lens sees are not quite the same.) With the SLR, viewing is done through the lens itself, and the view the photographer sees in the viewfinder is the view he will get on his film. Focusing an SLR is also done through the lens, and SLR's are designed so that the depth of field —that part of the scene in front and behind the point of focus that appears to be sharp—can be checked visually on the groundglass viewfinder.

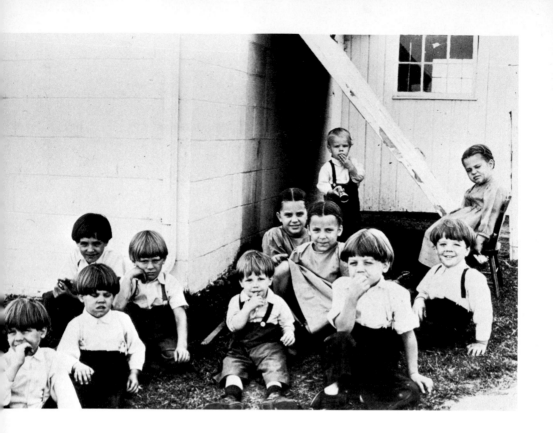

Fig. 1-4. These Amish children were playing near their home in the lush farm country of Lancaster, Pa., and were asked to sit for this picture. Most adult Amish do not believe in having their pictures taken. This belief stems from a biblical quotation, "Thou shalt not take unto thee any graven images." But the children seem to find having their pictures taken a game. The girl in the center said the group would allow their picture to be taken "If you'll give us a tip." The photographer gave them a handful of pennies, probably not more than a quarter's worth, and got this appealing photograph. The picture was originally taken using Ektachrome-X film. Later, a black-and-white print was made using Panatomic-X. Photograph by John Neubauer.

As any professional photographer knows, there are many 35mm cameras available, but relatively few 35mm systems. The word *system* is relatively new to photography. Briefly, it can be defined as the range of lenses and accessories available for use with a particular camera.

The Minolta SR system of 35mm photography extends from the well-designed, smoothly functioning camera body to lenses that range from the spectacular 16mm ƒ/2.8 fisheye MC Rokkor to the super-long 1000mm ƒ/6.3 telephoto mirror lens. It includes accessories for macrophotography, microphotography, and copy work, a super-critical spot meter, the first rapid-handling, hand-held three-color meter, and a new motor drive camera, along

with dozens of other pieces of equipment for both general and specialized photographic work.

In this manual you will find a complete description of the entire Minolta system, including operating instructions for every item of equipment along with practical, detailed information on how to get the best possible color slides and black-and-white photographs with the Minolta SR-T 100, the Minolta SR-T 101, and the motor driven Minolta SR-M.

As you read this manual, you will find that it is designed as a guide to both basic and advanced Minolta photography, which should help you expand your creative and technical photographic abilities. It is also intended to be used as a reference work that will help you in planning equipment purchases to meet your present and future photographic needs.

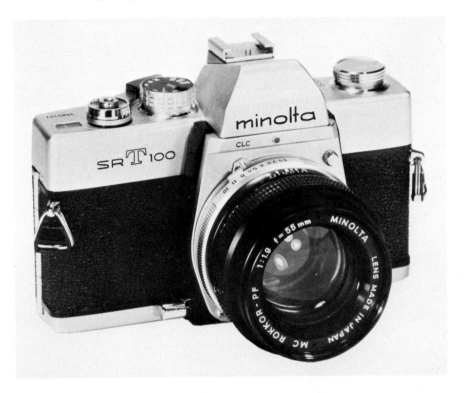

Fig. 1-5. The Minolta SR-T 100.

15

2

The Camera and Its Operation

The popularity of SR-T cameras is based on a number of factors, but the most important are dependable, high-quality performance and a large, versatile system of lenses and other accessories. Another consideration that comes into play is the feel of the camera, the way it cradles in the hand, the location of the film advance lever, the shutter release button, and the shutter speed dial, the solid feel of the lens barrel as you focus, and the sure click as you move from one *f*/stop to another.

In this chapter you will find a complete description of the SR-T 101 and the SR-T 100, along with operating instructions for all controls. Unless other-

Fig. 2-1. A long lens and a wide aperture worked together to throw everything out of focus except the subject, drawing full and immediate attention to him. The lens used was the MC Auto Rokkor 135mm *f*/2.8 on the Minolta SR-T 101. The exposure was 1/125 sec. at *f*/4 on Tri-X film rated at ASA 1000 for processing in Acufine. Photograph by John Neubauer.

wise noted, all descriptions apply to both the SR-T 101 and the SR-T 100. If you are unsure of the exact location of any control, refer to the diagrams that accompany each section. To fully master your camera, you should know it inside and out, so that in actual picture-taking situations you can respond quickly and unhesitatingly.

THE CAMERA

The first step in learning about your SR-T is to become thoroughly familiar with its controls and special features. Special uses for these controls will be described below. For the moment, concentrate on learning their location.

As you look at the SR-T 101 from the front, you see to the left of the lens the self timer lever, the mirror lock-up button, and the diaphragm stop-

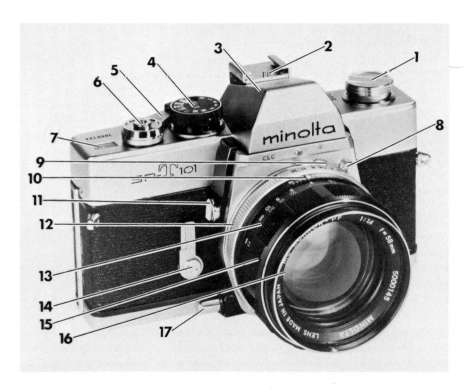

Fig. 2-2. Parts identification of the Minolta SR-T 101.

1. Film rewind crank and back cover release knob
2. Accessory shoe
3. Pentaprism
4. Shutter and ASA speed dial
5. Film advance lever
6. Shutter release button
7. Frame counter
8. Lens release button
9. Meter coupler
10. Depth of field scale
11. Mirror lock-up button
12. Diaphragm ring
13. Distance scale
14. Self timer lever
15. Focusing ring
16. Rokkor lens
17. Diaphragm stop-down button

17

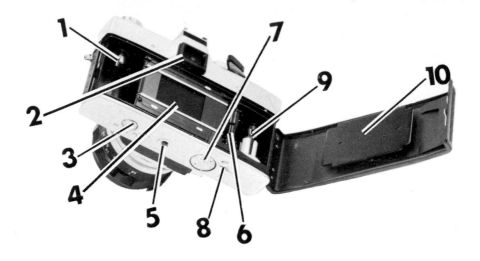

Fig. 2-3. Parts identification of the Minolta SR-T 101, with back open.

1. Rewind shaft	6. Sprocket
2. Finder eyepiece	7. Battery cover
3. Battery switch	8. Film rewind button
4. Focal plane shutter	9. Film take-up spool
5. Tripod socket	10. Film pressure plate

down button. To the top right of the lens is the lens release button, which is used to remove the lens from the lens mount. On the right side of the lens mount are two PC terminals, which are used in flash photography: One is marked "FP" and the other, "X."

The SR-T 100 does not have a mirror lock-up button or a self timer lever, but in all other respects, the front of the camera is the same as the SR-T 101.

On top of the camera body you find the film advance lever, the shutter and ASA (film speed) dial, the pentaprism housing for the viewfinder, the accessory shoe mounted on top of the pentaprism housing, and the combination film rewind crank and back cover release knob.

On the bottom of the camera is the battery switch, which you use to turn the meter on and off, the tripod socket, and the battery cover.

The back of the camera consists of the viewfinder eyepiece and a hinged cover. By pulling up on the cover release knob located on top of the camera, you open the back cover. As you look at the camera with the back open, you see the chamber that holds the 35mm film cassettes, the focal plane shutter, the double sprocket that turns to advance the film past the shutter, and the film take-up spool. On the inside of the hinged, back cover you see the film pressure plate, which is designed to keep the film absolutely flat.

Fig. 2-4. The mirror lock-up button and the self timer switch are to the left of the lens, as you look at the camera from the front.

THE LENS

The standard, meter-coupled (MC) Rokkor lens has a ridged focusing ring, engraved distance and depth of field scales, diaphragm ring, and meter coupler.

Changing Lenses

To remove the lens, hold the lens release button down, and with the camera facing you, turn the entire lens counterclockwise until it stops. Then

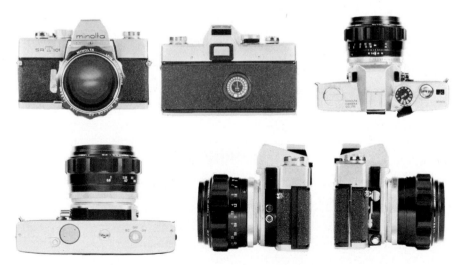

Figs. 2-5A–F. Views of the Minolta SR-T 101 with the MC Rokkor 58mm $f/1.2$ lens. (A) Front view. (B) Rear view. (C) Top view. (D) Bottom view. (E) Left profile. (F) Right profile.

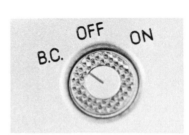

Figs. 2-6A–B. The battery switch in the "ON" position (A), the position that activates the CLC metering system. The battery switch in the "BC" position (B), the position for checking the condition of the batteries. With the switch at the BC position, look through the viewfinder at the indicator needle. If it points to the battery check mark, the battery can be considered as functioning properly.

simply lift the lens out. *Do not use excessive force.* If you try to force the lens to turn in the wrong direction, or fail to push the lens release button and apply too much force, you could damage the lens mount.

When you change a lens, or operate any control on a camera, never use too much force. All controls should operate smoothly. Although the Minolta SR-T cameras are rugged and designed for years of use, they are also precision instruments and should be treated with care. As a general rule, handle your camera firmly but gently.

To mount a lens, line up the red dot on the lens barrel with the red dot on the camera body, insert the lens into the bayonet-type lens mount on the camera, and with the camera facing you, turn the lens clockwise until it stops with a click.

Lenses can be changed while film is in the camera, because the shutter, which is inside the camera body, remains closed and prevents any light from hitting the film.

THE MIRROR

Removing the lens from the camera exposes the instant-return mirror, which is one of the largest to be found on any single-lens reflex camera. The large mirror eliminates any cutting off of the image at the corners (vignetting) when you use telephoto lenses or extension bellows. And since the through-the-lens exposure metering system takes its measurements from the mirror-reflected image, the lack of vignetting assures an accurate exposure regardless of the lens in use. The large mirror also helps make the image in the viewfinder brighter, which makes it easier for you to compose, focus, and match needles for exposure setting.

Caution: Do not touch the mirror. Its specially coated surface can be

damaged by fingerprints. In addition, you should be careful not to get any dust or dirt inside the camera when you have the lens off.

Built into the roof of the mirror chamber is an internal damper with a foot at each end, which contacts the front corners of the mirror. When you take a picture, the mirror swings up, out of the path of the light, which in turn passes through the shutter opening and exposes the film. The upward thrust

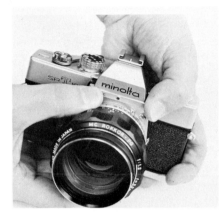
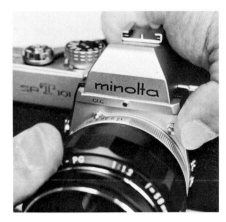

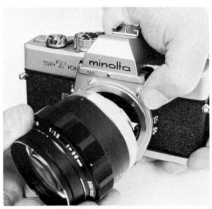
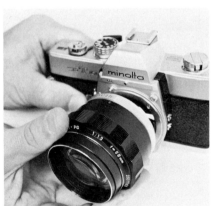

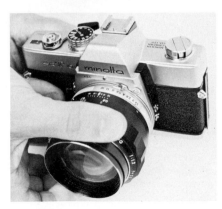

Figs. 2-7A–E. (A) To remove a lens, grip the lens barrel with your right hand and with your left thumb push down on the lens release button. Turn the lens counterclockwise. (B) When the red dot on the lens barrel is aligned with the red dot on the camera body, you can lift the lens out. (C) Lift the lens out of the bayonet lens mount. (D) To remount the lens, align the red dots on the lens barrel and the camera body. (E) Then turn the lens clockwise until it clicks into place.

of the mirror is absorbed by the spring-loaded damper. A strip of urethane foam also helps absorb any vibration caused by the movement of the mirror, thus ensuring sharp pictures at slow shutter speeds.

BATTERY POWER

Both the SR-T 101 and the SR-T 100 use a 1.35 volt mercury battery, which supplies power for the through-the-lens meter. When the camera is not in use, the battery switch, located on the bottom plate of the camera, should be in the "OFF" position. When you intend to store the camera for more than two weeks, it's a good idea to remove the battery and store it in a cool, dry place.

To remove a battery, turn the battery chamber cover on the bottom plate of the camera counterclockwise with your thumb, and let the battery drop out into your hand. When you replace a battery, make sure both sides of the battery and the battery chamber itself are clean by wiping them with a dry cloth. The button-shaped battery should be placed in the chamber with its plus side out and the cover replaced.

The Minolta uses a Mallory PX-625 battery or its equivalent. Other batteries that can be used are the Mallory PX-13, the Eveready EPX-625, and the Eveready EPX-13.

Checking Battery Power

Turning the battery switch to the "B.C." position before you start shooting a new roll of film will tell you whether the battery is supplying sufficient power to the meter. While the switch is in the "B.C." position, look in the viewfinder: If the indicator needle points to the battery check mark, you know the battery is working properly. If the needle does not hit the mark, check to see that the battery and battery chamber are clean, then try again. If the indicator needle will still not hit the mark, replace the battery.

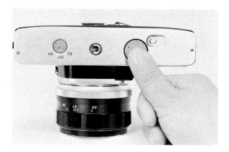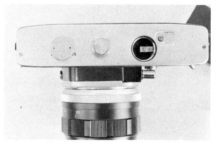

Figs. 2-8A–B. The Minolta SR-T 101 uses a 1.35-volt mercury battery (Mallory PX-625, PX-13, Eveready EPX-625, EPX-13, or equivalent). To install a battery, remove the battery chamber cover (A) by placing your thumb firmly against it and turning counterclockwise until the cover comes off. (B) With the cover removed, next place the mercury battery in the battery chamber. The battery must be placed in the chamber with the + side out. After you have placed the battery in the battery chamber, replace the battery chamber cover, turning it clockwise to secure it in position.

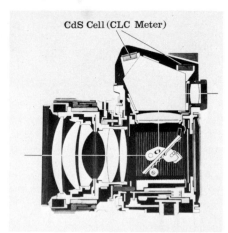

CdS Cell (CLC Meter)

Fig. 2-9. Cutaway model of an SR-T 101 shows placement of the CdS cells for the CLC (Contrast Light Compensator) metering system. Light entering the lens is split between the two cells, with each reading only a part of the total picture area on the groundglass. In combination, the cells measure light over the entire picture area, thus eliminating the need to average spot readings.

Do not leave the battery switch in the "B.C." position, since this will kill the battery in just a few hours. When you are through taking pictures for the day, turn the switch off, but don't forget to turn it on again before you begin your next picture-taking session.

It is particularly important to check the battery after the camera has been stored for any extended time. A weak battery can lead to poor exposure and the frustrations that go with it: wasted film and the irretrievable loss of potentially good pictures.

EXPOSURE MEASUREMENT

One of the most important features of the Minolta SR-T 101 and SR-T 100 is the rapid-reading, through-the-lens exposure system. As you look through the viewfinder, you see two needles on the righthand side of the viewing frame: One is the indicator needle; the other is a circle-tipped needle, which is coupled to the aperture, shutter speed, and ASA speed controls. Aligning these two needles gives you correct exposure at any combination of aperture and shutter speed.

Exposure readings are taken with the lens at full aperture (wide open), which means that you can focus, compose, and match needles for exposure with the image at its maximum brightness. With a Minolta meter-coupled lens on the camera—these are the standard lenses for the SR-T 101 and SR-T 100—the lens will stop down to the correct aperture automatically when you press the shutter release button and open up again as soon as the exposure is made.

ASA Speed Setting

To set the correct exposure, first set the ASA number of the film you are using on the ASA speed dial. ASA stands for American Standards Association, and is a system for designating the speed (light sensitivity) of film. When you purchase film, you will find the ASA number of the film printed on the instruction sheet that comes with it. Kodak Tri-X film, for example, has an

23

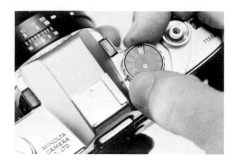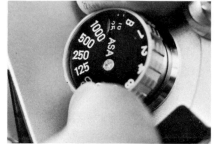

Figs. 2-10A–B. To set the ASA speed of the film being used, raise the outer ring of the shutter speed dial (A). Turn the outer ring of the shutter speed dial until the proper ASA number appears in the window opposite ASA (B).

ASA rating of 400, whereas the popular Plus-X has an ASA of 125. (For more on films and film speeds, see Chapter 6.)

The ASA speed dial is located in the shutter speed dial. Between the "B" and the 1/1000 sec. setting on the SR-T 101 and between the "B" and the 1/500 sec. setting on the SR-T 100, there is a small window, and in yellow lettering next to the window, the letters "ASA." The ASA number in the window should match that of the film you are using. To change the number, raise the outer ring of the shutter speed dial and turn the ring. This action changes the circle-tipped, follower needle to a higher or lower position in the viewfinder and couples the built-in metering system to the speed of the film you are using.

The ASA dial has the following figures printed on it: 6 . 10 . 16 . 25 .. 50 .. 100 .. 200 .. 400 .. 800 .. 1600 .. 3200. On the SR-T 101 you will see three additional settings: .. 6400. The dots between the numbered settings represent, beginning with the dot between 6 and 10, the following intermediate settings: 8, 12, 20, 32, 40, 64, 80, 125, 160, 250, 320, 500, 640, 1000, 1300, 2000, 2600, and on the SR-T 101, 4000 and 5200.

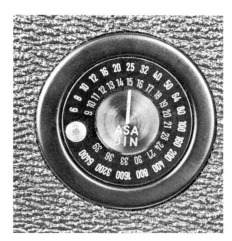

Fig. 2-11. On the back of each Minolta SR-T 101 camera body is an ASA/DIN conversion scale, which also serves as a handy reminder of the ASA speed of the film being used. To set the reminder, simply adjust the scale counterclockwise or clockwise, by moving the knob at the left of the scale until the correct number appears over the pointer.

For the convenience of travellers who are using film purchased outside the United States, the back cover of the camera has an ASA/DIN conversion scale. DIN is a system of rating emulsion speeds developed by the Deutsche Industrie Norm. To use this scale, turn the knob of the converting scale until the white pointer is opposite the correct rating. DIN is shown in red; ASA in white.

Setting the Shutter Speed

The second step in measuring exposure is to set the shutter speed. The shutter, which is located just in front of the film, consists of two curtains that travel across the full width of the negative frame from right to left. The curtains are separated by a slit, and the size of the slit, as it travels past the film, determines the exposure time. This type of shutter is called a *focal plane shutter*.

Shutter speeds for the SR-T 101 range from 1 sec. to 1/1000 sec. and "B" (bulb). Speeds for the SR-T 100 range from 1 sec. to 1/500 sec. and "B." The B setting is used when time exposures are being made. At B the shutter will remain fully open as long as the shutter release button is held down.

When you hand-hold your camera, you should try to use shutter speeds of 1/125 sec. or higher, although with practice you will be able to hand-hold

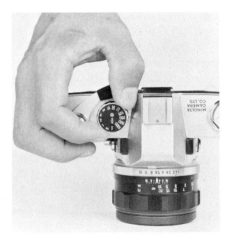

Figs. 2-12A–B. There are two controls for setting the exposure. They are the shutter speed dial and the aperture ring. The shutter speed dial and the aperture ring are worked in conjunction with each other to align the match needles in the viewfinder. The circle-tipped needle moves when either the aperture ring or the shutter speed dial is adjusted. The indicator needle moves according to the amount of light entering the lens and according to the ASA value of the film being used. To set the camera for the ASA value of the film being used, lift the outer ring of the shutter speed dial (A) and turn it until the correct ASA number appears in the small window on the shutter speed dial. When you have programmed the correct ASA number into the camera, adjust either the shutter speed dial or the aperture ring (B) to match the circle-tipped needle over the indicator needle in the viewfinder.

25

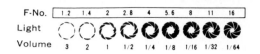
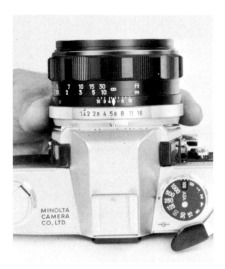

Figs. 2-13A–B. The index for the aperture setting is the diamond symbol in front of the diaphragm ring (A). The ring is engraved with figures from $f/1.4$ to $f/16$ for the MC Rokkor 58mm $f/1.4$ standard lens. When the shutter speed is constant, the light passing through the lens decreases 50 per cent for every increase in the aperture setting, or $f/$stop. For instance, when the diaphragm ring is turned from $f/2.8$ to $f/4$, the light entering the lens decreases 50 per cent. As the aperture figure decreases—from $f/8$ to $f/5.6$, for instance—the light passing through the lens increases. The relation between the aperture and the amount of light is shown in the diagram (B).

it at speeds as slow as 1/30 sec. and still get sharp pictures. The one exception to this rule is flash photography. Speeds for flash photography must be those recommended and vary according to the type of flash you use. The "60" mark on the shutter speed dial is shown in red to indicate that this is the highest speed you can use with electronic flash. At speeds slower than 1/30 sec., you should use a tripod or some other firm support.

On the SR-T 101, shutter speeds can be seen on a scale inside the viewfinder. The SR-T 100 does not have this feature.

To set the shutter speed, rotate the shutter speed dial until the speed you want is aligned with the indicator mark on the camera body or until that speed is centered between the indicator lines on the SR-T 101 shutter speed scale in the viewfinder. The shutter speed dial is coupled to the follow-up needle in the viewfinder and can be used to match needles for correct exposure.

Setting the Aperture (f/Stop)

The lens opening is called the *aperture*. This is simply a hole in the diaphragm, which opens up or closes down to let more or less light into the camera when you turn the diaphragm ring. The aperture is measured in terms of $f/$stops, which are engraved on the lens barrel. These $f/$stops are actually fractions that represent the focal length of the lens divided by the size of the lens opening. Because they are fractions, small $f/$numbers indicate large openings and large $f/$numbers indicate small openings, just as 1/8 ($f/8$) is larger than 1/16 ($f/16$).

Fortunately, the Minolta through-the-lens metering system eliminates

26

the need to worry about f/stops for most normal picture taking. Once you have set your ASA number and shutter speed, simply turn the aperture ring on the lens until the circle-tipped needle lines up with the indicator needle in the viewfinder. When you get into more advanced photography, however, you will want to know how f/stops work, and they are fully explained in Chapter 4.

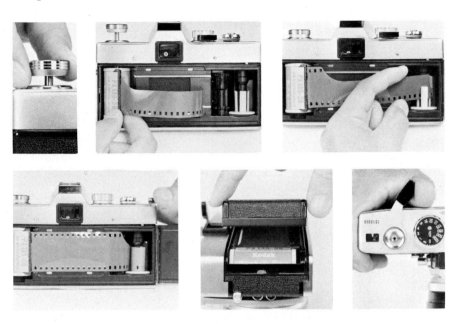

Figs. 2-14A–F. Loading film. First, open the back of the camera by raising the back cover release knob (A). The back cover will automatically pop open as the knob is raised. With the back cover open and the release knob still in the raised position, place the film cartridge in the compartment with the film leader pointed toward the take-up spool (B). Then push the release knob down into its former position. The release knob will not recess all the way unless the crank fork at the bottom of it, which protrudes into the film cassette compartment, correctly engages the top of the film cassette. In case the release knob does not fully recess and engage the film cassette, turn the release knob slightly to the left and right until it does. With the film cassette firmly in place in the cassette compartment, insert the film leader into any of the slots in the film take-up spool (C), setting it flush against the bottom of the take-up spool. Next, operate the film advance lever in several short strokes until the film begins to wind firmly around the take-up spool and both sides of the film perforations are securely engaged with the teeth of the sprocket gear (D). If the film advance lever locks during this procedure, simply press the shutter release button and continue advancing the film. As soon as both sides of the film perforations are definitely engaged on the sprocket gear, close the back of the camera (E). Then gently rotate the film rewind crank clockwise until you feel a slight resistance. Doing this assures that there will be no slack in the film and that it will be flat against the film pressure plate. Finally, advance the film (F) and press the shutter release button successively until the number "1" appears at the arrow mark in the frame counter window. Now, you are ready to take your first picture.

If the follow-up needle fails to move when you turn the diaphragm ring, change your shutter speed.

Summary of Exposure Setting

1. Set the ASA number for the film you are using on the ASA dial.
2. Set the shutter speed.
3. Rotate the diaphragm ring on the lens until the circle-tipped follow-up needle in the viewfinder aligns with the indicator needle.

LOADING FILM

The Minolta SR-T cameras take 35mm film, which can be used for black-and-white, color slide, color print, and infrared photography, depending upon the kind of film you use. This film comes in light-tight cassettes, and you can load it into the camera in broad daylight. As a precaution, however, it is best to avoid loading the camera in direct sunlight. Load the camera in the shade, or turn your back to the sun and load it in the shadow cast by your own body.

You will want to keep film loading as simple as possible. To avoid unnecessary fumbling, take the film cassette out of the foil package in which it is wrapped before you open the camera. Next, open the back cover of the camera by pulling up on the release knob, which serves double duty as the film rewind knob, until you feel a slight resistance. Give it a slight additional pull, and the back will automatically pop open.

The film leader projects from the film cassette. Take this leader and insert it into the slot in the film take-up spool on the right side of the camera, next to the hinge of the back cover. Then lay the leader down along the film track and put the cassette into the film chamber on the left side of the camera. The center drum that projects from the cassette should be down, pointing toward the bottom of the camera.

To fit the film cartridge securely into place, lift the rewind knob so that the rewind shaft is out of the way. Once the cassette is in place, push the rewind knob down and turn it left or right until the rewind shaft slips into the film cassette and the rewind knob is back in its normal position.

Next, advance the film advance lever in short strokes until the film is firmly wound around the take-up spool and the perforations on both sides of the film are firmly engaged by the teeth of the sprocket gear. If the film advance lever locks during this procedure, press the shutter release button and continue. Once you are sure the film is being wound correctly on the take-up spool and that both sprockets are meshing with the perforations in the film, close the camera back. The back will lock into place and form a light-tight seal.

Now lift out the film rewind crank on the rewind knob and gently rotate the crank in the direction of the arrow. Stop as soon as you feel a slight tension. This means you have taken up any slack in the film inside the cassette. Advance the film and press the shutter release button repeatedly until the

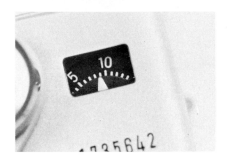

Fig. 2-15. The frame counter works automatically. As film is advanced, the counter automatically moves the frame number to the next correct number.

number "1" appears at the arrow mark in the window of the frame counter. You are now ready to start taking pictures.

CAMERA HANDLING

In addition to determining correct exposure, which has already been discussed, there are three actions involved in taking pictures: advancing the film, composing and focusing, and pressing the shutter release.

The Film Advance Lever

The film advance lever winds the shutter, advances the film, and operates the exposure counter. You can move it in a single 150° stroke or in a series of shorter strokes. Either way, the shutter cannot be released until it has been fully cocked, so there is no need to worry about overlapping of frames or unintentional double exposures. After the lever has been advanced all the way, it returns to a stand-off position about 20° from the camera body, which makes it easier to keep your thumb in position for advancing the film to the next frame. There is enough room between the lever and the viewfinder to allow you to keep your eye to the viewfinder and advance the film at the same time, an advantage when you are photographing action-packed scenes.

The Shutter Release Button

The shutter release button is located in the center of the film advance lever. Use moderate and even pressure on this control. Avoid jabbing at it with your finger, since this will cause a slight jerk, which can result in unsharp pictures.

As the shutter release button is pressed, the mirror rises out of the way of the lens, the MC Rokkor lens closes down to the predetermined aperture, the shutter curtain travels across the film frame, the mirror drops down into the viewing position again, and the lens reopens automatically to its widest aperture. This complex sequence happens so quickly that it seems almost instantaneous.

Focusing

The control-integrated viewfinder of the SR-T 101 and SR-T 100 is designed to simplify the camera-handling procedure and allow you to con-

29

centrate on the aesthetics of picture taking. You can operate everything—focus, exposure setting, and framing—without having to take your eye from the camera.

The viewing screen is made up of three areas. In the center is a circle composed of very fine microprisms, which give a rapidly shimmering image when the subject is not in focus. As the lens is focused to the point of maximum sharpness, the image appears to snap into critical focus. A fine, ground-glass collar surrounds the center spot and is useful when you focus on detailed subjects or work with long lenses. The balance of the screen consists of a very fine Fresnel lens, which increases overall image brightness and permits you to check areas outside the center of the screen for sharpness of focus.

With the normal lens set at infinity, the actual scene and the viewfinder image are in 1:1, or life-size, relationship. When longer focal length lenses are used, the image size inside the viewfinder will appear larger than the scene you see with your naked eye. On the other hand, the image size will appear smaller when wide-angle lenses are used.

The viewfinder shows only 94 per cent of the total image recorded on the film. The additional six per cent is a safety factor, added because most photographers take color slides and the mounts for the slides overlap the picture on all four sides. If the viewfinder showed 100 per cent of the picture area, the slide mount could cut out some important part of the picture.

Remember not to confuse focusing with framing the scene in the viewfinder. A lot of good pictures have been lost because the photographer focused on one subject and then decided to change his framing slightly to get a picture of something else without refocusing on the new subject. A good rule is to decide on your composition first and then turn the focusing ring for fine focus.

As you turn the focusing ring, it soon becomes apparent that the microprisms in the center of the viewfinder can be seen more clearly when you focus on a relatively contrasty area, one that consists of a clear separation of lights and darks or of colors. Focusing on flat, low-contrast areas is more difficult, but can afford good practice: As an exercise to improve your eye for focus, pick a flat surface and focus as best you can. Note the distance shown on the distance scale engraved on the lens barrel. Change the distance setting on the lens and focus again. When you get the same distance setting time after time, you are well on your way to mastery of accurate focusing under almost all conditions.

DEPTH OF FIELD CHECK. You can also check focus with the depth of field preview button. Depth of field is the area in front of and behind your subject that is in focus; the extent of this area varies. The smaller the aperture, the greater the depth of field. Pressing the depth of field button allows you to see how much foreground and background you have in focus. For a more complete discussion of depth of field, see Chapter 4.

INFRARED FOCUS. Invisible infrared light rays do not focus at the same point behind the lens that most visible rays of light focus. For this reason, an adjustment in focus is necessary when you are using either black-and-white

or color infrared film. When you use infrared film, first focus normally, then note the distance on the distance scale and set that distance opposite the red "R" on the lens barrel.

HOLDING THE MINOLTA

The Minolta SR-T 101 is not a heavy camera compared with press and studio cameras, but its built-in, rugged sturdiness gives it a solid feeling. Held properly, the camera will not tire the hands even after hours of use. The best way to get the feel of the Minolta SR-T 101 is to hold and turn it in the hands and to handle the controls and body surfaces until they become familiar to

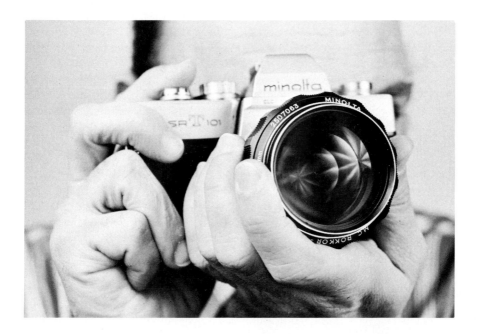

Figs. 2-16A–B. (A) The correct method for holding the camera in the horizontal position. The left hand firmly cradles the camera, with the fingers wrapped around the lens barrel; the right hand firmly grips the camera body, with the right index finger resting on the shutter release button. (B) The correct method for holding the camera in the vertical position. The left hand cradles both the body and the lens barrel and holds the body firmly against the face. The right hand holds the camera body, with the right index finger resting on the shutter release button.

the touch. Hold the camera to your eye and practice metering, focusing, and shooting with no film in the camera.

Now, begin going over the same actions, but this time give careful attention to each movement, each control, and each function. Instead of holding the camera any old way, pick it up with your right hand by the right side with the lens facing away from you. Bring it up to your eye for horizontal viewing, and place the weight of the camera in the palm of your left hand in such a way that your left thumb and index finger can grasp the lens focusing ring. Using your right hand only for steadying the camera, place the camera to your eye, and begin focusing with the fingers of your left hand. Try this several times until you find the most comfortable position for the camera. The camera should be placed so that if the right hand were taken away, it would remain balanced in the left. Now, using your right hand, grasp the right side of the camera, place your index finger on the shutter release button, and rest your thumb against the film advance lever. Practice advancing the lever and tripping the shutter until you can do it smoothly, without moving the camera.

Hands alone are not enough to hold the camera steady. You should also press the back of the camera firmly against your face. Holding the camera securely in both hands and pressing it against your face will give support at four points of the camera body—the bottom, the lens barrel, and the back and right sides of the camera. Let the lower right back of the camera rest against the heel of your right hand, and practice gently pressing the shutter release button by moving only your index finger.

To hold the camera correctly in the vertical position, simply tip the camera body so that the left side is at the top and the shutter release button at the bottom. Shift your left hand from the bottom of the camera to the lens barrel, wrap your fingers around it, and with the heel of your left hand, press the camera firmly against your face. Use your right hand to help steady the camera, but keep your index finger free to apply pressure gently on the shutter release button.

A poor body stance can cancel out the best camera support provided by the hands and face. Your feet should be planted solidly on the ground, in a

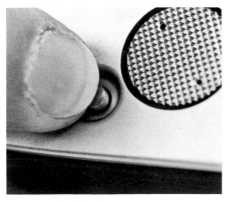

Fig. 2-17. The film rewind button is on the bottom plate of the camera body next to the battery cover. Depress the button while rewinding the film into the film cassette.

firm but comfortable position, with one foot slightly in front of the other. Pull your arms against your sides for added support, but keep your muscles relaxed. The idea is to stand firmly to avoid being knocked off balance. In this stance, it makes little difference whether you hold your breath or breathe in or out, as you trip the shutter. Breathe naturally.

When using slow shutter speeds, 1/30 sec. and slower, you can utilize any solid, nonmoving support. A tree, a wall, or the back of a chair can help you maintain a steady position. When you shoot from inside a car, never rest the camera on the window area while the engine is running: The vibration will cause blur in your pictures. For the same reason, when you fly in an airplane, do not push your camera lens against the window.

REWINDING THE FILM

When the final exposure on a roll of film has been made, you will feel a tug on the film advance lever as you try to advance it again. When you feel that tug, do not force the lever beyond this point. You could pull the film

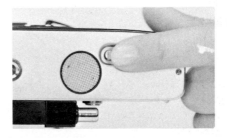

Figs. 2-18A–C. To unload film after it has been exposed in the camera, it must first be rewound into the film cassette. To rewind the film, depress the rewind button on the base plate of the camera (A). The button should remain depressed after you have taken your finger off it. If the button returns to its locked position, depress it again with your finger, and continuing to hold your finger against it, rewind the film for approximately two revolutions. Then advance the film advance lever one full stroke without depressing the rewind button. Depress the button again. This should hold the button in the unlocked position. To rewind the film into the film cassette, lift the rewind crank (B) and turn it clockwise. This will rewind the film into the cassette. When you feel a slight resistance, you will have rewound all but about three inches of the film. Another turn or two will then free the film from the take-up spool, and the film will be rewound completely into the film cassette. With the film rewound completely, open the camera back by lifting the rewind knob. With the back open, you can lift out the film cassette (C).

loose from the film cartridge, preventing normal rewinding and making it necessary to unload the camera in the dark.

The frame counter will indicate when the film supply has been used up. If you are using a 20-frame roll of film, rewind it when the counter reaches 20. If you are using a 36-frame roll of film, rewind it when the counter reaches 36. You may be able to get an additional frame beyond 20 or 21, but if the advance lever has traveled only half the distance toward the next frame, do not force it further.

To rewind film, take the camera out of the carrying case. Looking at the bottom plate of the camera, you will see a recessed button, which must be depressed to permit the film to be rewound. Press this button, unfold the rewind crank handle inside the rewind knob, and turn in the direction indicated by the arrow (clockwise). Once winding begins, it is not necessary to maintain pressure against the rewind button.

As the film draws to about four or five inches of being fully rewound, you will feel a slight tug. Turn the crank once or twice past this point, and the film will be completely rewound into the film cassette. At this point, lift the rewind knob and open the back cover. With the rewind knob still raised, tip the camera so that the film cartridge drops out. The camera can be reloaded immediately or left empty. In either case, close the back cover as soon as possible to prevent dust and foreign particles from entering. Make sure you hear the catch snap into place.

THE SELF TIMER

The built-in self timer on the SR-T 101 features a delay of five seconds to eight seconds, depending upon how far the lever is cocked. The self timer is activated by its own release button, which is on the front of the camera body behind the self timer lever. If the shutter is wound, it can be released by the self timer. The self timer may also be cocked and then bypassed for normal picture taking. Its lever is fully cocked at 90°.

The self timer is especially useful when you photograph static subjects requiring high image magnification or long exposure times. Since this control permits the camera shutter to be released without outside pressure, camera movement is virtually eliminated. The camera must be placed on a solid support or tripod for absolutely vibration-free operation, however.

THE MIRROR LOCK

To the right of the self timer on the SR-T 101 is the mirror lock. It has two functions: First, it locks the mirror up and out of the light path when a long series of identical exposures must be taken, as is common in copy work. This eliminates camera motion due to mirror movement. Second, locking the mirror up permits the use of the super-wide 21mm Rokkor $f/4$ lens. Because this lens extends so deeply into the camera body, its rear element interferes with the operation of the mirror. To avoid this interference, the mirror swings

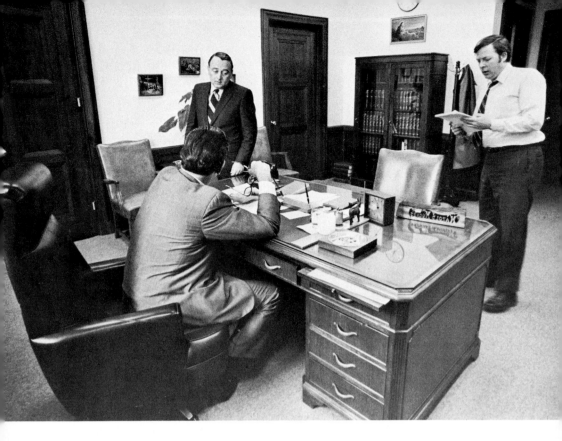

Fig. 2-19. The 35mm camera and its speed of handling make it the ideal tool for the photojournalist, who strives to capture the mood of a moment without forcing his presence into the scene. For this view, taken in the office of Sen. Harold Hughes of Iowa, the photographer made excellent use of the MC Auto Rokkor 28mm $f/2.5$ lens, exposing 1/60 sec. at $f/4$ on Tri-X film. Photograph by John Neubauer.

up and locks against the base of the pentaprism before or after the shutter is cocked.

Since the mirror lock is completely independent of the shutter release, its use does not result in a lost frame. Because the light is blocked from the prism when the 21mm Rokkor $f/4$ lens is used, a special finder, which fits into the accessory shoe, is used, and the through-the-lens exposure metering system is inoperative. To raise the mirror, turn the mirror lock button downward (clockwise) until it stops. The mirror will return to its usual operation when the lock button is returned to the red mark.

CARE AND STORAGE OF MINOLTA EQUIPMENT

There are several things the camera owner should know about the care and storage of his camera equipment, which will permit him to get the most use out of it without the need for extensive and costly repairs. Most important

is to keep your equipment clean. Keep all equipment not in use in cases or in plastic bags. Brushing the camera—but not the lens elements—frequently with a soft-bristle shaving brush to prevent dust and dirt from collecting in generally inaccessible parts of the camera mechanism. Store the brush in a plastic bag. Lens elements should be cleaned only with a lens tissue, a lens brush, and an air blower. For a detailed explanation of lens care, see Chapter 4.

A set of small, jeweler's screwdrivers should also be included in your maintenance kit. The screws of camera bodies and lenses loosen after heavy use. Periodic tightening of the screws will save many costly trips to the repairman. Be careful not to tighten them so forcefully that you break away the head of a screw.

Some final pointers:

1. Do not touch the instant-return mirror. If it has dust on it, brush it off with a soft camel's hair brush. If the mirror gets a finger mark on it, do not try to wipe it off with a lens tissue or any other cleaning material. Applying pressure on the mirror to clean it may throw it out of alignment, which would affect focusing adversely. Let an experienced camera repairman clean it.

2. When storing the camera, set the distance scale at infinity, release the shutter, and put the camera in the leather case provided for it.

3. Do not drop or otherwise sharply jar the camera.

4. Do not store the camera in high temperature or humidity.

5. When storing the camera for a long period, put it in its original packaging with a small bag of silica gel. Silica gel is a drying agent and keeps moisture and condensation from forming. Professional photographers make it a habit to keep several bags of silica gel in their gadget bag at all times.

3

Exposure and Metering

Correct exposure is the key to good photographic quality. The Minolta CLC through-the-lens exposure system, which is built into the SR-T 101 and SR-T 100, facilitates finding the appropriate exposure. This system combines the advantages of spot and averaging light measurements, eliminates their disadvantages, and lets you take a meter reading with the lens opened to its widest aperture. The system is part of a completely new camera design,

Fig. 3-1. An excellent example of the creative use of a 21mm lens. For this scene, the photographer positioned himself on the ground, shooting slightly upward in order to emphasize converging lines. The basic exposure of 1/15 sec. at $f/4$ was based on a reading taken with the Minolta Viewmeter 9 of the policeman's shirt. Exposures also were made at half-stop intervals up to $1\frac{1}{2}$ $f/$stops above and below the basic exposure. The headlights of a second police car, outside of camera range, were used to throw additional light on the scene. Photograph by John Neubauer.

rather than a modification of an old design, so there is no sacrifice in ease of handling or operation. With shutter, aperture, and viewing operations integral parts of the exposure measuring system, the SR-T 101 and SR-T 100 provide an unusually high degree of handling speed.

Built-in, through-the-lens metering lets you determine your exposure as you compose your picture, a step saver that can make all the difference in a fast-moving situation. Most important, through-the-lens metering with the Minolta means that only the picture area covered by the angle of view of the lens is measured, which permits more accurate exposures.

THE CLC EXPOSURE SYSTEM

Most exposure meters take an average light reading, and since the bright areas are often many times brighter than the darker areas, they give undue emphasis to the brighter portions of the viewing area. The split-light metering used by Minolta, however, results in a more balanced reading with highlights recorded brightly and shadows rendered suitably dark.

The Minolta through-the-lens metering system is called CLC, which stands for Contrast Light Compensator. A split-light measuring system, it is a practical alternative to spot metering and average metering. In photography, most areas are divided horizontally into light and dark zones. The sky in the upper half is usually the light zone and the ground in the lower half usually the dark zone. The picture area of the Minolta SR-T 101 and SR-T 100 is divided roughly, for light measuring purposes, into areas of light and dark. Separate readings are automatically made for these two areas, and the actual meter reading is based on an average of these two readings, but with more emphasis given to the darker, less illuminated areas within the field of view.

The CLC exposure metering system incorporates two extremely sensitive CdS (cadmium sulfide) cells, which are located inside the prism housing. One cell is positioned above the viewing objective in a special prism, and the other is located directly opposite the first. Light entering the camera through the lens is reflected from the mirror and into the CdS cells. The cells are aimed in such a way that each reads only a select portion of the total picture area; in combination, however, the cells measure the light over the entire picture area, thus eliminating the need to average manually a variety of spot readings.

Because of their location, the CdS cells are not appreciably affected by stray light, which may enter through the viewing eyepiece: The light coming through the eyepiece into the prism is almost entirely reflected, and stray light rays entering the lens are baffled out by a shield inside the mount.

Unlike other multiple-cell metering systems, which employ simple parallel electrical circuitry, the CdS cells in the Minolta's more sophisticated CLC circuitry system are arranged to complement each other in series. When cells are connected in parallel, no single cell has much effect on the other cell or cells in the circuit, and if a scene with both bright and dark areas is meas-

ured, the ordinary CdS parallel circuit will tend to be more influenced by the brighter areas. These are usually many, many times brighter than the important shadow areas. Because the CdS cells in Minolta's CLC circuit are arranged in series, each cell has a direct influence on the other. This interdependence causes the CLC circuit to give adequate value to the darker areas in a scene and thus produces a realistic exposure, which comes closer to falling within the contrast range of the film. Because of this arrangement in series, the two cells in the CLC system are able to perform functions automatically which would otherwise take considerable time and a great deal of experience.

The CLC system can be compared to the photographer who takes a highlight and shadow reading with a hand-held exposure meter and, instead of computing the average, chooses to expose for the dominant area in the scene while also considering areas of secondary importance.

BASIC EXPOSURE AND METERING CONSIDERATIONS

The amazing aspect of the CLC metering system of the SR-T 101 and SR-T 100 is that it provides such consistently accurate exposure information. It frees you from having to determine exposure mechanically and lets you concentrate your entire thought process on the creative and aesthetic side of your picture taking.

There are some basics to the act of taking a meter reading that you should be aware of, however. Being able to interpret a meter reading in relation to a particular scene and apply it to how you want that scene reproduced photographically will result in more creative and imaginative pictures, which can help distinguish your work from that of other photographers.

Faithful or Dramatic Rendition

Whereas many photographers go to great lengths to record a scene as faithfully as photographic materials will allow, others lean toward the more dramatic effects possible through exposure manipulation. An exposure that is less than normal results in a photograph with an overall tonality that is darker than usual. This is a low-key picture, in which the shadow areas are dark and deep and the highlights more subdued than in the original scene. The opposite, a high-key picture, results when the exposure is greater than normal. A high-key photograph has a light overall tonality. Under- and overexposure, when used purposefully to produce a predetermined effect, have long been used by professionals to make their work appear different.

High- and low-key effects are most rewarding when obtained under complementary lighting conditions. Contrast—the difference in brilliance between highlight and shadow areas—can vary greatly, even under the same illumination intensity. Scenes illuminated under flat light, which creates very few shadow areas, generally make disappointing low-key subjects. The same holds true for high-key effects in abnormally contrasty lighting conditions, where shadows make up a large portion of the scene.

In normal usage, the Minolta CLC metering system will not measure a scene to yield a high- or low-key rendition. It is only your interpretation of the meter reading which permits a change from normal rendition. Thus, for a low-key rendition, underexpose one, two, or even three f/stops to record only the barest detail on your film. For high-key rendition, overexpose one, two, or three full f/stops beyond the meter reading.

Adjusting the exposure factor is easy. To underexpose while reading the exposure directly through the lens, when using a film rated at ASA 125, set the dial at ASA 250. To overexpose one full f/stop, using the same film, adjust the dial to ASA 60. And to overexpose two full f/stops, set the dial at ASA 30.

A word to those who would rather make a faithful recording of subjects: If you find that your photographs seem consistently under- or overexposed, even when the setting on the ASA dial is exactly that recommended by the film maker, heed the following advice: If the slides or prints are consistently too light, adjust the ASA setting on the dial to the next *highest* notch and run some tests to see if the results are to your taste. If the slides or prints are consistently too dark, adjust the ASA setting to the next *lowest* notch. As long as everything else remains consistent, especially processing and printing, you will soon arrive at an ASA setting that will suit you.

The need to make this slight adjustment on the camera in no way indicates a malfunction of the metering system. Rather, it is a means of satisfying individual preferences. Once you make this slight adjustment, no other will be necessary as long as you use the same film. If you use a variety of films, make a note of the ASA adjustment, if one is necessary, for each type of film you use.

CONTRAST

A more detailed explanation of contrast in lighting will help solve some basic problems that are often encountered. First, contrast should not be confused with overall brightness. Contrast is simply the difference in brilliance between dark and light areas in a scene.

Some of the most contrasty lighting situations are found in low-level, available light scenes, where even the dimly lit highlight areas are many times brighter than the inky black shadow areas. Even though the Minolta CLC metering system indicates an accurate exposure for a situation such as this, you should not expect results that show great detail in both highlight and shadow areas, because photographic films, both black-and-white and color, simply cannot accurately record detail over so wide a range. You must decide which area is more important and take your meter reading accordingly. If shadow detail is more important, take a reading in an area where shadows predominate. If highlights are important, include more of these than shadows as you set the exposure. The professional's solution to the problem is to bracket the exposure by taking pictures at three or more different f/stops. Later he selects the exposure that recorded the most detail in those areas most important to him.

Flat light, which tends to eliminate shadows, is more often a problem when you shoot with black-and-white film. Since the black-and-white film records in tones from white through gray to black, a lack of shadows often deprives the print of the deep black tones that make the grays appear richer and the highlights brighter.

Flat light often occurs under conditions that may catch you by surprise. The sun can be shining brightly in a sky clear of haze and clouds, but if your subject is in the shade of a building, tree, or similar shielding object, it will be illuminated by a flat, shadowless light. Even when your subject is not in the shade, you may find that you can shoot only with the sun at your back, in which your subject will be flatly lit.

There are several ways in which contrast can be artificially increased: Filters are helpful in some cases, and it is also possible to decrease exposure and extend the development of the film. But these emergency steps do not produce the results possible under conditions of normal contrast.

On the other hand, flat light and color films complement each other, because colors, side by side, provide their own kind of contrast. When taken under flat light, a color slide of a red barn in a green field against a blue sky will show subtle differences in detail, texture, and color, which would be lost under harsh, contrasty sidelight. Candid portraits are also more life-like due to the soft, delicate colors that come through under flat or diffused light.

EXPOSURE WITH HAND-HELD METERS

Critical and extremely selective meter readings are best performed by spot meters. Minolta manufactures two hand-held spot meters—the Minolta Viewmeter 9°, which has an angle of acceptance of only 9°, and the Minolta Auto-Spot 1°, which has a 1° angle of acceptance. These meters can be very useful when you take backlighted portraits. The Auto-Spot 1°, for instance, allows you to stand a comfortable eight to ten feet from your subject and read only the shadows or highlights, depending upon the interpretation you want to give to the portrait. You would have to hold a normal, averaging meter just a few inches from your subject to get an accurate reading, and this is often inconvenient—sometimes even impossible.

If you do not own a hand-held spot meter, you can get similar results by using a telephoto lens on your SR-T 101 or SR-T 100. Set your exposure and take note of the f/stop and shutter speed. Then switch back to a normal lens, and use the aperture–shutter speed combination you got with the telephoto lens. This technique is useful if you photograph a backlighted subject using a normal or wide-angle lens and want to bring out the detail in your subject.

EXPOSURE WITHOUT A METER

On some occasions there may not be time to take a meter reading, so you should be able to interpret the light falling on a particular scene or sub-

ject and adjust your exposure without referring to the meter. A frontlighted scene, for example, with the sun over your shoulder, may call for a basic exposure of 1/250 sec. at $f/8$. If you change your position so that the light falls on the subject at a 45° angle, open the lens one full $f/$stop to retain the same detail in the subject. If you change your position again so that the light comes from behind the subject, open the lens two full $f/$stops to retain detail. On the other hand, if the subject is an inanimate object rather than a person, retaining your basic exposure but changing position can help the textural qualities of the subject.

Even the highly sophisticated CLC metering system is only a tool to help you interpret the scene. If there is a great deal of sky in a picture and you want to retain some of the foreground detail, open up the lens to give more exposure than the metering system indicates. For most of your picture taking, however, you will find that the exposure readings provided by the CLC metering system of the SR-T 101 and SR-T 100 will correctly interpret the scene and the subject. For information on exposure using filters, see Chapter 6. Exposure in closeup and macrophotography is covered in Chapter 8.

Fig. 3-2. Shooting directly into the sun and underexposing by two $f/$stops resulted in this striking action scene on the flight deck of the helicopter carrier Princeton. The picture was taken during a naval maneuver in the Caribbean. The camera was a Minolta SR-7 with the MC Auto Rokkor 55mm $f/1.7$ lens. The sky was burned in later in the darkroom. Photograph by John Neubauer.

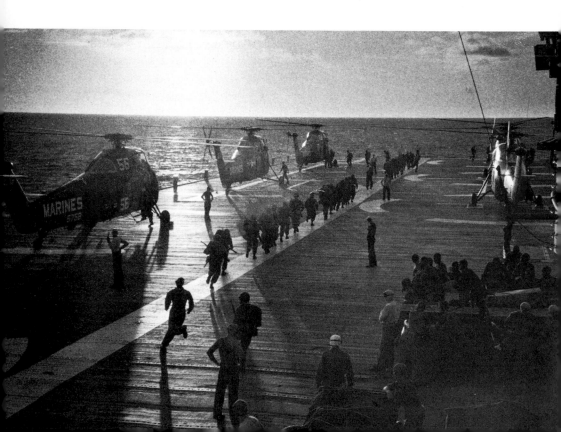

4

Lenses

The lens is the most important part of the camera. It makes the whole picture-taking process possible. The system of interchangeable lenses for the camera contributes to its versatility and flexibility. Interchangeable lenses provide you with a choice of focal lengths for controlling the angle of coverage, introducing deliberate distortion into your photography, controlling perspective for accurate reproduction and exaggerating it for particular visual effect, and reaching out in distance when it is safer not to approach the subject, as when you photograph wildlife.

The lens is a light-gathering optical instrument. How well it gathers the light and projects it onto the film determines (assuming that you have accurately focused the lens and held the camera steady) the sharpness of the final image—its resolution and contrast.

The Minolta SR-T 101 and SR-T 100 are high-quality precision instruments, and Minolta Rokkor lenses, manufactured in Minolta's own factories, are optically superior in resolution, sharpness, contrast, and illumination of the image area. The Minolta Camera Co., Ltd., is one of only two companies in Japan, and one of the few in the world, to manufacture optical glass and lenses for its own cameras. Even the crucibles or pots, in which the glass is made are produced by Minolta's own skilled workmen, using the most advanced automated manufacturing methods.

Each Minolta lens has an anti-reflection coating on all air surfaces to reduce light loss caused by reflection. If a lens is not coated, the light lost through reflection would be about 20 per cent. Besides reducing this loss, coating prevents flare and ghosting of images, reduces fog level, and improves image contrast. Minolta makes use of a double-layer coating process. The first layer is antimony oxide and the second, thicker than the first, is magnesium fluoride. The two layers jointly allow almost 100 per cent of the light to reach the film. This double-layer coating has a unique emerald hue, which instantly identifies the lens as a Minolta Rokkor.

Once the complex process of manufacturing optical glass has been completed—from the production of glass crucibles to polishing and coating—the

Fig. 4-1. For scenic photography, nothing takes in sweep and grandeur as well as the 21mm lens. The camera must be held absolutely perpendicular to parallel lines; otherwise lines will converge, giving the scene a distorted look. The great depth of field possible with the 21mm lens permits foreground-to-background sharpness. Photograph by Robert D. Moeser.

lens elements are placed in a lens mount, which is milled to fit precisely into the camera mount. This alignment procedure is critical, for it must be done with extreme accuracy if the aerial image is to align and coincide perfectly with the film plane.

Each Minolta Rokkor lens undergoes a careful quality control check before it is released for distribution and sale to ensure that it will provide maximum resolution, corner-to-corner sharpness, and a high degree of color correction for superior results in color and black-and-white photography.

Minolta manufactures a line of lenses extensive enough to fulfill practically every requirement of the professional and advanced amateur photographer. General purpose lenses range from the extreme wide-angle 21mm lens to the 1000mm telephoto. Special purpose lenses include a 16mm semi-fisheye lens, a macro lens for extremely close focusing, and a short-mount 100mm lens for use with the Minolta bellows extension unit. The details of

each lens are given in this chapter and the one following. Special purpose lenses are described in greater detail in subsequent chapters.

More than 30 Rokkor lenses are available for the Minolta SR cameras. Over half of them (18) are MC (meter-coupled) Rokkor lenses, which couple directly to the through-the-lens metering system of the SR-T 101 and SR-T 100, permitting exposure determination with the lens wide open. There are also the Auto Rokkors, which have automatic diaphragm operation but do not couple to the metering system, and the Rokkors, which are preset.

Figs. 4-2A–B. Lenses other than meter-coupled MC Rokkors can be used on the Minolta SR-T 101. When they are, however, you must use the stop-down measurement method to determine exposure through the lens, since they do not have the meter coupling pin found only on the MC Rokkor lenses. When the stop-down measurement method is used, the indicator needle moves as the lens diaphragm is opened or closed, and the follow (circle-tipped) needle is activated by the shutter speed dial. With Auto Rokkor lenses (A), the following steps are taken to make a stop-down measurement exposure reading: (1) advance the film; (2) press the diaphragm stop-down button, which will remain depressed until it is pressed in again or until the shutter release button is depressed; (3) set the shutter speed; (4) turn the diaphragm ring until the two needles align; (5) press the diaphragm stop-down button again to reopen the lens aperture blades so you can (6) focus easily in preparation for shooting your picture. You can also set the aperture first and then the shutter speed if you wish. (B) To determine a through-the-lens exposure reading when you use manual preset Rokkor lenses: (1) set the shutter speed; (2) set the maximum aperture of the lens, closing it down until the two needles in the viewfinder align. When the needles are aligned, you can take the picture. With manual preset lenses, you need not use the diaphragm stop-down button, since the aperture blades close and open as the aperture ring is turned. If you focus or compose your picture after you have determined your exposure setting, and you have done that by opening the lens to its maximum aperture, be sure to close the lens down again to the correct opening before making your picture. Otherwise you may have a serious problem with overexposure.

(A)

Figs. 4-3A–J. This sequence of photographs shows the areas of coverage of various focal length lenses and provides a vivid view of the impact of the extremely wide and extremely long focal length lenses. (A) 18mm. (B) 28mm. (C) 35mm. (D) 58mm. (E) 100mm. (F) 135mm. (G) 200mm. (H) 300mm. (I) 600mm. (J) 1000mm.

(B)

(C)

(D)

(E)

(F)

(Cont'd. on p. 48.)

(G)

(H)

(I)

(J)

FOCAL LENGTH

The focal length of a lens determines the size of the image that will be recorded on the film, assuming a set camera-to-subject distance. The shorter the focal length, the greater the angle of view and the greater the area of coverage; the longer the focal length, the smaller the angle of view and the smaller the area of coverage. If a photographer were to use a 28mm lens to photograph a man from a distance of seven feet, with the camera in the vertical position, he would take in the full frame of the man. If he then shifted to a 58mm lens, the area of coverage would be from about the man's waist up. With a 135mm lens, coverage would extend from his upper chest to the top of his head.

The focal length of a lens also determines, to some extent, the depth of field. With the camera at a set distance from the subject, and with the aperture setting the same for all lenses used, the depth of field will be greater with the shorter focal length lens, and shallower with the longer focal length lens. If the camera is 7 feet from the subject and the aperture is $f/8$, the depth of field with a 28mm lens will extend from 4 feet 3⅛ inches to 20 feet 10½ inches; the area in front of the subject will be in apparent focus by about 3 feet, and behind the subject by about 13 feet. With a 135mm lens, the depth of field will extend from only 6 feet 10 inches to 7 feet 2⅛ inches.

The focal length of each Rokkor lens is engraved on the lens mount in bright white lettering, such as "f=58mm." On some Rokkor lenses the focal length is also engraved on the lens barrel in brilliant orange lettering. The focal length engraving "f=" should not be confused with the $f/$number. *Focal length* is a term in optics which refers to the distance from the front of the lens when the lens is focused on an infinitely distant point (generally something at least 1000 times as far away as the focal length of the lens) to the surface of the film.

$f/$STOPS AND LENS SPEED

The term $f/stop$, or *aperture setting*, is used to describe the amount of light admitted through the lens. An aperture ($f/$stop) setting of $f/5.6$ admits

twice as much light as a setting of $f/8$ but only half as much light as a setting of $f/4$. The term *lens speed* is used to describe the maximum light-gathering capabilities of a particular lens. The 21mm $f/2.8$ MC Rokkor lens, for instance, is twice as fast as the 21mm $f/4$ Rokkor. At its maximum aperture of $f/2.8$, it admits twice as much light as the 21mm $f/4$ does at its maximum aperture. The maximum aperture of a lens is determined by the diameter of the optical components of the lens and the focal length of the lens. Thus, if the optical components are 50mm in diameter and the focal length of the lens is 100mm, the relative aperture of the lens should be $f/2$. If the diameter is 25mm and the focal length is 100mm, the relative aperture should be $f/4$.

Each lens has a series of f/stops engraved on the aperture ring. These numbers have a direct relationship to each other. They show the photographer the relative amounts of light admitted according to the aperture, or f/stop, used. The smaller the f/stop, the more light admitted; the larger the f/stop, the less light admitted. Opening up the lens to the next smaller f/stop allows twice as much light to enter the lens; stopping down the lens to the next larger f/stop reduces the amount of light coming in by half. Generally, the lens is opened up when lighting conditions are poor or when a shallow depth of field is desired for a particular photographic effect. The lens is usually stopped down to achieve greater depth of field. Adjusting the f/stops on the aperture ring upward or downward opens up or closes down the group of thin blades seen inside the lens. Opening up or closing down these blades is what actually controls the amount of light entering the lens. As a rule, f/stop numbers on the aperture ring are engraved so that the number to the left of one marking indicates a doubling of the number to the right of it.

You can achieve control over the f/stops by working them in combination with the shutter speed. If, for instance, you want to shoot at an aperture of $f/4$, but the match-needle alignment in the viewfinder indicates an aperture of $f/8$, you can get the desired working aperture by adjusting the shutter speed two speeds faster. If the speed is 1/60 sec., you would move it to 1/250 sec. The shutter speed/aperture combination of 1/250 sec. at $f/4$ transmits the same amount of light through the lens as the shutter speed/aperture combination of 1/60 sec. at $f/8$.

PERSPECTIVE

When you compare the dramatic difference between a scene taken with a wide-angle lens and the same scene photographed through a telephoto lens, it may seem hard to believe that perspective, which means the apparent convergence of parallels in the picture, is determined solely by the distance between the camera and the subject. But the fact is, if you keep the camera at the same position and change lenses, all you will change is the amount of the scene taken in and the size of the subject in your negative or color slide.

As an example, a photographer may take a series of pictures of a long street scene. The street is lined on either side with trees and lamp posts. At the end of the street, there is a 13-story building. To take his pictures, the

photographer uses a 21mm lens, a 58mm lens, and a 200mm lens. The viewing perspective in all of the pictures is exactly the same as long as the camera remains in the same position. In the picture made with the 21mm lens, foreground subjects will appear larger than those in the distance. The buildings on either side of the street will appear taller than the 13-story building at the end of it, even though those nearer the camera may only be 8 stories tall. In the picture made with the 58mm lens, fewer of the foreground trees, lamp posts, and buildings nearest the camera will appear in the photograph; in the picture made with the 200mm lens, perhaps only the 13-story building will be seen. If a section of each picture, covering the identical subject area, were printed under the enlarger to the same scale, each would be geometrically alike. The only way the photographer could change the perspective of the scene would be by changing his camera position.

Perspective Control and Viewpoint

Perspective and viewpoint are important controls, which render striking results when they are understood and properly utilized. A wide angle lens, for example, is generally used by architectural photographers to take in the full sweep of a building. The architectural photographer will strive to achieve straight lines in his picture so that the photographed building does not appear to be toppling over because of perspective convergence. To accomplish this, he must set his camera on a tripod and make absolutely sure that the camera is perfectly level and perpendicularly aligned with the lines of the building. The magazine photographer on an editorial assignment would also use a wide-angle lens to photograph the building, but unlike the architectural photographer, he might deliberately introduce distortion by slightly tipping his camera up or down. If he were to shoot from a crouched position, with the camera angled upward, the building would appear to lean backward, or even to topple over, and its roof lines would appear to converge. On the other hand, should the photographer change his viewpoint by moving his camera to a nearby structure that is as tall or taller than the building he is photographing and point his camera downward, the roof lines would dominate the picture, and the bottom floors would appear to converge.

Portrait photographers also use perspective control in their work to control image size and retain the normal perspective relationship between the subject's nose and ears. If the portrait photographer tried to fill the negative area with a face shot using a normal lens of about 50mm, 55mm, or 58mm, he would have to move so close to the subject that a distortion of the facial features would occur. At a camera distance from the face of 18 inches, the subject's ears will be about 25 per cent farther from the lens than the nose. The result will be a picture that is distorted in relation to the way we are accustomed to viewing a face. Generally, we do not look at a person's face from 18 inches away. But if we did, we would find that the nose would appear much larger and farther away from the ears, just as the camera saw it from 18 inches away. A photograph, because it is only two-dimensional, actually accentuates the real distortion at this distance.

51

The portrait photographer must back away about six or seven feet from his subject and use a longer lens so that the facial features come into a relationship that appears more natural. At this increased distance, the normal lens produces a smaller image, so the portrait photographer must employ a longer lens to produce a larger image. Since subject-to-camera distance—and this alone—determines distortion, changing to the longer lens (in portrait photography the lens would generally be 100mm) does not alter the rendition of the facial features.

In general, the wide-angle lens is used to expand on the relationship of one object to another, and the telephoto lens to compress or foreshorten the relationship. Although it is true that distance from the subject controls perspective, you can alter the appearance of perspective in your photographs by your choice of lenses and viewpoint.

ANGLE OF VIEW

The angle of view of a lens is the area it covers. The angle of view of a 58mm lens, for instance, is 41°; that of a 135mm lens is 18°. The maximum aperture of the lens has nothing to do with the angle of view, or coverage. A 135mm $f/3.5$ lens and a 135mm $f/2.8$ lens both have the same angle of view —18°. Wide-angle lenses have a greater angle of view than do longer lenses. The 16mm $f/2.8$ MC Rokkor fisheye has, for example, an angle of view of 180°.

Three angles are involved with the angle of view of a lens—diagonal, horizontal, and vertical. With the 16mm $f/2.8$ MC Rokkor-OK, for instance, the horizontal angle of view is 138° and the vertical angle of view is 87°. The diagonal angle of view is the actual angle of view of the lens, whereas the horizontal and vertical angles of view are in fact recorded on the film. For the most part, when the angle of view is discussed, the diagonal measure is referred to. The angle of view for lenses used with 35mm cameras is computed with the lens focused at infinity and is based on the angle diverging from the principal point of the lens to the corners of the 35mm film frame, which is 43.2mm at the diagonal. The image brightness of a lens and the sharpness of a lens begin to fall off beyond the circle of the angle of view of a lens, and because they do, lenses designed for 35mm photography generally cannot be used with larger cameras.

DEPTH OF FIELD

In theory, only one plane can be focused on sharply, and anything else in front of or behind the point of sharpest focus will be out of focus. In practical terms, however, the areas in front of and behind the point of focus may also be sharp. When any camera lens is sharply focused on one particular point, objects both closer and farther away appear to blur and become indistinct. These are the areas we refer to as *out of focus*. This decrease in definition is gradual, however, and there is still a band on either side of this plane of focus in which objects remain reasonably sharp. The depth to which this band extends is what we call *depth of field*.

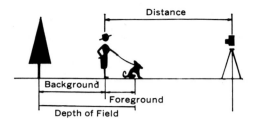

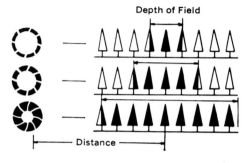

Fig. 4-4. Diagram showing how the camera-to-subject distance and lens aperture setting affect depth of field.

Depth of field is a function of the laws of optics, rather than the design or quality of any particular lens. It is determined by three factors: the focal length of the lens, the distance from the lens to the subject, and the aperture at which the lens is set.

At a given distance and aperture setting, a shorter focal length lens records a greater depth of field than a longer focal length lens. For example, a 35mm lens focused at a point 15 feet away and set at an aperture of $f/5.6$ produces a usable depth of field from 9 feet 2⅛ inches to 42 feet 1⅜ inches. A 135mm lens with the same distance and aperture settings provides a depth of field from 14 feet 5 inches to 15 feet 8 inches. So with the same settings and the same camera-to-subject distance, the 35mm lens produces a depth of field of about 33 feet, whereas the 135mm lens produces a depth of field of only 15 inches.

These same lenses set at the same aperture but focused at infinity yield

Fig. 4-5. The depth of field preview button is pushed in to close the shutter blades down to the taking aperture. Stopping down the lens in this fashion and sighting through the viewfinder, you can visually determine how much of your scene will be in focus.

53

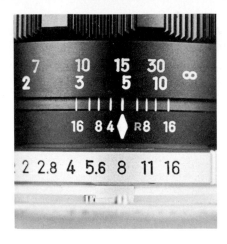

Fig. 4-6. The depth of field scale on the lens barrel is used when you are working in a fast-moving situation and there is not sufficient time to focus for each changing scene. With the lens aperture set at $f/8$ and the distance focused at 15 feet, the field of apparent sharpness will extend from about 12 feet to about 25 feet, or about 4 meters to about 7 meters.

a much greater depth of field. For the 35mm lens, the depth of field extends from 22 feet 9⅜ inches to infinity. For the 135mm lens, the depth of field extends from 320 feet 3⅞ inches to infinity. Thus, it is apparent that depth of field increases as the lens is focused at greater distances and also that the amount of increase is much greater with shorter focal length lenses than with longer ones.

The lens aperture also controls depth of field. The more the lens is stopped down, the greater the depth of field; the more the lens is opened up, the shallower the depth of field. For instance, with the medium length 85mm lens set at an aperture of $f/2.8$ and focused at 5 feet, the depth of field extends from 4 feet 11 inches to 5 feet 1 inch—a mere 2 inches. Keeping the same camera-to-subject distance, but closing down the lens to $f/22$, extends the depth of field from 4 feet 5⅛ inches to 5 feet 9⅛ inches, yielding a more workable range of sharpness of 16 inches.

Depth of field can be determined by looking through the viewfinder while depressing the diaphragm stop-down button to see the image as it will be photographed, or by referring to the depth of field markings on the lens barrel, or by consulting depth of field charts. Most photographers will find that referring to the depth of field markings on the lens barrel is most convenient.

If you look down at the lens in the shooting position, you will find the adjustable aperture ring directly in front of the camera body. Just in front of the ring is an engraved, nonmoving depth of field scale. In front of that is the revolving footage scale, which shows the distance at which the lens has been focused. Thus, at one glance, you can see all the information necessary to set the controls for the depth of field required for a particular photograph.

The depth of field scale includes a set of numbers that correspond to f/stops on either side of the arrow pointing toward the footage scale. This allows depth of field settings to be made in two ways: First, suppose you want to take a picture of a group of people sitting at a picnic table and wish to

shoot from an oblique angle. First, you would focus on the person nearest you and note the distance shown on the footage scale of the lens barrel. Next, you would focus on the person farthest from you and note that distance. Then, you would rotate the focusing ring of the lens barrel until both noted distances fell between the same aperture markings on the depth of field scale. Finally, you would set the lens aperture to the setting indicated on the depth of field scale and adjust the shutter speed dial for the correct exposure indicated by the match needle in the viewfinder. The second method involves the use of hyperfocal distance.

Figs. 4-7A–B. (A) A view through a normal lens with the lens set at full aperture. Notice that only the central portion of the picture, that part focused on, is in sharp focus. (B) A view through the same normal lens, but set at a small aperture. Notice that sharp focus now extends from the foreground to the background.

Hyperfocal Distance

To find the hyperfocal distance, the lens is first set at infinity. When the lens is at the infinity setting, the depth of field extends from infinity to a point nearer the camera. The distance from the camera to the near point is called the *hyperfocal distance*. (The near point, of course, depends on the aperture

and the lens. For instance, if the lens is 35mm and the aperture is set at $f/11$, the near point will be 11 feet 7⅛ inches. The distance from the camera to 11 feet 7⅛ inches will be the hyperfocal distance.)

If the lens is focused on the hyperfocal distance, the depth of field will extend from half the hyperfocal distance to infinity. As a rule of thumb, when making use of the hyperfocal distance, you should try to stay as far away from your subject as the near point determined by the infinity setting and the aperture being used. The hyperfocal distance is most used by newspaper photographers, especially when covering fast-breaking events, which provide little time for focusing.

INFRARED MARKINGS

All Minolta Rokkor lenses are corrected to bring visible light rays into the same focal point so that colors of the spectrum merge in proper relationship to each other on film. Invisible infrared rays, on the other hand, have their focal point somewhat farther away than that for visible rays. Because of this, normal focus settings generally do not apply when you use infrared film or infrared filters, particularly when you work at close focusing ranges and use apertures larger than $f/8$. There is no set guide to follow to allow for the shift of focus which occurs when you use infrared films or filters. The most practical method devised by Minolta to compensate for it is placing an infrared focusing index on the lens barrel, just to the right of the normal focusing index. The infrared focusing index is indicated by a small "R" stamped on the depth of field ring in red. To allow for the shift of focus when you use infrared film or filters, the distance mark indicated for regular film is set opposite the infrared mark, "R," on the depth of field scale. This focusing adjustment corrects for shift of focus.

AUTOMATIC DIAPHRAGM OPERATION

The MC Rokkor and Auto Rokkor lenses have automatic diaphragms, which are always open to their maximum aperture except at the instant of exposure. The diaphragm stop-down button, located at the base of the lens mount, permits previewing the depth of field for the aperture and distance setting without interfering with the automatic operation of the lens.

The automatic operation of the diaphragm—the opening up, closing down, and opening up again of the diaphragm before, during, and after the instant of exposure—is accomplished by means of an internal linkage within the lens barrel. On the rear of each MC Rokkor and Auto Rokkor lens is a spring-

Fig. 4-8. One of the most creative tools available is the zoom lens. When the lens is used zooming at a slow shutter speed, visually startling effects can be achieved. This photograph was made at a one-second exposure, zooming the lens for the full duration of the exposure. Photograph by John Neubauer.

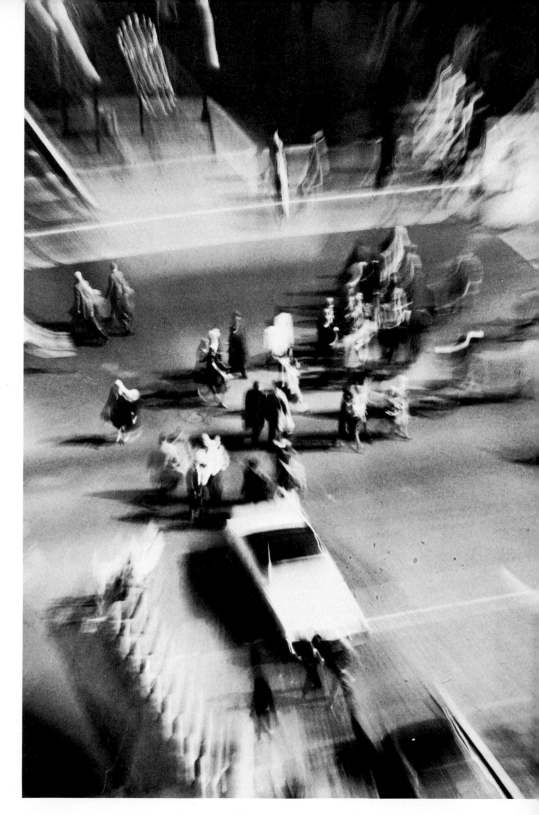

loaded pin, which protrudes slightly. The pin is linked to the diaphragm of the lens. When the lens has been mounted on the camera, the pin is set in motion with the release of the shutter button by means of a lever at the base of the instant-return mirror. When the shutter release button is pressed, the lever pushes against the pin until the diaphragm is closed down to its predetermined aperture. The position of the pin and the distance it travels when engaged by the lever are determined by the aperture (f/stop) for which the lens is set.

If you look at the rear of the lens, with the protruding pin to the right, and turn the aperture ring clockwise to open up the diaphragm or counterclockwise to close it down, the pin will move up or down in position, depending upon the aperture being set. Engaging the pin with the finger and moving it downward will open up the thin blades of the diaphragm. This exercise duplicates the action that occurs when the lever at the base of the instant-return mirror engages the pin linked to the diaphragm. In actual operation, when the shutter button is released, the mirror rises, the lens closes down to its predetermined aperture, the shutter curtain opens up exposing the film, the shutter curtain closes, the lens diaphragm opens up to its maximum aperture, and the mirror drops back into the viewing position.

MC ROKKOR LENSES

MC stands for meter-coupled. MC Rokkor lenses couple to the Contrast Light Compensator (CLC) exposure metering system of the Minolta SR-T 101 and SR-T 100, permitting you to determine your exposure through the lens by means of the match-needle system with the lens opened to its widest aperture. The MC Rokkors can also be used on earlier Minolta SR cameras; however, the earlier models do not have the meter coupler of the SR-T 100 and SR-T 101, so the MC Rokkors operate only as standard automatic diaphragm lenses, remaining at maximum aperture at all times except at the moment of exposure.

AUTO ROKKOR LENSES

When used with Minolta SR cameras, except the SR-T 101 and SR-T 100, Auto Rokkor lenses function as fully automatic lenses. The diaphragm remains at maximum aperture until the shutter release button is pressed and then closes down automatically for exposure at the predetermined aperture, reopening automatically for the next exposure.

When used with the SR-T 100 or SR-T 101, the Auto Rokkors still operate automatically but do not couple to the CLC metering system. To determine exposure through the lens utilizing the match-needle system of the SR-T 100 or SR-T 101 with Auto Rokkor lenses, the diaphragm stop-down button must be engaged. Then the aperture ring is turned in conjunction with the shutter speed dial until the needles are aligned in the viewfinder, and the diaphragm stop-down button is disengaged by pressing it inward, which

opens the Auto Rokkor to its maximum aperture. The lens closes down automatically to the correct aperture when the shutter release button is pressed and reopens automatically after the exposure has been made.

ROKKOR LENSES

These are manual preset lenses, meaning that the aperture always remains at its manual setting, before, during, and after the exposure, unless it is opened to its maximum aperture to facilitate viewing and composition. If you decide to use $f/8$ as the aperture for a particular exposure, set the aperture ring of the Rokkor lens to that position. It will remain at that setting because Rokkor lenses do not have the automatic diaphragm arrangement of the MC Rokkors or the Auto Rokkors. There is an extra ring near the aperture setting ring of the preset Rokkor lenses. That ring is used to open the diaphragm to its maximum aperture for viewing and composition and then to close it down to its working aperture before the exposure is made. All manual preset Rokkor lenses can be used on all Minolta SR cameras.

If you use a preset Rokkor lens on the SR-T 101 or SR-T 100, you can obtain a through-the-lens exposure. First, set the desired shutter speed, opening the lens to its widest aperture, and gradually close it down until the needles in the viewfinder are aligned.*

Lens Markings

Each Rokkor lens has engraved markings that indicate the focal length, maximum aperture, aperture settings, footage and metric distance scales, depth of field, and infrared focusing index. In addition, each lens, except those in the Rokkor zoom lens series, is marked with code letters. The first letter denotes the number of element groups, and the second indicates the number of elements that make up each lens. The code letters and their meanings are:

First Letter	Second Letter
T=3 groups	C=3 elements
Q=4 groups	D=4 elements
P=5 groups	E=5 elements
H=6 groups	F=6 elements
S=7 groups	G=7 elements

LENS CHANGING

The lens mount on the Minolta SR cameras is unique; only MC Rokkor, Auto Rokkor, and Rokkor lenses fit it without special adapters. The mount is of a bayonet design into which you insert the lens and twist it slightly so that the grips on the rear of the lens fit exactly into the grooves of the lens

*The Rokkor 21mm lens does not permit through-the-lens metering: The camera mirror must be locked up because of the deep rear-element configuration of this lens.

mount and lock into position after passing a locking catch. To remove a lens, release the locking catch with the lens release button. The Minolta bayonet mount ensures rapid lens interchangeability and tight, wobble-free fitting of the lens.

To mount a lens, follow these simple steps: First, hold the lens firmly in the right hand and turn it so that the red dot at the rear of the lens barrel faces up. Hold the camera in the left hand with the body facing you. Notice that above the lens mount, immediately below the engraved nameplate, there is a raised red dot. To the right of this red dot is the lens release button, which you operate by pressing downward. To mount the lens, align both red dots, and turn the lens barrel clockwise, about 45°, until it locks into position. The lens is locked securely when you hear a slight, but definitely discernible, click.

To remove the lens, hold the camera in the left hand, with the thumb extended above the camera body so that you can comfortably reach the lens release button while gripping the lens barrel firmly with the right hand. Press the left thumb downward on the lens release button; then, with the right hand, twist the lens counterclockwise, until the raised red dot below the nameplate and the red dot on the lens barrel are aligned. After accomplishing this, remove the lens by pulling it outward. Remember, you should never apply excessive force since this can damage the lens mount. If the lens does not turn easily, you have probably forgotten to press the lens release button.

The bayonet mount has been designed so that the lens will engage it only in the correct position. If you feel any resistance while mounting the lens to the body, recheck the red dot alignment rather than try to force the lens into the mount. When you hear a slight, distinct click, you will know that the lens has been properly mounted.

No special alignment technique or confusing scales are required in mounting any Rokkor lens. They may be removed or mounted at will, regardless of aperture or shutter speed setting.

GUIDE AND SELECTION

Currently, there are 30 MC Rokkor, Auto Rokkor, and Rokkor lenses for Minolta SR cameras, and as this manual was being written, 3 others were being introduced. The lenses range in focal length from 16mm to 1000mm. Each lens has a black satin finish, with the aperture ring finished in satin chrome. The focusing rings and aperture rings are knurled and milled for sure gripping. Each lens has its own serial number, engraved either on its front mounting ring or around its front rim. You should make note of the serial number of each lens you own. In the event the lens is lost or stolen, you should report it immediately to your local police department and to your insurance company.

There are three general categories of lens focal lengths: normal or standard, wide-angle, and telephoto. Normal, or standard, lenses are those with focal lengths of 50mm to 58mm. Wide-angle lenses generally have focal lengths of 21mm to 35mm. Telephoto lenses are those ranging in focal length

from 85mm to 300mm. Telephoto lenses are subcategorized into medium and long. Medium telephotos are those with focal lengths of 85mm to 135mm. Long telephotos are those with focal lengths greater than 200mm. Lenses with focal lengths shorter than 21mm, such as the 16mm $f/2.8$ MC Rokkor fisheye, are considered special purpose lenses, as are the 50mm $f/3.5$ MC Macro Rokkor, the Auto Zoom and Zoom Rokkors, and the Auto Bellows and Bellows Rokkor lenses.

Normal Lenses

The multitude of lenses available often leads a photographer to ask which lens, or lenses, he should buy. But the fact is that most photographs are taken with a normal (standard) lens. In theory, this is a lens with a focal length equal to the diagonal of the image area on the negative and an angle of view of approximately 53°. In 35mm photography, however, the 24 × 36mm negative frame has a diagonal of 43.2mm, and, in practice, the standard lens is generally somewhat longer.

For example, the standard 55mm $f/1.7$ MC Rokkor and the 55mm $f/2$ Auto Rokkor each have an angle of view of 43°, which closely matches the normal viewing angle of the eye. The standard 58mm $f/1.4$ MC Rokkor and the 58mm $f/1.2$ MC Rokkor each have an angle of view of 41°. In almost all the picture-taking situations a photographer is likely to encounter, any one of these lenses will do the job for him; therefore, a 55mm or 58mm lens is furnished as standard equipment with the SR-T 101. Which of the normal Rokkor lenses is furnished with the camera depends upon the choice of the photographer at the time of purchase. The SR-T 100 comes with a 55mm $f/1.9$ MC Rokkor lens.

Normal lenses are also favored because they have a greater maximum aperture than wide-angle and telephoto lenses and generally offer better optical performance. But there is no such thing as an all-purpose, universal lens. Each lens permits you to achieve a particular effect. The effect you want depends upon the requirements of the shooting assignment and your interpretation of them. Although the normal lens is used extensively by both the professional and the advanced amateur, it cannot fulfill all photographic requirements.

Wide-Angle Lenses

Wide-angle lenses are second in popularity to normal lenses. This is partially because, at any given camera-to-subject distance, wide-angle lenses take in a greater angle of view and deliver greater depth of field, aperture for aperture, than either the normal or telephoto lenses.

The range of wide-angle lenses available for Minolta SR cameras includes the 21mm $f/4$ Rokkor, the 28mm $f/2.5$ MC Rokkor, the 28mm $f/3.5$ MC Rokkor, the 35mm $f/1.8$ MC Rokkor, the 35mm $f/2.8$ MC Rokkor, and the 35mm $f/4$ Rokkor.

Wide-angle lenses are used to take in a broader sweep of a scene. How much of a scene you want to take in and how far from the central subject you

Fig. 4-9. The impressive ceiling of a church is brought into direct relationship with the altar in this sweeping view, made possible by the use of a 21mm lens. Because the light level was low in the church at the time the picture was made, the photographer used a column as a brace to steady the camera for a rather slow exposure of 1/8 sec. Photograph by Robert D. Moeser.

will be will dictate the focal length of the wide-angle lens. Wide-angle lenses are generally used in architectural photography, for interiors in industrial and commercial photography, and for group portraits. Newspaper and magazine photographers use the 35mm lens extensively, because when it is set at its hyperfocal distance, it provides a great depth of field, allowing them to photograph fast-breaking stories without having to refocus for each picture. They may switch to a 28mm lens when photographing large groups in small surroundings.

A new wide-angle lens, the 21mm $f/2.8$ MC Rokkor, was introduced as this manual was being written. Its angle of view is 92°, the same as that of the 21mm $f/4$ Rokkor, which has been discontinued. The new 21mm $f/2.8$ MC Rokkor can be used on all Minolta SR cameras without having to lock the mirror up. To use the old 21mm $f/4$ Rokkor, on the other hand, the mirror must be locked up and a special optical finder fitted into the accessory shoe. Lenses of this focal length have a certain amount of distortion at the edges. In a close-up of a group, for instance, the person at the farthest edge will appear ovoid. This egg-shaped distortion is not usually noticeable in photographs of inanimate objects, unless the object itself has a unique shape.

When subjects of the same size are photographed obliquely with wide-angle lenses, those closest to the camera appear large, whereas those at greater distances appear to diminish in size rapidly. This illusion of depth increases as the focal length decreases.

Architectural photographers often use the 21mm lens because its 92° angle of view gives them greater visual command of the scene. When using this lens, they minimize apparent distortion by holding the camera perpendicular to the ground and by removing from its field of view any distracting objects in the foreground.

Extreme wide-angle lenses like the 21mm and the 28mm are also used to achieve a variety of special effects ranging from humor to dramatic impact. By positioning a wide-angle lens as close to a subject's face as its minimum focusing distance will allow, the apparent distortion is often humorous. Using the same lens and the same camera-to-subject distance to photograph a hand clutching a knife or gun will add drama.

The creative use of a wide-angle lens can also heighten the visual impact of an ordinary scene. Imagine the scene of a draftsman bent over his drawing board. Instead of photographing this from an eye-level position, the photographer can add drama by moving close to the edge of the drawing board and pointing the camera downward until it is in a vertical position. The top of the subject's head will appear at the top of the frame.

The 16mm $f/2.8$ MC Rokkor and the 18mm $f/9.5$ Rokkor are special purpose lenses with angles of view of 180° each. Both lenses provide full-frame 24 × 36mm pictures without the vignetting commonly associated with such lenses, although the peripheral image is somewhat rounded. The distance to the subject and the angle of the camera at the time of exposure determine the degree of roundness. Both of these special purpose, wide-angle lenses provide through-the-lens viewing. The 16mm $f/2.8$ MC Rokkor, however, is a focusing lens, whereas the 18mm $f/9.5$ Rokkor is a fixed-focus lens.

Telephoto Lenses

A telephoto lens is one that has a longer focal length than a standard lens. The longer the focal length, the larger the size of the image the lens is capable of recording on film. This increased image size is directly proportional to the focal length, so that a lens with twice the focal length of another lens will produce an image that is twice as large. The angle of coverage of a lens is also directly proportional to the focal length. This means that a lens of twice the standard focal length can cover only half the angle of view while recording images twice the size. A 100mm telephoto, for example, has an angle of view of 24°, whereas a 200mm lens, twice the focal length of the 100mm lens, has an angle of view of 12°, only half that of the 100mm lens.

Telephoto lenses compress space in such a way that distances between near and far objects seem to be smaller than they really are. We have all seen pictures of traffic snarls in which all the vehicles seem to be riding up on each other's bumper. Those pictures are generally made with 200mm or longer lenses.

Telephoto lenses are most often used to record larger images than it would be possible to capture from the same camera-to-subject distance with normal lenses. Photographing boats or ships on rivers, lakes, bays, and oceans is an instance in which ideal distance positioning is almost impossible. In such cases, relatively long distances between the photographer and his subject are the rule rather than the exception. By shooting with a long telephoto of 200mm or 300mm, the photographer is able to close the distance gap and fill his picture frame.

A telephoto lens is a prerequisite for the photographer at a sporting event, since the very nature of sports makes it impossible for him to move around among the participants. Lightweight, hand-holdable telephoto lenses of relatively fast speed, such as the 200mm $f/3.5$ MC Rokkor, combined with high-speed film, permit the sports photographer to produce pictures that bring the viewer directly into the action.

Fashion photography and telephoto lenses have long been associated. Whether the picture calls for a closeup view of a pearl necklace draped around a model's neck, or a full length view of the latest in an evening gown or a fur coat, the telephoto lens can be depended upon to produce the most natural and flattering perspective. The larger images produced by the longer lenses also help retain razor sharp detail and texture.

Telephoto lenses not only magnify image size in proportion to their focal lengths, they also magnify any camera movement that may occur during the actual exposure. Thus, one of the most important requirements for successful telephotography is steadiness. With practice, most photographers can learn to hand hold a camera while using up to 300mm lenses; to avoid any chance of camera shake, however, you should use a tripod and cable release, or gunstock or chestpod supports. Lacking these supports, brace your camera against a tree, a rock, the window frame of your automobile (after you have shut off the engine), or some other firm support, and use the highest shutter speed possible that is consistent with the depth of field desired.

Fig. 4-10. For informal portraits, a medium focal length lens should be used. In this case, the lens was a 100mm, which permits you to stand sufficiently away from your subject so as not to intrude too much, and yet allows the subject to fill the frame. Photograph by John Neubauer.

Since telephoto lenses provide a shallower depth of field at the same apertures and working distances than normal and wide-angle lenses, focusing becomes more critical as the focal length increases. But it is just this shallow depth of field that can be used so effectively to throw a background out of focus. This technique is known as *selective focus*. Photographers who do candid work often make use of selective focus to isolate their subjects from any background that might otherwise prove distracting.

Portrait photographers frequently use the 100mm and 135mm lenses,

because they allow them to work reasonably close to their subject without distorting facial features. (See perspective control and viewpoint, page 51.)

Telephoto lenses tend to render distant objects lighter and less contrasty than those nearby. This is mainly due to such atmospheric conditions as fog, smog, dust, and air turbulence. The use of a UV (ultraviolet) filter helps to minimize the effect of haze on color film, and hence to increase the contrast of the picture. Filters can also be used to increase contrast in black-and-white photos. (See filters, Chapter 6.) Unfortunately, none of these conditions can be completely eliminated by filters, development adjustments, or special films. However, unfavorable atmospheric conditions can be used to advantage by the creative photographer who sees, perhaps, a river front scene with the fog masking the buildings in the background.

Special Purpose Lenses

There are nine special purpose lenses for the Minolta SR cameras. These are the 16mm $f/2.8$ MC Rokkor, the 18mm $f/9.5$ Rokkor, the 50mm $f/3.5$ MC Macro Rokkor, the 100mm $f/4$ Auto Bellows Rokkor, the 135mm $f/4$ Bellows Rokkor, the 600mm $f/5.6$ Tele Rokkor, the 1000mm $f/6.3$ Tele Rokkor (a catadioptric lens), and four zoom lenses: the 50–100mm $f/3.5$ Auto Zoom Rokkor, the 80–160mm $f/3.5$ Auto Zoom Rokkor, the 100–200mm $f/5.6$ Zoom Rokkor, and the 160–500mm $f/8$ Auto Zoom Rokkor.

The 16mm and 18mm lenses have special applications in photojournalism where a picture editor may want to distort a scene deliberately to make a particular editorial point. Other uses for these special purpose lenses are found in fashion photography, architecture, industry, and science.

The 50mm $f/3.5$ MC Macro Rokkor, the 100mm $f/4$ Auto Bellows, and the 135mm $f/4$ Bellows lenses have special applications in closeup and macrophotography, since their range of focus can be extended to within a fraction of an inch of the subject, producing 1:1 and greater magnification ratios. A complete description of the uses of these lenses is contained in Chapter 8.

The very long telephoto lens, the 600mm $f/6.3$ Tele Rokkor, is used for long-range sports photography, missile launches, police surveillance, wildlife photography, and similar situations in which the photographer is unable to get closer to his subject. A tripod is a must with a lens of this size. Filters must also be used to minimize unfavorable atmospheric conditions.

The 1000mm $f/6.3$ Tele Rokkor is a catadioptric lens, or so-called mirror lens, because it utilizes refracting and reflecting optics to reduce the size and weight of the lens. Light rays are admitted to the lens by refraction and are reflected to the image plane through a series of internal mirrors. Mirror lenses do not have diaphragm controls as do ordinary lenses. The amount of light entering a mirror lens is controlled with neutral density filters. A 4× neutral density filter, for instance, cuts down the light entering a mirror lens by approximately two $f/$stops. Mirror lenses provide an unusual degree of optical correction and flatness of field for lenses of their size, and they produce pho-

tographs of unusual image size and striking visual impact. Because there is no diaphragm control, the depth of field is almost nonexistent.

Zoom Lenses

Unlike a fixed focal length lens, a zoom lens offers continuously variable focal lengths, which produce an infinite range of magnifications and angles of view. Because of their unique ability to vary in focal length, zoom lenses were first employed in motion picture and television work. They allow motion picture cameramen to add impact to their photography by letting them rapidly move in on or away from a subject. For the still photographer, the major advantage of the zoom lens is the increased speed it permits for framing a subject without having to change either camera-to-subject distance or lenses. Zoom lenses should be most appreciated by the photographer who wants to travel light. A single zoom lens can provide the same coverage and angle of view as three or four fixed focal length lenses.

Zoom lenses also permit exceptional speed in photographing fast-moving action: Individual fixed focal length lenses can seldom be changed quickly enough to vary the field of coverage. A sports photographer covering a golf match, for instance, can use his zoom lens at its shortest focal length to get a long shot as the player begins his back swing and at a medium-long focal length to show the player with the club raised behind his head. Another long shot will depict the player as he connects with the ball, and then a series of tight head and shoulder shots will capture his expressions as he drops the ball in the cup to win the match. The still photographer using fixed focal length lenses would have to try to juggle three cameras, or rely on only one and the single point of view it would give him.

Three of the four Rokkor zoom lenses have automatic diaphragm operation. The other, the 100–200mm $f/5.6$ Zoom Rokkor, is a manual preset lens. Once the focus of a zoom lens has been set at a particular point, the focus remains the same as the focal length varies. As the focal length changes, however, depth of field also changes. Figures 4-3A through 4-3J show various angles of view possible with zoom lenses.

Zoom lenses used with the Minolta SR-M motor drive camera provide even greater flexibility in covering fast-breaking events when changing lenses and manually advancing the film could not be accomplished quickly enough to take in all the action.

SELECTING A LENS OUTFIT

With this extensive range of lenses available, choosing the most useful combination of lenses to purchase is difficult. Obviously, you should select lenses that will help you take the kind of photographs you want. For general purpose photography, the 35mm, 58mm, and 100mm or 135mm lenses, which would take care of most wide-angle, normal, portrait, and medium-telephoto requirements, may be the ideal combination. If you wish to produce more unusual photographs, the 16mm, the 50mm macro, and the

200mm lenses may be the right combination. Whatever combination of lenses you decide upon, in whatever number of focal lengths—three, five, or seven —your decision should be based on what end results you desire.

LENS HOODS

Lens hoods are available for the Rokkor lenses listed in the accompanying chart. Some lenses, such as the 135mm $f/2.8$ MC Rokkor, the 200mm $f/3.5$ Rokkor, and the 300mm $f/4.5$ MC Rokkor, have built-in lens hoods. Separate screw-in lens hoods are available for shorter lenses. No lens hood is necessary for the 50mm $f/3.5$ MC Macro Rokkor, because the front lens element is recessed so deeply within the lens barrel.

Lens hoods help protect the lens from dust, rain, and the photographer's fingers, all of which degrade the crisp images Rokkor lenses are so carefully designed to produce. Use of a lens hood is especially important when the photographer shoots into the light, *e.g.,* when he takes a backlighted portrait outdoors, because it helps prevent extraneous light from entering the lens. The right size lens hood must be used. If the lens hood is designed for a longer lens, there will be vignetting of the image. A lens hood designed for a short focal length lens but used on one of a longer focal length will still permit stray light to enter the lens.

CARE OF THE LENS

Use of the lens hood is one way of caring for the lens, since it protects the surface of the lens from being accidentally struck or scratched. Front and rear lens caps should be used when the lens is not on the camera, and the lens should be kept in the lens case to protect the lens barrel from getting scratched

Fig. 4-11. The Minolta SR-T 101 Compartment Case.

or otherwise damaged. If you do not wish to carry the lens in the lens case, because the case takes up too much room in your gadget bag, at least wrap the lens in a chamois cloth for protection.

The front and rear lens surfaces should be kept clean to ensure as crisp an image as possible. Clean the lens only with photographic lens tissue, sometimes liquid photographic lens cleaner (used sparingly), and a camel's hair brush or a forced air blower. To clean a lens, first wipe it clean of all surface dust, using the forced air blower or camel's hair brush. Use lens tissue to remove any surface soil other than dust. For stubborn soil, use additional lens tissue, moistening it with liquid lens cleaner and wiping gently over the lens surface. Dry away the lens cleaner with two or three sheets of lens tissue. Do not scrub or apply pressure since this could damage the lens coating. Professional photographers clean their lenses carefully before each assignment.

5

Lens Guide and Directory

This lens guide and directory to MC Rokkor, Auto Rokkor, and Rokkor lenses describes each lens manufactured by the Minolta Camera Co., Ltd., for the Minolta SR-1, Minolta SR-2, Minolta SR-3, Minolta SR-7, Minolta SR-T 100, Minolta SR-T 101, and Minolta SR-M motor drive cameras. It covers lenses currently in production as well as those that have been discontinued.

The information provided in this chapter includes mechanical features, dimensional diagrams, number of elements and groupings, diagonal angles of view, aperture ranges, focusing ranges, weights, filter sizes, diaphragm systems, and depth of field tables in meters and feet. Depth of field tables are

Fig. 5-1. The 28mm lens, with its 76° angle of view, is ideal for architectural photography. When taking architectural pictures, you must be sure to keep all lines in your picture straight. This is assured by holding the camera perpendicular to the ground. This view is of a scale model of a building. It was photographed on the roof of the existing building, taking advantage of the natural sky, clouds, and the surrounding tree line, to give it a real-life look. Photograph by John Neubauer.

Fig. 5-2. A 21mm lens was used for this study of the old quarter in New Orleans. Had the camera not been held perfectly perpendicular to the ground, the lines of the columns of the building would have converged, introducing unwanted distortion. The photographer used a Minolta SR-T 101 with the 21mm Rokkor lens. The exposure was 1/500 sec. at f/11. Photograph by Robert D. Moeser.

not given, however, for zoom lenses. The depth of field for a particular focal length and aperture on a zoom lens can be derived by referring to the depth of field table for the nearest corresponding fixed focal length lens.

Lenses are described in order of their focal lengths, with those of shorter

Fig. 5-3. A 21mm lens, a rainy day, and a rain-splattered windshield add up to this impressionistic view of the Washington Monument in Washington, D. C. The photographer shot this through the car windshield, with the focus set for the Washington Monument. Photograph by Robert D. Moeser.

focal lengths covered first. In cases where there are two or more lenses of the same focal lengths, the one with the greater maximum aperture is described first. Zoom lenses are listed at the back of the chapter, starting with the one having the shortest zoom range.

In addition to the wide range of lenses available for the Minolta SR cameras from the Minolta Camera Co., Ltd., a number of lenses of other manufacturers can also be used. Minolta makes adapters for Leica, Praktica, and Exakta mount lenses, all of which lock securely to Minolta SR camera bodies with the use of a special key supplied with each lens mount adapter. Any Exakta or Praktica mount lens can be used with SR cameras and can be focused through their full range. Leica mount lenses can be used only for close-ups and copying, since they have a different back focus arrangement. Exakta, Praktica, and Leica mount lenses do not couple to the through-the-lens metering system of the SR-T 101 or SR-T 100, nor do they operate as automatic diaphragm lenses.

MC FISHEYE ROKKOR-OK 16mm f/2.8 LENS

Type: ultra-wide-angle
Focal length: 16mm
Aperture range: f/2.8 to f/16 in full
 click stops; half stops from f/4;
 marked for infrared
Construction: 11 elements in 8 groups
Diaphragm: automatic,
 meter-coupled
Angle of view: 180° diagonal
 138° horizontal
 87° vertical
Frame coverage: 24 × 36mm, edge-
 to-edge
Focusing range: 1 ft. to infinity
Filters: filter turret built-in with ring
 control and marked click stops for
 1A, Y-48, O-54, and 80B filters
Lens hood: built-in
Weight: 15.6 oz.
Size: 73 × 63mm

UW ROKKOR-PG 18mm f/9.5 LENS (DISCONTINUED)

Type: ultra-wide-angle
Focal length: 18mm
Aperture range: f/9.5 to f/22 in full
 click stops; marked for infrared
Construction: 7 elements in 5 groups
Diaphragm: manual
Angle of view: 180° diagonal
 124° horizontal
 76° vertical
Frame coverage: 24 × 36mm edge-
 to-edge
Focusing: fixed focus, 18 in. to infin-
 ity
Filters: 37.5 screw-in rear mount;
 Y-48 and UV filters provided
Lens hood: bayonet type supplied
Weight: 8.5 oz.
Size: 59 × 41mm

MC ROKKOR 21mm *f*/2.8 LENS

Type: wide-angle
Focal length: 21mm
Aperture range: *f*/2.8 to *f*/22 in full
 click stops; marked for infrared
Diaphragm: automatic,
 meter-coupled
Angle of view: 92° diagonal
 81° horizontal
 59° vertical
Focusing range: 9.6 in. to infinity
Weight: 15.6 oz.

W ROKKOR-QH 21mm *f*/4 (DISCONTINUED)

Type: wide-angle
Focal length: 21mm
Aperture range: *f*/4 to *f*/16 in full
 click stops; marked for infrared
Construction: 8 elements in 4 groups
Diaphragm: manual
Angle of view: 92° diagonal
 81° horizontal
 60° vertical
Focusing range: 3 ft. to infinity
Filters: 55mm series
Lens hood: slip-on type
Weight: 5.8 oz.
Size: 60 × 20mm

 Note: The mirror must be locked
in the up position when this lens is
used. A separate optical viewfinder
showing the field of coverage is pro-
vided with this lens. The viewfinder
is mounted in the accessory shoe on
top of the pentaprism housing.

MC W ROKKOR-S1 28mm *f*/2.5 LENS

Type: wide-angle

Focal length: 28mm

Aperture range: f/2.5 to f/16 in full
click stops; half stops from f/4;
marked for infrared

Construction: 9 elements in 7 groups

Diaphragm: automatic,
meter-coupled

Angle of view: 76° diagonal
65° horizontal
46° vertical

Focusing range: 1.75 ft. to infinity

Filters: 55mm series

Lens hood: 55mm screw-in type sup-
plied

Weight: 12.8 oz.

Size: 64 × 61mm

MC W ROKKOR-SG 28mm *f*/3.5 LENS

Type: wide-angle

Focal length: 28mm

Aperture range: f/3.5 to f/16 in full
click stops; marked for infrared

Construction: 7 elements in 7 groups

Diaphragm: automatic,
meter-coupled

Angle of view: 76° diagonal
65° horizontal
46° vertical

Focusing range: 2 ft. to infinity

Filters: 55mm series

Lens hood: 55mm diameter screw-in
type supplied

Weight: 8.6 oz.

Size: 63 × 45mm

MC W ROKKOR-HH 35mm *f*/1.8 LENS

Type: wide-angle
Focal length: 35mm
Aperture range: *f*/1.8 to *f*/16 in full
 click stops; half stops from *f*/2.8;
 marked for infrared
Construction: 8 elements in 6 groups
Diaphragm: automatic,
 meter-coupled
Angle of view: 64° diagonal
 54° horizontal
 38° vertical
Focusing range: 1 ft. to infinity
Filters: 55mm series
Lens hood: 55mm diameter (55mm
 screw-in) supplied
Weight: 14.8 oz.
Size: 66 × 68mm

MC W ROKKOR-HG 35mm *f*/2.8 LENS

Type: wide-angle
Focal length: 35mm
Aperture range: *f*/2.8 to *f*/16 in full
 click stops and half stops; marked
 for infrared
Construction: 7 elements in 6 groups
Diaphragm: automatic,
 meter-coupled
Angle of view: 64° diagonal
 54° horizontal
 38° vertical
Focusing range: 1.3 ft. to infinity
Filters: 52mm series
Lens hood: 52mm screw-in
Weight: 7.6 oz.
Size: 63 × 45mm

	1.8	2.8	4	5.6	8	11	16
∞	∞ / 65' 9"	∞ / 42'10"	∞ / 30' 4"	∞ / 21' 6"	∞ / 15' 3"	∞ / 10'11	∞ / 7' 9"
20	28' 6" / 15' 5"	36'11" / 13' 9"	57' 2" / 12' 2"	256' / 10' 6"	∞ / 8'10"	∞ / 7' 2	∞ / 5' 8⅜"
10	11' 8" / 8' 8¾"	12'10" / 8' 2¼"	14' 7" / 7' 7½"	18' 1" / 6'11"	27' 6" / 6' 2⅛"	105' / 5' 4¼"	∞ / 4' 6"
7	7' 9¼" / 7' 4⅜"	8' 3½" / 6' 1"	8'11" / 5' 9¼"	10' 1" / 5' 4½"	12' 4½" / 4'11"	18' 4" / 4' 4¾"	58'11" / 3' 9¾"
5	5' 4⅜" / 4' 8¼"	5' 7" / 4' 6¼"	5'10" / 4' 4¼"	6' 4½" / 4' 1¾"	7' 1¾" / 3'11"	8' 8¾" / 3' 6½"	12' 9" / 3' 2"
4	4' 2" / 3' 9¼"	4' 4½" / 3' 3⅜"	4' 6½" / 3' 7"	4' 9⅜" / 3' 5¼"	5' 2½" / 3' 3⅜"	6' 0" / 3'⅜"	7' 7" / 2' 9¼"
3	3' 1¾" / 2'11"	3' 2¼" / 2'10"	3' 3¼" / 2' 9¼"	3' 4⅜" / 2' 8¼"	3' 7¼" / 2' 7"	3'11" / 2' 5¼"	4' 6¼" / 2' 3¼"
2.5	2' 6" / 2' 5¼"	2' 7½" / 2' 4"	2' 8½" / 2' 4¼"	2' 9¼" / 2' 3⅜"	2'11" / 2' 2½"	4' 0" / 2' 1⅜"	3' 5" / 1'11"
2	2'¼" / 1'11"	2' 0" / 1'11"	2' 1¼" / 1'11"	2' 1¾" / 1'10"	2' 2" / 1' 9"	2' 3" / 1' 9¼"	2' 6" / 1' 8¼"
1.5	1' 6¼" / 1' 5"	1' 6⅜" / 1' 5½"	1' 6½" / 1' 5¾"	1' 6¾" / 1' 5½"	1' 7¼" / 1' 4¾"	1' 7⅜" / 1' 4½"	1' 8¾" / 1' 4"
1.25	1' 3¼" / 1' 2⅜"	1' 3¼" / 1' 2¾"	1' 3⅜" / 1' 2¾"	1' 3½" / 1' 2½"	1' 3¾" / 1' 2¼"	1' 4½" / 1' 2"	1' 4½" / 1' 1¾"
1.0	1' / 11½"	1'½" / 11½"	1'¼" / 11¼"	1'¼" / 11¾"	1'⅜" / 11¾"	1'½" / 11½"	1'¾" / 11¼"

W ROKKOR-QE 35mm *f*/4 LENS (DISCONTINUED)

Type: wide-angle
Focal length: 35mm
Aperture range: *f*/4 to *f*/22
Construction: 5 elements in 4 groups
Diaphragm: manual
Angle of view: 64° diagonal
 54° horizontal
 38° vertical
Focusing range: 1.3 ft. to infinity
Filters: 55mm series
Lens hood: 57mm diameter (55mm
 slip-on)
Weight: 6.4 oz.
Size: 62 × 36mm

MC ROKKOR-PF 55mm *f*/1.7 LENS

Type: normal
Focal length: 55mm
Aperture range: *f*/1.7 to *f*/16 in full
 click stops; half stops from *f*/2.8;
 marked for infrared
Construction: 6 elements in 5 groups
Diaphragm: automatic,
 meter-coupled
Angle of view: 43° diagonal
 36° horizontal
 25° vertical
Focusing range: 1.75 ft. to infinity
Filters: 52mm series
Lens hood: 54mm diameter (52mm
 screw-in)
Weight: 7.9 oz.
Size: 63 × 37mm

AUTO ROKKOR-PF 55mm *f*/2 LENS (DISCONTINUED)

Type: normal
Focal length: 55mm
Aperture range: *f*/2 to *f*/16 in full
 click stops; marked for infrared
Construction: 6 elements in 5 groups
Diaphragm: automatic
Angle of view: 43° diagonal
 36° horizontal
 24° vertical
Focusing range: 1.75 ft. to infinity
Filters: 52mm series
Lens hood: 54mm diameter (52mm
 slip-on)
Weight: 7.2 oz.
Size: 60 × 35mm

MC ROKKOR-PG 58mm *f*/1.2 LENS

Type: normal
Focal length: 58mm
Aperture range: f/1.2 to f/16 in full click stops; half stops from f/2; marked for infrared
Construction: 7 elements in 5 groups
Diaphragm: automatic, meter-coupled
Angle of view: 41° diagonal
 34° horizontal
 23° vertical
Focusing range: 2 ft. to infinity
Filters: 55mm series
Lens hood: 57mm diameter (55mm screw-in)
Weight: 16 oz.
Size: 69 × 54mm

58mm F1.2 AND F1.4 MC ROKKOR LENSES (in feet)

F No. / Dis (ft)	1.2	1.4	2	2.8	4	5.6	8	11	16
∞	∞ / 282'	∞ / 244'	∞ / 171'	∞ / 121'	∞ / 85'	∞ / 61'	∞ / 43'	∞ / 30'	∞ / 22'
30	33' 6" / 27' 2"	34' 2" / 26' 9"	36' 3" / 25' 7"	39' 9" / 24' 1"	45'11" / 22' 4"	59' 0" / 20' 2"	98' 0" / 17' 9"	∞ / 15' 2"	∞ / 12' 8"
15	15'10" / 14' 3"	15'11" / 14' 2"	16' 5" / 13'10"	17' 1" / 13' 5"	18' 1" / 12'10"	19' 9" / 12'11"	22' 9" / 11' 3"	29' 0" / 10' 2"	47' 7" / 9' 0"
10	10' 4" / 9' 8⅛'	10' 5" / 9' 8"	10' 7" / 9' 6"	10'10" / 9' 3"	11' 3" / 9' 0"	11'10" / 8' 8"	12'11" / 8' 2"	14' 8" / 7' 7"	18' 2" / 6'11"
7	7' 2" / 6' 1⅛"	7' 2¼" / 6'10"	7' 3" / 6' 9"	7' 5" / 6' 8"	7' 7" / 6' 6"	7'10" / 6' 4"	8' 3" / 6' 1"	8'11" / 5' 9"	10' 1" / 5' 5"
5	5' ⅞" / 4'11"	5' 1" / 4'11"	5' 2" / 4'10"	5' 2" / 4'10"	5' 3" / 4' 9"	5' 5" / 4' 8"	5' 7" / 4' 6"	5'10" / 4' 4"	6' 4" / 4' 2"
4	4' ½" / 3'11⅜"	4' 1" / 3'11"	4' 1" / 3'11"	4' 1" / 3'11"	4' 2" / 3'10"	4' 3" / 3' 9"	4' 4" / 3' 8"	4' 6" / 3' 7"	4' 9" / 3' 5"
3.5	3' 6" / 3' 5½"	3' 6½" / 3' 5½"	3' 6¾" / 3' 5¼"	3' 7" / 3' 4¾"	3' 7½" / 3' 4½"	3' 8¼" / 3' 4"	3' 9¼" / 3' 3¼"	3'10¾" / 3' 2¼"	4' ¾" / 3' ¾"
3	3' ¼" / 2'11⅝"	3' ½" / 2'11⅝"	3' ½" / 2'11½"	3' ¾" / 2'11¼"	3' 1" / 2'10¾"	3' 1½" / 2'10½"	3' 2¼" / 2'10"	3' 3¼" / 2' 9¼"	3' 4¾" / 2' 8¼"
2.5	2' 6⅛" / 2' 5¾"	2' 6¼" / 2' 5¾"	2' 6½" / 2' 5¾"	2' 6½" / 2' 5½"	2' 6¾" / 2' 5¼"	2' 7" / 2' 5"	2' 7½" / 2' 4¾"	2' 8¼" / 2' 4¼"	2' 9" / 2' 3½"
2.25	2' 3⅛" / 2' 2⅞"	2' 3¼" / 2' 2⅞"	2' 3¼" / 2' 2¾"	2' 3½" / 2' 2¾"	2' 3½" / 2' 2½"	2' 3¾" / 2' 2½"	2' 3¾" / 2' 2¼"	2' 4" / 2' 2"	2' 4¾" / 2' 1"
2	2' ⅛" / 1'11⅞"	2' ¼" / 1'11¾"	2' ¼" / 1'11¾"	2' ¼" / 1'11¾"	2' ½" / 1'11¾"	2' ¾" / 1'11½"	2' ¾" / 1'11¼"	2' 1¼" / 1'10¾"	2' 1¾" / 1'10½"

MC ROKKOR-PF 58mm *f*/1.4 LENS

Type: normal
Focal length: 58mm
Aperture range: f/1.4 to *f*/16 in full
 click stops; half click stops from
 f/2; marked for infrared
Construction: 6 elements in 5 groups
Diaphragm: automatic,
 meter-coupled
Angle of view: 41° diagonal
 34° horizontal
 23° vertical
Focusing range: 2 ft. to infinity
Filters: 55mm series
Lens hood: 57mm diameter (55mm
 screw-in)
Weight: 9.7 oz.
Size: 62 × 40mm

MC ROKKOR 85mm *f*/1.7 LENS

Type: telephoto
Focal length: 85mm
Aperture range: f/1.7 to *f*/16 in full
 click stops; half stops from *f*/2;
 marked for infrared
Diaphragm: automatic,
 meter-coupled
Angle of view: 29° diagonal
 24° horizontal
 16° vertical
Focusing range: 3.5 ft. to infinity
Filters: 55mm series
Lens hood: 57mm diameter (55mm
 screw-in) supplied
Weight: 16 oz.

MC TELE ROKKOR-PF 100mm f/2.5 LENS

Type: telephoto
Focal length: 100mm
Aperture range: f/2.5 to f/22 in full
click stops; half stops from f/4;
marked for infrared
Construction: 6 elements in 5 groups
Diaphragm: automatic,
meter-coupled
Angle of view: 24° diagonal
20° horizontal
14° vertical
Focusing range: 4 ft. to infinity
Filters: 55mm series
Lens hood: 57mm diameter (55mm
screw-in)
Weight: 14.4 oz.
Size: 65 × 68mm

MC TELE ROKKOR-QE 100mm f/3.5 LENS (DISCONTINUED)

Type: telephoto
Focal length: 100mm
Aperture range: f/3.5 to f/22 in full
click stops; half stops from f/4;
marked for infrared
Construction: 5 elements in 4 groups
Diaphragm: automatic,
meter-coupled
Angle of view: 24° diagonal
20° horizontal
14° vertical
Focusing range: 4 ft. to infinity
Filters: 52mm series
Lens hood: 54mm diameter (55mm
slip-on)
Weight: 8.4 oz.
Size: 63 × 54mm

TELE ROKKOR-TC 100mm ƒ/4 LENS (DISCONTINUED)

Type: telephoto
Focal length: 100mm
Aperture range: ƒ/4 to ƒ/22
Construction: 3 elements in 3 groups
Diaphragm: manual
Angle of view: 24° diagonal
　　　　　　　20° horizontal
　　　　　　　14° vertical
Focusing range: 4 ft. to infinity
Filters: 46mm size
Lens hood: none
Weight: 8.4 oz.
Size: 56 × 80mm

MC TELE ROKKOR-PF 135mm ƒ/2.8 LENS

Type: telephoto
Focal length: 135mm
Aperture range: ƒ/2.8 to ƒ/22 in full
　　click stops; half stops from ƒ/4;
　　marked for infrared
Construction: 6 elements in 5 groups
Diaphragm: automatic,
　　meter-coupled
Angle of view: 18° diagonal
　　　　　　　15° horizontal
　　　　　　　10° vertical
Focusing range: 5 ft. to infinity
Filters: 55mm series
Lens hood: built-in
Weight: 15 oz.
Size: 67 × 93mm

MC TELE ROKKOR QD 135mm f/3.5 LENS

Type: telephoto
Focal length: 135mm
Aperture range: f/3.5 to f/22 in full
click stops; half stops from f/4;
marked for infrared
Construction: 4 elements in 4 groups
Diaphragm: automatic,
meter-coupled
Angle of view: 18° diagonal
 15° horizontal
 10° vertical
Focusing range: 5 ft. to infinity
Filters: 52mm series
Lens hood: 52mm screw-in supplied
Weight: 14 oz.
Size: 64 × 88mm

135mm F2.8 AND F3.5 MC TELE ROKKOR LENSES (in feet)

Dis (ft) \ F No.	2.8	3.5	4	5.6	8	11	16	22
∞	∞ 246'	∞ 518'	∞ 449'	∞ 318'	∞ 225'	∞ 159'	∞ 113'	∞ 80'
50	54' 1" 46' 6"	55' 2" 45' 9"	56' 1" 45' 1"	59' 1" 43' 4"	63'11" 41' 1"	72' 3" 38' 3"	88' 8" 34'11"	131' 31'
30	31' 5" 28' 9"	31' 9" 28' 5"	32' 1" 28' 2"	33' 0" 27' 6"	34' 5" 26' 7"	36' 8" 25' 5"	40' 5" 23'11"	47' 2"
20	20' 7" 19' 5"	20' 9" 19' 4"	20'11" 19' 2"	21' 3" 18'11"	21'10" 18' 6"	22' 8" 17'11"	24' 0" 17' 2"	26' 3" 16' 2"
15	15' 4" 14' 8"	15' 5" 14' 7"	15' 6" 14' 7"	15' 8" 14' 5"	16' 0" 14' 2"	16' 5" 13'10"	17' 1" 13' 4"	18' 2" 12'10"
12	12' 2" 11'10"	12' 3" 11' 9"	12' 4" 11' 9"	12' 5" 11' 7"	12' 7" 11' 5"	12'11" 11' 3"	13' 3" 10'11"	13'11" 10' 7"
10	10' 2" 9'10"	10' 2" 9'10"	10' 2" 9'10"	10' 3" 9' 9"	10' 5" 9' 7"	10' 7" 9' 5"	10'10" 9' 3"	11' 3" 9'¼"
8	8' 1" 7'11"	8' 1¼" 7'10¾"	8' 1⅜" 7'10⅝"	8' 2" 7'10"	8' 3" 7' 9¼"	8' 4¼" 7' 8⅛"	8' 6⅛" 7' 6⅜"	8' 9" 7' 4½"
7	7'¾" 6'11¼"	7' 1" 6'11"	7' 1" 6'11"	7' 1⅝" 6'10½"	7' 2⅛" 6' 9⅜"	7' 3⅛" 6' 9⅛"	7' 4½" 6' 8"	7' 6⅜" 6' 6⅜"
6	6'½" 5'11½"	6'¾" 5'11¼"	6'¾" 5'11¼"	6' 1¼" 5'11"	6' 1¼" 5'10½"	6' 2¼" 5'10"	6' 3¼" 5' 9⅜"	6' 4⅝" 5' 8"
5	5'⅜" 4'11⅝"	5'½" 4'11½"	5'½" 4'11½"	5'⅝" 4'11⅜"	5' 1" 4'11"	5' 1⅜" 4'10⅝"	5' 2⅛" 4'10⅛"	5' 3" 4' 9⅜"

TELE ROKKOR-TC 135mm f/4 LENS (DISCONTINUED)

Type: telephoto
Focal length: 135mm
Aperture range: f/4 to f/22
Construction: 3 elements in 3 groups
Diaphragm: manual
Angle of view: 18° diagonal
　　　　　　　 15° horizontal
　　　　　　　 10° vertical
Focusing range: 5 ft. to infinity
Filters: 46mm series
Lens hood: 48mm diameter (46mm
　 slip-on)
Weight: 13.7 oz.
Size: 56 × 115mm

MC TELE ROKKOR-QF 200mm f/3.5 LENS

Type: telephoto
Focal length: 200mm
Aperture range: f/3.5 to f/22 in full
　 click stops; half stops from f/5.6;
　 marked for infrared
Construction: 6 elements in 4 groups
Diaphragm: automatic,
　 meter-coupled
Angle of view: 12° diagonal
　　　　　　　 10° horizontal
　　　　　　　　7° vertical
Focusing range: 8 ft. to infinity
Filters: 62mm series
Lens hood: built-in
Weight: 25.4 oz.
Size: 70 × 135mm

MC TELE ROKKOR-PE 200mm f/4.5 LENS

Type: telephoto
Focal length: 200mm
Aperture range: f/4.5 to f/22 in half
 click stops; marked for infrared
Construction: 5 elements in 5 groups
Diaphragm: automatic,
 meter-coupled
Angle of view: 12° diagonal
 10° horizontal
 7° vertical
Focusing range: 8 ft. to infinity
Filters: 52mm series
Lens hood: built-in
Weight: 17.6 oz.
Size: 63 × 130mm

MC TELE ROKKOR-HF 300mm f/4.5 LENS

Type: telephoto
Focal length: 300mm
Aperture range: f/4.5 to f/22 in full
 click stops; half stops from f/8;
 marked for infrared
Construction: 6 elements in 6 groups
Diaphragm: automatic,
 meter-coupled
Angle of view: 8° diagonal
 7° horizontal
 5° vertical
Focusing range: 15 ft. to infinity
Filters: 72mm series
Lens hood: built-in
Weight: 40.5 oz.
Size: 80 × 200mm

TELE ROKKOR-TD 600mm *f*/5.6 LENS (DISCONTINUED)

Type: telephoto
Focal length: 600mm
Aperture range: *f*/5.6 to *f*/45
Construction: 4 elements in 3 groups
Diaphragm: manual
Angle of view: 4° diagonal
　　　　　　　3° horizontal
　　　　　　　2° vertical
Focusing range: 33 ft. to infinity
Filters: 126mm series
Lens hood: 126mm diameter
　(126mm screw-in)
Weight: 165 oz.
Size: 132 × 530mm

RF TELE ROKKOR 1000mm *f*/6.3 LENS (DISCONTINUED)

Type: telephoto
Focal length: 1000mm
Aperture range: *f*/6.3 to *f*/22 by
　means of neutral density filters
Construction: mirror lens
Diaphragm: manual
Angle of view: 2° 30′ diagonal
　　　　　　　2° horizontal
　　　　　　　1° 30′ vertical
Focusing range: 100 ft. to infinity
Filters: 49mm series
Lens hood: 200mm diameter
　(200mm screw-in) supplied
Weight: 23.2 lb.
Size: 217 × 450mm

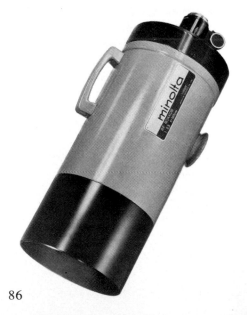

AUTO BELLOWS ROKKOR-TC 100mm *f*/4 LENS

Type: bellows
Focal length: 100mm
Aperture range: f/4 to *f*/32 in full
 click stops
Construction: 3 elements in 3 groups
Diaphragm: automatic
Angle of view: 24° diagonal
 20° horizontal
 14° vertical
Focusing range: with Auto Bellows,
 1:1 to infinity
Filters: 55mm series
Lens hood: none
Weight: 5.8 oz.
Size: 63 × 35mm

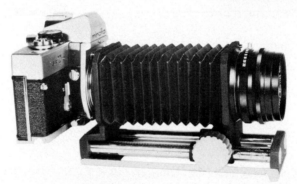

BELLOWS ROKKOR-TC 135mm *f*/4 LENS (DISCONTINUED)

Type: bellows
Focal length: 135mm
Aperture range: f/4 to *f*/22 in full
 click stops
Construction: 3 elements in 3 groups
Diaphragm: manual
Angle of view: 18° diagonal
 15° horizontal
 10° vertical
Focusing range: with Bellows I, 1:1
 to infinity
Filters: 46mm series
Lens hood: none
Weight: 7.1 oz.
Size: 56 × 55mm

MC MACRO ROKKOR QF 50mm f/3.5 LENS

Type: macro
Focal length: 50mm
Aperture range: f/3.5 to f/22 in full
click stops; half stops from f/5.6;
marked for infrared. (With life-
size adapter, aperture range is
f/5.6 to f/32 in full click stops;
half stops from f/8)
Construction: 6 elements in 4 groups
Diaphragm: automatic,
meter-coupled
Angle of view: 46° diagonal
40° horizontal
27° vertical
Focusing range: 9 in. to infinity; with
life-size adapter, 1:2 to 1:1
Filters: 55mm series
Weight: 11.6 oz. with life-size
adapter
Size: 68 × 55mm

AUTO ZOOM ROKKOR 50–100mm f/3.5 LENS (DISCONTINUED)

Type: zoom
Focal length: 50–100mm
Aperture range: f/3.5 to f/22 in full
click stops
Construction: 15 elements in
9 groups
Diaphragm: automatic
Angle of view: 46° to 24° diagonal
39° 30' to 20° horizontal
27° to 14° vertical
Focusing range 6.6 ft. to infinity
Filters: 77mm series
Lens hood: 77mm diameter (77mm
screw-in)
Weight: 30 oz.
Size: 82 × 126mm

AUTO ZOOM ROKKOR 80–160mm *f*/3.5 LENS (DISCONTINUED)

Type: zoom
Focal length: 80–160mm
Aperture range: *f*/3.5 to *f*/22 in full
 click stops
Construction: 15 elements in
 10 groups
Diaphragm: automatic
Angle of view: 28° 30′ to 15° diag.
 24° to 12° horizontal
 16° to 9° vertical
Focusing range: 8 ft. to infinity
Filters: 77mm series
Lens hood: 77mm diameter (77mm
 screw-in)
Weight: 47.8 oz.
Size: 84 × 206mm

ZOOM ROKKOR 100–200mm *f*/5.6 LENS (DISCONTINUED)

Type: zoom
Focal length: 100–200mm
Aperture range: *f*/5.6 to *f*/22 in full
 click stops
Construction: 8 elements in 5 groups
Diaphragm: manual
Angle of view: 24° to 12° diagonal
 20° to 10° 20′ horiz.
 14° to 6° 50′ vertical
Focusing range: 7 ft. to infinity
Filters: 52mm series
Lens hood: 52mm diameter (52mm
 screw-in)
Weight: 19.5 oz.
Size: 58 × 175mm

AUTO ZOOM ROKKOR 160–500mm *f*/8 LENS (DISCONTINUED)

Type: zoom
Focal length: 160–500mm
Aperture range: *f*/8 to *f*/22 in full
 click stops
Construction: 16 elements in
 11 groups
Diaphragm: automatic
Angle of view: 15° to 5° diagonal
 24° to 4° 10′ horiz.
 16° to 2° 40′ vertical
Focusing range: 15 ft. to infinity
Filters: 77mm series
Lens hood: 77mm diameter (77mm
 screw-in)
Weight: 97 oz.
Size: 87 × 490mm

6

Films and Filters

The instant you trip the camera shutter you set off a chain reaction that pretty well determines how your final picture will look. That chain reaction involves not only the lens aperture and shutter speed but the film and filter also, since each of these controls is related to the other. The combination one photographer chooses will differ from that of another, thus providing a mark of individuality in each person's photography.

BLACK-AND-WHITE FILMS

The number of black-and-white films available in 35mm size grows larger each year. But they can be broken down roughly into three general classes—slow, medium, and high speed—according to their relative sensitivity to light, which is expressed as an ASA number, or rating. ASA numbers are based on a formula devised by the American Standards Association, which coordinates and approves standards for the photographic industry. A low number, of say ASA 25, means that the film has less light sensitivity than a film with a rating of ASA 160.

Slow Films

Slow films are those rated from ASA 20 to ASA 50. Films in this speed range are widely used. Their ability to render detail brilliantly and sharply is unsurpassed, because they have inherent fine grain and high contrast. Thus, they are especially popular with photographers who intend to produce very large prints. As a rule, slow films allow considerably less latitude for exposure error than medium- and high-speed films, but for the careful worker the results attainable are more than worth the extra attention that he must devote when determining exposure.

Medium-Speed Films

Medium-speed films are rated from ASA 100 to ASA 200. These films produce slightly more grain and less contrast than slow films, but they allow

Fig. 6-1. Antique shops are excellent places for shooting mood pictures, like this one taken at Burtonsville, Md. The picture was originally photographed in color. It was duplicated later on Panatomic-X for this black-and-white print. Photograph by John Neubauer.

greater latitude in exposure error. Medium-speed films are popular for general outdoor work because they permit greater manipulation of the camera's controls: Shutter speeds can be set to freeze action or slowed down to produce blur; lens aperture settings can be stopped down for maximum depth

of field or opened wide for selective focus. With a normal amount of care in handling, these films are capable of producing extreme enlargements of satisfactory quality.

High-Speed Films

High-speed films are rated from ASA 250 to ASA 400 or higher. Although they can produce prints of good quality when used outdoors in sunlight, they are more suited to use indoors under natural lighting conditions. Films in this class yield negatives of less contrast than slower films, which is advantageous to the photographer shooting indoors under available light conditions, because the contrast range in this situation tends to be extreme. Less contrasty negatives help preserve the natural appearance of the original scene.

High-speed films offer the widest latitude for exposure error, although overexposure will increase the appearance of grain in the finished prints. Overexposure is almost as harmful to high quality in all classes of black-and-white film as it is in color film. Overexposure produces proportionately more density in the highlight areas, where it probably is not needed, than in the shadow areas, where it probably is needed. Overexposure due to light scatter, or halation, degrades image sharpness. When this happens, the highlight areas of the picture appear to bleed into the middle tones and shadow areas.

COLOR FILMS

There are two major types of color film: those that produce positive transparencies (color slides) and those that produce negatives.

Color Slide Films

Color transparencies, more commonly called *slides,* result from a reversal of the photographic image during development of the color film. When viewed against a light source or projected on a screen, these slides provide a strikingly vivid color reproduction of the original scene. The slower color

Fig. 6-2. The ⊖ symbol engraved to the left of the film advance lever shows the exact position of the film in the camera. It is used to measure precisely the distance from the subject to the film for closeup and macrophotography.

slide films produce images with the greatest sharpness, the finest grain structure, and the highest contrast.

Three types of color slide film are available. Daylight types are made to produce natural looking results under normal, outdoor daylight conditions. In addition, two types of film are manufactured for use with artificial lighting: Type A is made for use under photoflood lights, which are found in portrait studios and on theater stages; Tungsten Type is balanced for use in tungsten light, which illuminates our homes, and with studio floodlights. Filters can be used to balance out any of these films to any type of lighting; they are explained in detail below.

Negative Color Films

For photographers more interested in viewing their work in print form, color negative films might prove more convenient. By exposing negative color film, which is available only in a limited variety of emulsions, color prints of very high quality can be made quickly and inexpensively.

CHOOSING THE RIGHT FILM

Most films, whether black-and-white or color, are adequate for general, all-around photography. However, since each can do some things better than others, it is to your advantage to decide just what you want to do. If you plan to shoot primarily outdoors, a slow or medium-speed film will best serve your purpose. On the other hand, if you expect to do most of your shooting in low-level, available light situations, a high-speed film will provide the best results.

The photographer who intends to work with long focal length lenses, even if most of his shooting will be outdoors in bright sunlight, would be wise to use a high-speed film so that he can use a high shutter speed, which helps lessen camera movement, and a small lens aperture for increased depth of field.

For closeup and table-top photography, where light conditions can be controlled, a slow film will help produce crisp detail, whereas a fast film will permit stopping down the lens to a smaller aperture for increased depth of field.

In the end, gaining experience by trying films of different speeds is the only way you can decide which films will best fulfill your particular needs.

FILTERS

Whereas general purpose films have been designed to respond to colors in nature in about the same way that the human eye sees them, the use of filters often adds unexpected impact to a photograph. Filters can darken the sky to give clouds a dramatic effect, which transforms an ordinary scene into a spectacular one. They can lighten sky and water to lend a hazy mood to a seascape and provide more pleasing flesh tones in portraits taken outdoors. Filters permit the use of indoor color film outdoors and of outdoor color film

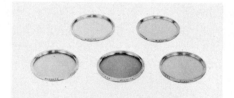

Fig. 6-3. The infrared index (a red "R" on the lens barrel) is used when you shoot with infrared film. After you have made the normal focusing adjustment, turn the focusing ring to align the distance on the focusing scale with the red "R" on the depth of field scale.

indoors. There are filters to warm skin tones, penetrate haze, eliminate surface reflections, and create night effects in daylight.

Interestingly enough, filters add excitement to photographs by subtracting from the full spectrum of light entering the camera lens. Because filters are subtractive, exposure generally has to be increased to use them correctly. And how much of an exposure increase—called a *filter factor* or *exposure multiple*—is necessary depends upon the particular filter.

Suppose you want to photograph a scene that includes a weather-beaten barn atop a softly rising hill, framed in the foreground by clusters of freshly cut wheat—the sky rich and blue, and the clouds puffy and majestic. The scene could be photographed straight on. If you react as most photographers, you will expose at least two frames—one vertical, one horizontal—shooting from the viewpoint from which you first viewed the scene. But if you seek something special in your photograph, you will immediately consider shooting the scene several other ways, such as from a variety of viewpoints and with different filters to capture unusual moods.

Minolta manufactures filters as well as lenses from glass it makes in its own factories. Each Minolta filter is solid glass, uniform in quality, and optically ground flat to provide minimal distortion. And each filter is double threaded, a special feature that allows a lens hood to be screwed into the filter once the filter has been screwed into the lens. For optimum lens performance, a lens hood should always be used.

Fig. 6-4. Minolta's solid glass filters are important aids for heightening or diminishing specific kinds of photographic effects.

UV	46mm	52mm	55mm	62mm	67mm	77mm	126mm
Yellow	46mm	52mm	55mm	62mm	67mm	77mm	126mm
Red		52mm	55mm				126mm
Orange		52mm	55mm				
Green		52mm	55mm				
Polarizing		52mm	55mm				
80 B		52mm	55mm				
85 A		52mm	55mm				
1 A		52mm	55mm				
ND		52mm	55mm				

Fig. 6-5. Filters available from Minolta and filter mount sizes.

For Black-and-White Films

There are four Minolta filters for use with black-and-white films: yellow (Y-48), orange (O-54), green (G-0), and red (R-59). These are available to fit lenses accepting either 52mm or 55mm series filters. For lenses accepting 46mm, 52mm, 67mm, and 77mm series filters, only the UV (ultraviolet) and yellow Minolta filters are available. There were also UV, yellow, and red Minolta filters available in the 126mm series size for the 600mm $f/5.6$ Tele Rokkor-TD.

Minolta does not make filters for the 300mm $f/4.5$ MC Tele Rokkor-HF (72mm series) or the 1000mm $f/6.3$ RF Tele Rokkor (49mm series) lenses. Filters that fit Minolta lenses accepting 46mm, 49mm, 62mm, 67mm, 72mm, and 77mm series filters are also available from independent filter manufacturers.

For Color Films

For color photography, Minolta makes several filters. The Skylight 1A helps reduce blue and add warmth to a scene. Many professional photographers use this filter as a protective device for the front element of the lens. The Minolta 80B balances the light source when daylight color film is used indoors; the Minolta 85 and 85B filters balance the light source when tungsten (indoor) color film is used outdoors in daylight. The Skylight 1A and the 80B, 85, and 85B filters are available only in 52mm and 55mm series filters.

When and how do you use filters? Many photographers use them almost all the time. Most make it a habit to keep at least the Skylight 1A on all lenses regularly, as much to reduce any excess blue that may show up on color film as to protect lenses in rainy or dusty weather.

Effects of Filters on Black-and-White Films

But how do yellow, green, orange, and red filters affect pictures when used with black-and-white films? These filters can be referred to as *contrast* or *effect* filters. They control tonal values so that you can achieve a technically correct rendition of a particular scene and exaggerate or suppress tonal differences to portray certain effects, such as bringing out the detail of

foliage in a landscape or heightening contrast between clouds, sky, and sails in a marine scene.

Each filter subtracts a particular color or colors from the light entering the lens. A red filter absorbs blue and green; a blue filter, red and green; a green filter, red and blue; a yellow filter, blue; a magenta filter, green; and a cyan filter, red.

Keeping this in mind will make it easier for you to understand why, for example, a red filter darkens blue sky and brings out clouds. The filter holds back the blue light from the sky but lets the white light from the clouds, which of course includes red, pass through. Thus, the clouds are more heavily exposed, and therefore lighter, than the sky.

The general rule of thumb when using filters with black-and-white film is that filters lighten their own color and darken other colors.

More than any other filter, the yellow (Y-48) Minolta filter produces tones that most closely relate to what the eye sees naturally. The Y-48 very effectively emphasizes white tones against a blue background, such as cloud formations against a blue sky. It is useful for most landscape views, architectural work, some outdoor portraits, and snow scenes when the sunlight is extremely bright.

The orange (O-54)) Minolta filter does what the yellow does, only more so. It depicts blue much darker and yellow and red much brighter than they appear to the naked eye. It is better suited to telephotography than the yellow filter because of the amount of contrast it adds to the scene. Similarly, it may be more useful in architectural photography, where strong contrast in a scene may be required.

The green (G-0) Minolta filter produces effects similar to those of the yellow, except that it renders greens lighter. This is sometimes desirable when photographing a landscape with large areas of green foliage because, in effect, it lightens the shadows, providing better overall definition. At the same time, the green filter renders red somewhat darker. It is well suited to outdoor portraiture against the sky, since it darkens the sky while it enhances flesh tones.

The red (R-59) Minolta filter produces extreme contrast. Blue skies become very dark, nearly black, and clouds take on a stark white look. The red filter can be used to simulate night scenes because it underexposes slightly. Some very striking, exciting landscapes and architectural views can be obtained by using this filter.

Effects of Filters on Color Films

Unlike filters for black-and-white, which are used to control tonal values, filters for color films are used to change the quality of the light entering the the lens in order to achieve the proper color balance for the particular film.

In color photography, it is essential to know the color temperature of a light source if the color film is to reproduce true color. Color temperature is usually expressed in terms of units Kelvin (formerly degrees Kelvin), which is a way of giving a measurable value to a light source. It is named for W. T.

Kelvin, who discovered an effective way of measuring the color temperature of different light sources. The Kelvin (K) color temperature of a light source is the temperature on an absolute scale to which a perfect black body radiator—one which does not reflect any light falling on it—would have to be heated to emit light of the same color as the light source in question. These temperature measurements are applicable to all incandescent light sources, such as home lights, studio lights, and electronic strobe lights. The lower the color temperature of a source, the richer the light is in yellow and red. The higher the color temperature, the richer it is in blue.

Based on Kelvin's formula, daylight generally has a color temperature of about 6500 K. Tungsten lamps, such as quartz halogen, have a color temperature of 3200 K; photoflood lamps have a color temperature of 3400 K.

Using the Kelvin formula, film manufacturers sensitize color films to react according to the light source to which they are intended to be exposed. Thus, a film such as Kodak High Speed Ektachrome Tungsten would be properly used under 3200 K light sources and Kodachrome II Professional Type A under 3400 K light sources; Kodachrome II, Ektachrome-X, GAF 64 Color Slide Film, GAF 200, Agfachrome CT 18, and other daylight films would be properly used outdoors in daylight.

Light Balancing and Color Compensating Filters

Light balancing filters, in effect, raise or lower the color temperature of the light entering the lens. The Minolta 80B, 85, and 85B filters are light balancing filters, which change the color quality of the light source reaching the film to what it should ideally be for the emulsion.

For instance, the 80B filter balances light out by lowering the color temperature of a daylight source to a tungsten light source of 3400 K. Thus, with the 80B filter, daylight color films, such as Kodachrome II, Kodachrome-X, GAF 64, GAF 200 Color Slide Film, and other daylight color films, can be used indoors when you photograph under photoflood lights with a color temperature of 3400 K.

The same kind of light balancing changes occur with the use of 85 and 85B filters. With the 85, indoor films, such as Kodachrome II Professional Type A and Dynachrome A Tungsten, can be used outdoors in daylight. The 85B permits the use outdoors in daylight of High Speed Ektachrome Tungsten and other indoor films balanced for use with studio lamps.

Whereas light balancing filters bridge the relatively wide gap between films corrected for particular light sources, color compensating filters are used when more subtle but precise changes in color balance are desired. Color compensating (CC) filters are used singly or combined, depending upon the amount of color correction required. But because the scattering of light through the filters may cause a loss of definition, it is best to use the minimum number of CC filters required to achieve the color balance nearest to that desired.

The density of a CC filter is indicated by the numbers in the filter desig-

nation, and the color by the last letter. The CC10Y filter, for instance, is yellow, hence the last letter Y, and its density value is 10. The CC10Y filter would be used to absorb excess blue. A chart showing the Kodak CC filters and the colors they absorb appears on page 103.

The density value indicates the amount of exposure increase necessary to compensate for the loss of light through the lens caused by the use of a filter. Hence, the density value is an indication of the filter factor to be applied; however, with the CLC exposure metering system, you need not worry about this. As a matter of general interest only, these factors are given in the chart on page 103.

Filter Factors

The Minolta SR-T 101 and SR-T 100 CLC through-the-lens exposure system provides the photographer with an important advantage when working with filters in that he need not overly concern himself with filter factors: The CLC meter measures the light directly through the lens and through the filter. (See Exposure and Metering, Chapter 3.) These factors do become important, however, when Minolta hand-held meters are used.

A filter factor is simply the allowance in exposure that must be made for the amount of light that does not pass through the lens when a filter is used, and not all filters have a filter factor. There is none, for instance, for either the Skylight 1A or the UV filters. But with all other filters, some kind of exposure compensation must be made if not already provided for by a metering system.

With the yellow (Y-48), Minolta recommends a 2× factor. This means that you should adjust the exposure to allow twice the light to enter the lens as would enter without the Y-48 in place. Suppose, for instance, that your Minolta Viewmeter 9 hand-held exposure meter shows an exposure of 1/250 sec. at $f/8$. To double the exposure to allow for the use of the yellow filter, you would either open the lens aperture one stop to $f/5.6$ and retain the shutter speed of 1/250 sec. or increase the shutter speed to 1/125 sec. and keep the aperture at $f/8$.

Filter factors, or exposure multiples, are to filters what guide numbers are to flash photography—simply an approximation of what the manufacturer believes would be the best compensation to make in photographing under normal conditions. However, the filter factor can change, depending upon whether the photographic session is in the morning or the evening, in the summer or the winter, indoors or outdoors.

For example, a recommended factor might produce greater compensation in exposure than is wanted to attain a certain effect. So, although the photographer can generally rely on the factors Minolta recommends for most of his photographic requirements and tastes, he really should work out his own set of exposure factors for each filter. For exacting work, this rule even applies to using the CLC metering system, because differences in processing, printing, and individual taste can all influence the final acceptability of a negative or color slide.

The Skylight Filter

The Skylight 1A filter is used to absorb excessive ultraviolet light when the photographer shoots snow scenes, seascapes, mountain scenes, and other distant views. It helps reduce the effects of haze and adds a slightly warmish tone to the scene. In open shade or on heavily overcast days, this filter helps absorb the ultraviolet light, which produces an overall bluish cast under these conditions.

The UV (Ultraviolet) Filter

This filter is available from Minolta for lenses accepting 46mm, 52mm, 55mm, 62mm, 67mm, and 77mm series filters. The UV filter, like the Skylight 1A, helps to reduce the bluishness inherent in a particular scene, as well as to absorb the sun's ultraviolet rays. The UV filter is particularly useful for beach and snow scenes, where light is scattered about because of water vapor and dust particles in the atmosphere.

The Polarizing Filter

A favorite of all professional and advanced amateur photographers is the versatile polarizing filter. Since it does not change the color rendition of a scene, the polarizing filter can be used with either black-and-white or color film. The Minolta polarizing filter will darken the sky in the scene you are photographing, thus heightening the visual impact. It will remove or reduce the reflections from water when you photograph marine scenes or from glass surfaces when you photograph, say, an art object in a display case. It will help eliminate annoying reflections when you photograph oil paintings, people, and other objects behind glass windows.

In a color photograph of a panoramic scene, the polarizing filter will provide spectacular saturation and separation of colors and make the sky a rich, deep blue where it otherwise might wash out. And it does this without changing the other colors in the scene.

The polarizing filter is unique because, instead of absorbing some colors and transmitting others as normal filters do, it holds back only rays of light that are travelling in a certain plane. Light usually vibrates in all directions, but in some cases more of the light vibrates in one plane than another, and is called *polarized light*. This is especially true of skylight when you are standing at right angles to the sun and of reflections from nonmetallic surfaces, such as glass, water, and snow, when your camera is pointed at an angle of about 35° from the reflecting surface.

As you rotate the polarizing filter, it will hold back more and more of the polarized rays, until you reach a maximum darkening effect in which none of the polarized rays can get through.

You can judge the results of using a polarizing filter directly through the lens of your Minolta SR-T 101 or SR-T 100 and determine for yourself the effect you want. For maximum darkening of blue sky, stand at right angles to the sun. For maximum elimination of reflections from a nonmetallic surface,

Fig. 6-6. Polarizing filters are used to eliminate or control reflections. They can also be used to darken skies to produce unusual and dramatic photographic effects. Polarizing filters are recommended for photographing water, glass, or other reflecting surfaces, as well as polarizing light emanating from the sky.

experiment by changing your angle of view: The critical angle will be somewhere between 30° and 40°, depending upon the nature of the reflecting surface.

The Neutral Density Filter

There are occasions in photography when the amount of light reaching the film should be reduced without heightening the contrast of a scene; neutral density filters serve this purpose. They are used to control exposure without changing colors or tonal values. Neutral density filters come in a variety of densities, and they are available with filter factors of $2\times$, $4\times$, $6\times$, $8\times$, and $10\times$, which indicate a reduction in exposure of 1, 2, 2½, 3, and 3½ aperture settings.

Neutral density filters are of greatest benefit when the photographer is using a fast film outdoors in extremely bright light. They are also used when a large diaphragm opening is desired to control depth of field or to permit a slow shutter speed in order to create a blur depicting the effect of motion.

The Creative Use of Filters

There are hundreds of ways filters can be used creatively. With black-and-white films, this could mean the use of a red filter to dramatize a landscape that might otherwise not be given a second look. In architectural photography, the orange filter will heighten the effect of increased contrast between a building, clouds, and sky. Or the photographer may want to try recording a beach scene by keeping the camera on a tripod and making multiple exposures, first with the red filter, then the green, and maybe the blue (80B).

Filters designed for use with black-and-white films need not be limited to them exclusively. The yellow filter can, for instance, be used with a daylight color film to add a golden glow to a midday sky, or the red filter can be used to dramatize a city skyline suffering the ill effects of industrial pollution.

When you use a daylight light balancing filter, exciting things might happen by exposing an indoor color film under regular table lamp lighting. Or an orange filter could be used over an electronic flashgun to give a warmish glow to an outdoor color portrait.

The effects of these and other combinations of filters can be previsualized in whole or in part through the viewfinder of the Minolta SR-T 101 and SR-T 100, because the photographer views directly through the lens and filter.

Light Balancing Filters

Color temp. of Light Source[1]		Wratten No.	Color of Filter	Exposure Increase (fractions of a stop)[2]
2800 K	2950 K	82C		$2/3$
2900 K	3060 K	82B	Bluish	$2/3$
3000 K	3180 K	82A		$1/3$
3100 K	3290 K	82		$1/3$
3200 K	3400 K		No filter required	
3300 K	3510 K	81		$1/3$
3400 K	3630 K	81A		$1/3$
3500 K	3740 K	81B	Yellowish	$1/3$
3600 K	3850 K	81C		$1/3$
3850 K	4140 K	81EF		$2/3$

[1]The light source is brought to 3200 K or 3400 K, respectively, by means of the appropriate filter.

[2]These values are approximate. If extremely accurate results are required, these values should be checked by actual trial, more especially when more than one filter is used.

Color Temperatures of Artificial Light Sources

Candle or paraffin lamp	2000 K
Acetylene lamp	2400 K
Carbon filament incandescent lamp	2080 K
Incandescent lamps: vacuum	2400–2600 K
gas-filled 100–500 Watts	2800–3000 K
Projection lamp, 1000 Watts	3200 K
Philips Argaphoto or Osram Nitraphot Type B	3200 K
Philips Photolita or Osram Nitraphot Type S	3400 K
Carbon arc lamp	3800 K
Halogen lamps	3400 K
K. I. Special carbon arc	6000 K*

*The above figures are correct within about 50 K.

COLOR COMPENSATING FILTERS

Maximum Density	Yellow Filter (absorbs blue)	Exposure Increase (fractions of a stop)[1]	Magenta Filter (absorbs green)	Exposure Increase (fractions of a stop)[1]	Cyan Filter (absorbs red)	Exposure Increase (fractions of a stop)[1]
0.05	CC–05Y	—	CC–05M	1/3	CC–05C	1/3
0.10	CC–10Y	1/3	CC–10M	1/3	CC–10C	1/3
0.20	CC–20Y	1/3	CC–20M	1/3	CC–20C	1/3
0.30	CC–30Y	1/3	CC–30M	2/3	CC–30C	2/3
0.40	CC–40Y	1/3	CC–40M	2/3	CC–40C	2/3
0.50	CC–50Y	2/3	CC–50M	2/3	CC–50C	1

Maximum Density	Red Filter (absorbs blue and green)	Exposure Increase (fractions of a stop)[1]	Green Filter (absorbs blue and red)	Exposure Increase (fractions of a stop)[1]	Blue Filter (absorbs red and green)	Exposure Increase (fractions of a stop)[1]
0.05	CC–05R	1/3	CC–05G	1/3	CC–05B	1/3
0.10	CC–10R	1/3	CC–10G	1/3	CC–10B	1/3
0.20	CC–20R	1/3	CC–20G	1/3	CC–20B	2/3
0.30	CC–30R	2/3	CC–30G	2/3	CC–30B	2/3
0.40	CC–40R	2/3	CC–40G	2/3	CC–40B	1
0.50	CC–50R	1	CC–50G	1	CC–50B	1 1/3

[1]These values are approximate only. If very accurate results are required, the above values should be checked by practical trial, especially when more than one filter is in use.

NOTE: The Kodak Skylight filter is designed for use in the open with daylight-type color film in such cases as give bluish results without a filter. This filter is mainly of use for subjects partly in shadow under a clear blue sky. Occasionally it may be suitable for exposures on a cloudy day, for distant subjects, mounted scenery, sunny snowscapes, or air photographs.

NOTE: The use of daylight-type film with Kodak Wratten filter 80A is recommended only in case of emergency, since it requires a six times increase of exposure.

103

Fig. 6-7. The alert photographer will keep his camera loaded, ready to shoot, and with him at all times. This view was taken as the photographer was driving home. A Minolta Y-48 (yellow) filter was used to emphasize the backlighted cloud. Photograph by Robert D. Moeser.

7

Auxiliary Lighting

During the early years of photography, picture taking was limited to the daylight hours when adequate light was available. This limitation diminished as technological advances took place. Flash powder opened the door to photography inside dark interiors and at night. This was followed by the introduction of floodlights—a safer and more controllable form of illumination. Eventually, flashbulbs and electronic flash units came on the scene.

Photography literally means painting with light, and because light is so important to good photography, it will help to review the general principles of lighting and its effects on the subject.

The best way to learn about lighting is to pay close attention to the factors that contribute to the formation of shadow. Soft, indistinct shadows, caused by flat lighting conditions, lessen the appearance of form and texture in a subject. If the subject is wearing coarse textured clothing or is handling a textured object, flat light, such as that directed from the camera position, eliminates most of the shadows that would pick out the texture. On the other hand, harsh, contrasty light produces large areas of deep, dark shadows. This occurs when a subject is illuminated by a single spotlight or by a single flash unit fired at an angle to the subject. High-key or shadowless, photographs, made with indirect or flat light, produce images that appear soft, indistinct, and illusionary. Low-key photographs, made with contrasty light, appear sharp, dramatic, and somber. By controlling the effect of shadows, the photographer can predetermine the visual effect of his photographs.

FLASHBULBS

Flashbulbs consist of a glass shell, which contains a primer, and in most cases, an extremely thin, wire-like material made up of aluminum and magnesium.

When the camera shutter is tripped, a weak current provided by a battery ignites the primer, and this in turn causes the wire to burn very rapidly inside the bulb, producing a brilliant light. The glass shell is lacquered on the inside

Fig. 7-1. Working with models is always enjoyable work for the photographer, especially when they are as pretty as Kathy Doyle of Washington, D. C. Two umbrella lights were used for this picture, one on either side of Miss Doyle at 45° angles to her face. The exposure was 1/60 sec. (the correct shutter speed on the Minolta SR-T 101 for synchronizing with electronic flash) at $f/8$. The film used was Tri-X rated normally at ASA 400. Photograph by John Neubauer.

Fig. 7-2. The Minolta Deluxe Flash Unit III has a folded-type reflector and swivels to any of five click-stop positions. It takes a regular base, a pinless base, and AG-type flashbulbs. It can be used either with a cord or without one. The unit also fits on the accessory shoe of the Minolta SR-T 101.

and outside surfaces to provide strength and protection against shattering under the sudden, intense heat of the flash.

Flashbulbs are made in a variety of sizes and are designed to fit different contact bases in the flashgun. The Minolta Deluxe Flash Unit III accepts the three most popular contact bases: the regular, bayonet base, which is inserted into the bulb opening of the flashgun and given a slight twist to make contact, and the pinless base and the AG base, both of which are simply snapped into the contact opening for perfect seating.

Flashbulbs vary in other ways to suit different purposes. Minolta users will be most interested in the M-type and FP-type (focal plane) bulbs. As the camera shutter is tripped, there is a small but measurable interval between the time the current is applied to the primer and the time the wire ignites. About 20 milliseconds are required for M and FP bulbs to ignite and reach maximum light output. The peak of M flashbulbs is brief but intense; FP bulbs of the same size have a weaker but longer lasting peak. This has a direct effect on the amount of usable light falling on the subject.

Other popular flashbulbs include the fast-peak F bulbs, which are less powerful than M and FP bulbs and have only primer material to burn, and the M-2 and smaller bulbs, also less powerful than M and FP bulbs. However, these smaller bulbs are adequate for most occasions when high-speed films are used. All manufacturers provide complete information, which you should follow when using any flashbulb.

Synchronizing Flashbulbs with the Minolta Shutter

The Minolta Deluxe Flash Unit III, which accepts M, FP, F, and M-2 flashbulbs, is hooked up to the camera by connecting the flashgun lead to one of the two synchronization terminals, located midway down the lefthand side of the lens mount. When the lead is connected to the "FP" terminal, FP flashbulbs can be used at all shutter speeds up to 1/1000 sec. When the lead is connected to the "X" terminal, proper synchronization will take place for F bulbs at shutter speeds up to 1/30 sec. and for M bulbs up to 1/30 sec.

GUIDE NUMBERS

Exposure determination with any artificial light source depends upon the intensity of the light and the distance from the light to the subject. Correct

Fig. 7-3. There are two sync terminals on the Minolta SR-T 101: One is designated "FP," the other "X." With electronic flash, the cord is plugged into the X terminal. When using FP-type flashbulbs, the FP terminal is used.

exposure is found by using *guide numbers,* which differ according to the intensity of the light source you use and the speed of the film.

Manufacturers of flash equipment provide suggested guide numbers with each of their units. To compute your exposure, measure the distance in feet from your flash to your subject and divide that distance into the guide number. The answer will be the correct *f*/stop setting. For example, if the guide number for a flashbulb used in conjunction with an 80 ASA film is 100 and the distance to the subject is 10 feet, you would divide 100 by 10 and get an *f*/stop of *f*/10. Guide numbers for flashbulbs vary according to the shutter speed being used. At 1/60 sec. the guide number may be 100, at 1/125 sec. it could change to 75, and at 1/200 sec. to 60.

You may wish to work out your own set of guide numbers based on the performance of your equipment and the quality you expect to see in your negative or color slide. To accomplish this, position your flash unit ten feet from your subject. Then take a series of pictures, changing the aperture setting for each exposure. For each new exposure, have your subject hold a sheet of paper marked with the aperture setting used for that particular picture. After the film has been processed, decide which exposure has provided the best picture. If it is the one in which the aperture setting was *f*/8, for example, multiply 8 by 10 (flash-to-subject distance); you will arrive at 80, which will be the guide number you will want to use in the future for that particular combination of film, flash, and shutter speed.

ELECTRONIC FLASH

The photographer who uses an appreciable amount of auxiliary light in his work should seriously consider using electronic flash. Most electronic flash units, such as the Minolta Electroflash, emit a burst of light that generally lasts for about 1/1000 sec. The brief flash duration of 1/1000 sec. freezes most movement that either the camera or the subject make. For photographing athletic events, children, animals, and other subjects whose movements cannot be controlled, electronic flash provides the means to capture the sharpest images possible.

The power supply for the Minolta Electroflash can be a.c. household

Fig. 7-4. The Minolta Electroflash has "Hi" and "Lo" neon lights to indicate correct guide numbers and to prevent underexposure. When the voltage of the battery subsides and the light becomes weak, the Lo lamp warns that the camera aperture should be adjusted. The Electroflash provides about 370 flashes per load when alkaline batteries are used. This unit also works on a.c. power and with nickel cadmium batteries.

current, four penlight batteries, or four rechargeable AA nickel cadmium batteries.

Synchronizing Electronic Flash with the Minolta Shutter

For most convenient use, the electronic flash unit is mounted to the SR-T 101 or SR-T 100 by means of the accessory shoe located at the top of the prism housing. The connecting cord is plugged into the "X" synchronization outlet on the lefthand side of the lens mount, and the shutter dial is set at 1/60 sec., which is marked in red, or at any other shutter speed *slower* than 1/60 sec.

Fig. 7-5. The Minolta Electroflash is shown mounted in the accessory shoe on top of the Minolta SR-T 101. To mount a flash unit into the accessory shoe, slide the foot of the flash unit into the accessory shoe from the back of the camera. Then tighten the screw of the flash unit for a secure, wobble-free fit.

PHOTOFLOOD LAMPS

Photoflood lamps are used extensively for portraiture and copy work with both black-and-white and color films, although any number of other applications are possible. An advantage of photofloods over electronic flash or flashbulbs is that the photographer can see exactly how his light falls across the subject. He can make minute adjustments in distance or height to control highlights and shadows at will. And when the photofloods are set exactly as desired, he can measure the exact exposure by using the SR-T exposure system in the usual manner.

The photographer who shoots Type A color film, which is balanced for photofloods, can expect about four hours of use from each lamp before the rated color balance begins to shift and a reddish cast becomes noticeable in the photographs. Since this color shift has no effect on black-and-white film, photofloods can be used for black-and-white work considerably longer.

TUNGSTEN-HALOGEN LAMPS

A relatively new form of artificial light is the tungsten-halogen lamp. It has certain advantages over photofloods, which include a longer life without a shift in color balance plus compact size. Like photofloods, these lamps burn continuously for exact control up to the instant of exposure.

REFLECTORS

Reflectors used with photoflood or tungsten-halogen lamps provide a means of gaining the maximum intensity of light from both these sources. Some types of photoflood lamp have built-in reflectors. These create a fixed field of coverage, which does not allow you the kind of control possible with separate reflectors.

Most of the simpler photo-reflectors are made of low-cost, highly durable spun aluminum. They are made in different sizes and are measured according to their diameter. The different sizes allow for different areas of coverage, which run from very narrow, for spotlight effects, to very large, for soft, even light. Generally, the smaller reflector will produce sharper and deeper shadows. Conversely, the larger reflector will help create softer and less intense shadows.

More sophisticated reflectors are also available. These are designed for greater efficiency in light output and are used primarily with tungsten-halogen lamps to make them capable of providing high-intensity light over great distances. However, the less expensive aluminum reflectors are generally more than adequate for simple, multi-light portrait settings and copy work. These lightweight reflectors can be easily positioned on top of adjustable light stands or clamped to furniture, windows, and doorways with alligator clamps.

BOUNCE LIGHTING

When you use artificial light and try to include in the same photograph several subjects that are at varying distances from your light source, determining exposure can be a problem. For example, if you are using flash and trying to take a picture of a group of people seated around a table in a restaurant, those subjects nearest the flash could be overexposed while those farthest away could be underexposed.

If you are using color negative film for color prints or black-and-white film, you might select an average distance between near and far subjects, use this distance to determine correct exposure, and then compensate later in the darkroom by allowing more or less light to strike various parts of the print. But the chances are you won't want to go through this time-consuming, complicated process yourself, and to have it done for you by a custom photographic processor is expensive. Furthermore, if you are taking color slides, no such controls can be used, since the image they produce is the final one.

One of the most convenient solutions to the problem is to use bounce lighting, which can produce a very natural lighting effect when properly used. To get bounce lighting, aim your light source toward a wall or ceiling so that it will bounce back onto the subject. In effect, you are using the walls and ceilings as reflectors to give the light wider, more even distribution over greater distance.

When you use bounce light under average conditions, the light loss amounts to about three full *f*/stops. If a normal exposure with high-speed

film is $f/16$ with the flash aimed directly at the subject, bouncing the light from an average height ceiling would mean that you should open up your lens to $f/5.6$. However, exposure differences for bounce lighting can change drastically with the room size and the color of the reflecting surfaces. When you first attempt bounce flash, you should bracket your exposures and continue to do so until you develop a feel for the conditions that affect exposure. As your experience grows, you will need to do little or no bracketing to produce natural looking photographs without the harsh background shadows of straight-on flash.

SYNCHRO-SUN FLASH PHOTOGRAPHY

When you photograph someone outdoors in the sunlight, you will often find that your subject has harsh, unpleasant shadows falling across his face. Filling these shadows in with enough light to give a pleasant, natural appearance while retaining the proper exposure for background detail calls for more than a camera exposure adjustment. It requires the use of flashbulbs or electronic flash with just the right light balance, which is called *synchro-sun exposure*.

Your object in using synchro-sun flash is to lower the contrast ratio between highlights and shadows. For the subject to retain a natural appearance, shadows should be visible, but they should be light enough to show detail. Let's work out a situation in which you would use synchro-sun flash.

Suppose you want to photograph a young lady sitting beside a water fountain under a noonday sun. The color film you are using is rated at ASA 64. Looking closely at your subject, you see that her eyes, lower cheeks, and neck are hidden in dark shadow from the direct sunlight. The exposure scale for the Minolta Electroflash indicates a guide number of 80 for ASA 64 film.

To compute your exposure, first take an overall reading of the subject and background with the through-the-lens meter of the SR-T 101 or SR-T 100. Doing this, you will find that the normal exposure used to photograph the young lady would be $f/8$ at 1/60 sec. You do not want to employ a shutter speed higher than 1/60 sec. because then the Minolta Electroflash will not synchronize properly with the camera.

By dividing the flash guide number, which is 80, by the $f/$stop indicated for a normal reading, you get an answer of 10. This is the distance in feet at which you should place the flash from your subject to get the right synchro-sun exposure. If you have an extension cable for your flash unit, you can place the camera closer to the subject. It is always the distance from the flash unit to the subject that is used to compute the correct exposure when you use flash and not the camera-to-subject distance.

By moving the camera closer to the subject, or by changing the focal length of the lens, you can fill more of the picture frame; thus, you can take a medium view of your subject by using a normal lens and then by changing to a longer lens or by moving in closer to your subject, you can take a head-and-shoulders portrait.

Improper Synchronization

Blank areas on a negative or color slide made with a flash exposure indicate improper synchronization between flash and shutter. Lack of proper synchronization is generally caused by failure to plug the flashgun lead into the correct outlet or by use of a shutter speed higher than that recommended for the flashbulb or electronic flash used.

Fig. 8-1. In industrial photography, sometimes a more striking photograph can be produced by showing a close-up rather than an overall view. That is what the photographer chose to do for this picture. To do it, he used the MC Macro Rokkor 50mm $f/3.5$ lens on his Minolta SR-T 101, basing his exposure on a through-the-lens reading. Photograph by Robert D. Moeser.

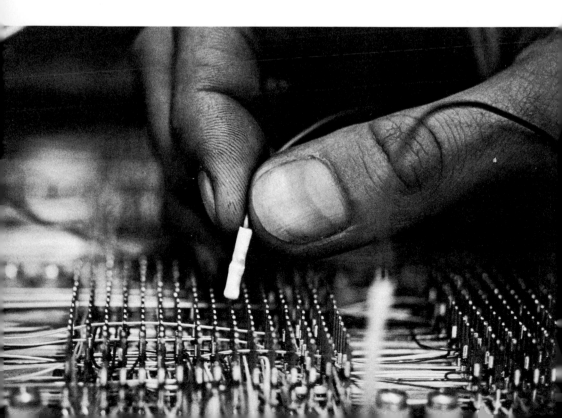

8

Closeup and Macrophotography

Closeup and macrophotography provide new and often startling views of common, everyday subjects. They take the photographer into a whole new visual world. Insects suddenly become strange monsters from a foreign planet. A flower petal becomes an enormous, multi-hued tropical leaf. The fabric of a shirt becomes an intriguing abstract in the style of a Japanese painting. Closeup and macrophotography are extensively used in photography for science, space, nature, agriculture, and law enforcement research. They are applied in medicine to diagnose ills and in dentistry to probe beyond the surface enamel of a tooth. For any photographer, closeup and macrophotography provide a stimulating test of photographic technique and ingenuity.

There is some dispute about the exact meaning of the terms *closeup photography* and *macrophotography;* however, the Minolta Camera Co., Ltd., considers closeup photography to include any picture taken from as far away as three feet to distances close enough to make an image 1/10 life-size on the negative or color slide.. Macrophotography extends the range of closeup photography from 1/10 life-size to a magnification of about 25 times life-size.

The term *magnification ratio* indicates the direct relationship between image size and object size. A 1:1 magnification ratio indicates that the size of the image on the film is the same as that of the actual object. A 2:1 ratio indicates a 2× magnification, which is an image on the film twice the size of the actual object. When you read a magnification ratio, the number on the left represents the image size, and the number on the right represents the object size.

In closeup and macrophotography, exposure values change as image magnification is increased. Fortunately, however, the matter of exposure is simply academic when you use the through-the-lens metering system. Since exposure adjustments are automatic, you can concentrate your full attention on lighting, composition, and keeping the camera steady and level.

GENERAL PRINCIPLES

To take closeup pictures, the photographer usually brings his camera lens as close to the subject as he can, but in doing so, he must extend the lens farther from the film plane to keep his subject in focus. With ordinary lenses of any focal length, he can bring the lens only as close as its nearest focusing point. The closest focusing point of the 58mm MC Rokkor $f/1.2$, for instance, is 1 foot 10½ inches. At this lens-to-subject distance, the image-size to object-size ratio is about 1:10. With the 50mm MC Macro Rokkor $f/3.5$ lens, the closest focusing distance is nine inches, and with the lens focused to its nearest point, a ratio of 1:2 can be achieved. To achieve ratios in which image size is as great as or greater than object size (1:1, 2:1, 3:1, and so on), bellows extensions, closeup lenses, extension tubes, reverse rings, or life-size adapters must be used.

When the focusing range of the lens is extended beyond the nearest point of focus, the photographer must allow for an adjustment in exposure because of the diminished amount of light now reaching the film plane. The exposure adjustment can be accomplished by opening up the lens aperture, by lengthening exposure time, or by a combination of both. Because of the extremely shallow depth of field that results at close working distances, it is recommended that you make exposure adjustments using slower shutter speeds.

Suppose you are doing a close-up of the face of a wristwatch, and using your through-the-lens meter, arrive at an exposure combination of 1/60 sec. at $f/5.6$. If you use the 50mm MC Macro Rokkor lens and focus it at 10 inches, your depth of field will be ¼ inch. This is obviously a very narrow range to work in. With the lens set at $f/5.6$, pinpoint focus is extremely critical, and the slightest movement can throw the picture completely out of focus. Since the smaller the aperture, the greater the depth of field, you obviously will want to use the aperture that provides the greatest possible depth of field —in this case, $f/22$. Using this aperture, depth of field can be increased to cover approximately ¾ inch. Even this does not allow much room for focusing error. Therefore, a sturdy tripod and a cable release are usually considered essential tools for all closeup photography.

In short, the best results when you do closeup work are assured when the camera is perpendicular to the subject, the subject is essentially flat, the smallest lens aperture is used, the camera is on a tripod, and the shutter is released with a cable release or a self timer. This assumes, of course, that the critical element, exposure, has been correctly determined and applied.

If you use the through-the-lens CLC metering system, the correct exposures for most closeup photography are automatically determined by matching the needles in the viewfinder. There may be times, however, when you will want to use exposures longer than those possible using the match-needle system. In these cases, you will need to use a hand-held meter and make an exposure compensation, which is explained in the following section.

CLOSEUP EXPOSURE FACTORS

Closeup and macrophotography require increasing the distance between the lens and the film plane. The farther away from the film plane the lens gets, the larger the image size becomes. When the distance from the object to the lens is greater than the distance from the lens to the film plane, the image on the film will be smaller than life-size. When the distance from the object to the lens is the same as the distance from the lens to the film, the image on the film will be life-size. When the distance from the object to the lens is less than the distance from the lens to the film, the image on the film will be larger than life-size.

As you extend the lens away from the film in order to achieve greater magnification, the light reaching the film will become less intense. This is not usually a problem until the magnification ratio involved is greater than $1:8$. With a normal lens, the problem does not arise until the lens is focused on a subject that is about two feet from the camera. As the magnification ratio increases beyond the $1:8$ ratio, an adjustment must be made in the exposure setting. This adjustment is expressed by a number called the *exposure factor,* or *bellows factor.* The exposure factor is determined by the following formula:

$$EF \text{ (exposure fictor)} = \frac{\text{lens-to-film distance}^2}{\text{focal length}^2}$$

If the magnification ratio is known, the exposure factor can be computed by using an even easier formula:

$$EF \text{ (exposure factor)} = (\text{magnification ratio} + 1)^2$$

Thus, if the magnification ratio is $1:2$ (or one-half life-size),

$$EF = (\frac{1}{2} + 1)^2$$
$$EF = (1\frac{1}{2})^2$$
$$EF = 2\frac{1}{4}$$

This means that exposure must be increased $2\frac{1}{4}$ times over whatever exposure reading was obtained with a hand-held light meter. If the EF was 4, the exposure would have to be increased four times, and so on. Remember that exposure always doubles for each change downward in f/stop and halves for each change upward. Thus, $f/8$ is twice as large as $f/11$ and half as large as $f/5.6$. With an EF of 4 and a light meter reading of $f/8$, the adjusted aperture would be $f/4$, or two full f/stops down from $f/8$. With an EF of 4 and a light meter reading of $f/11$, the adjusted aperture would be $f/5.6$, or two full f/stops down from $f/11$.

When the exposure factor involves a fraction, the adjusted aperture is calculated by using the following formula:

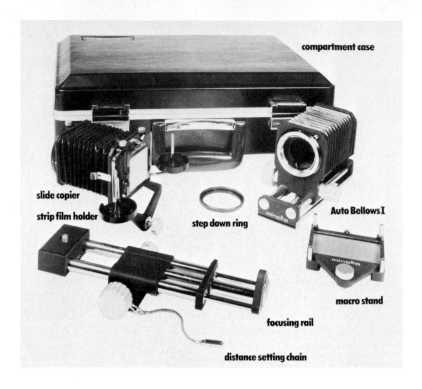

compartment case

slide copier

strip film holder

step down ring

Auto Bellows I

macro stand

focusing rail

distance setting chain

Fig. 8-2. The Minolta Automatic Bellows Outfit designed for closeup and macro-photography. The kit includes the Minolta Auto Bellows I, a focusing rail with a distance setting chain, a macro stand, a slide copier with strip film holders, and a stop-down ring.

$$\mathrm{EA\ (effective\ aperture)} = \frac{f \times f}{\sqrt{EF}}$$

Thus, if the EF equals 2¼ (2.25), and the f/stop is f/8,

$$\mathrm{EA} = \sqrt{\frac{8 \times 8}{2.25}}$$

$$\mathrm{EA} = \sqrt{\frac{64}{2.25}}$$

$$\mathrm{EA} = \sqrt{28.4}$$

EA=5.3, or for practical purposes, f/5.6

You will find these computations worked out for you in the tables accompanying this chapter and directly on the lens barrel of the 50mm MC Macro Rokkor lens. Remember that these calculations are necessary only when you use a hand-held light meter.

116

SPECIAL TOOLS FOR CLOSEUP AND MACROPHOTOGRAPHY

The special tools for closeup and macrophotography are the 50mm MC Macro Rokkor $f/3.5$ lens, the Minolta supplementary closeup lenses, which screw into the filter mount of normal Minolta lenses, the Minolta SR Extension Tube Set II, the Minolta Reverse Adapters, the Minolta Auto Bellows I, and the Minolta Bellows III.

Even without these special tools, the normal Minolta SR lenses permit a great variety of closeup photography. The MC Rokkor 58mm $f/1.4$ lens can be focused as close as 1.97 feet; the MC Rokkor 55mm $f/1.7$ can be focused even closer—to 1.75 feet. The 58mm $f/1.4$ has a magnification ratio, at its minimum focusing distance, of $1:8.14$; the 55mm $f/1.7$ has a magnification ratio, at its minimum focusing distance, of $1:6.8$. So, for the photographer who is not equipped with a macro lens or with any of the other special accessories for closeup work, an appreciable part of the world of closeup photography is still within his viewfinder.

Closeup Lenses

There are three Minolta closeup lenses that screw into the filter mount of normal Rokkor lenses. These are the No. 0, the No. 1, and the No. 2. Lens 0 is for use with the 100mm and 135mm lenses; lenses 1 and 2 are for use in combination or singly and allow working as close as nine inches from the subject. If filters are necessary, they can be screwed into the closeup lens. When any of these supplementary closeup lenses are used, the aperture setting is the same as it would be for normal photography. No exposure compensation or adjustment is necessary, since there is no lengthening of the distance between the film plane and the lens.

Closeup lenses effectively shorten the focal length of the lens into which they are screwed, which permits the photographer to bring the lens closer to the subject. Closeup lenses 1 and 2 are primarily intended for use with normal Minolta lenses. With the No. 1 closeup lens screwed into the 55mm MC Rokkor $f/1.7$ lens, for example, the focusing range extends from 23 inches to 14 inches. Using the No. 2 closeup lens on the 55mm $f/1.7$ changes the focusing range so that it extends from 14 inches to 10 inches. The 1 and 2 closeup lenses can be used in combination to achieve even shallower focusing ranges: On both the 55mm $f/1.7$ and the 58mm $f/1.4$ lenses, the focusing range extends from only seven inches to five inches.

The 0 lens is for use with 100mm and 135mm telephoto lenses. With the 0 lens, the normal focusing range of the 100mm MC Rokkor $f/2.5$ changes to 42.5–20.75 inches and that of the 135mm MC Rokkor $f/2.8$ to 42–23.5 inches. The use of closeup lenses in combination is not recommended for the longer lenses, because closeup lenses are simple meniscus lenses and are only partially corrected for spherical aberration; thus, some image degradation can be expected when they are used. Although this is not much of a problem with normal lenses, it does become noticeable when longer lenses are used.

When using closeup lenses, shoot at the smaller apertures, because optical

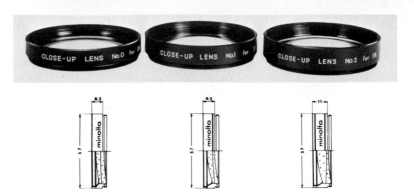

Figs. 8-3A–B. Supplementary closeup lenses for the Minolta SR camera system (A). Shown are closeup lens No. 0, closeup lens No. 1, and closeup lens No. 2. The lenses come in 52mm and 55mm filter mount diameter sizes. Schematic diagrams of closeup lenses (B).

Closeup Lenses

Closeup Lens	Taking Lens	Photographic Range	Magnification Rate	Photographing Distance
No. 0	100mm	$9\frac{7}{16}''$ x $1'$ $2\frac{3}{16}''$—$4\frac{3}{4}''$ x $7\frac{1}{16}''$	0.1—0.2	$42\frac{1}{2}''$—$20\frac{7}{8}''$
	135mm	$6\frac{7}{16}''$ x $10\frac{15}{16}''$—$3\frac{13}{16}''$ x $5\frac{11}{16}''$	0.13—0.25	$42\frac{1}{8}''$—$23\frac{5}{8}''$
No. 1		$7\frac{13}{16}''$ x $11\frac{3}{4}''$—$3\frac{13}{16}''$ x $5\frac{11}{16}''$	0.12—0.25	$23\frac{5}{8}''$—$13''$
No. 2	55mm	$4\frac{5}{16}''$ x $6\frac{7}{16}''$—$2\frac{3}{4}''$ x $4\frac{1}{16}''$	0.22—0.35	$14\frac{3}{16}''$—$10\frac{1}{4}''$
No. 1 + No. 2		$2\frac{15}{16}''$ x $4\frac{7}{16}''$—$2\frac{1}{16}''$ x $3\frac{1}{16}''$	0.32—0.46	$7\frac{1}{16}''$—$5\frac{1}{16}''$
No. 1		$7\frac{13}{16}''$ x $11\frac{3}{4}''$—$3\frac{13}{16}''$ x $5\frac{11}{16}''$	0.12—0.36	$23\frac{5}{8}''$—$14\frac{3}{16}''$
No. 2	58mm	$4\frac{1}{8}''$ x $6\frac{3}{16}''$—$2\frac{5}{8}''$ x $3\frac{15}{16}''$	0.23—0.36	$14\frac{3}{16}''$—$11''$
No. 1 + No. 2		$2\frac{5}{8}''$ x $4\frac{3}{16}''$—$2''$ x $3''$	0.34—0.47	$7\frac{1}{16}''$—$5\frac{1}{16}''$

performance is generally better at these apertures. Stopping down the lens also gives greater depth of field, which will increase the apparent sharpness of the picture.

Extension Tubes

Extension tubes are used to increase the magnification ratio by lengthening the lens-to-film distance. They are inserted between the lens and the camera body and permit the use of the normal camera lens, which does away with the problem of aberration encountered when closeup lenses are used. Extension tubes can be used singly or in combination to provide greater magnification ratios than are possible with supplementary closeup lenses, and when used with bellows units, provide even greater magnification ratios.

Extension Tubes (f = 55mm)

Combination No.	Combination of Tubes No.	Photographic Range	Magnification Rate	Distance from Subject to Film Plane	Exposure Multiple
1	EB + 1 + 2 + 3 + EL	15/16" × 1 7/16"~7/8" × 1 5/16"	1.0~1.1	8 3/8"~ 8 7/16"	4(2)
2	EB + 2 + 3 + EL	1" × 1 9/16"~15/16" × 1 7/16"	1/1.1~1.0	8 7/16"~ 8 3/8"	4(2)
3	EB + 1 + 3 + EL	1 1/4" × 1 7/8"~1" × 1 9/16"	1/1.3~1/1.1	8 5/8"~ 8 7/16"	3(1.5)
4	EB + 3 + EL	1 1/2" × 2 9/16"~1 1/4" × 1 7/8"	1/1.6~1/1.3	8 7/8"~ 8 5/8"	3(1.5)
5	EB + 1 + 2 + EL	1 7/8" × 2 7/8"~1 1/2" × 2 9/16"	1/2.0~1/1.6	9 1/2"~ 8 7/8"	2(1)
6	EB + 2 + EL	2 7/16" × 3 3/4"~1 7/8" × 2 7/8"	1/2.6~1/2.0	10 3/4"~ 9 1/2"	2(1)
7	EB + 1 + EL	3 13/16" × 5 11/16"~2 7/16" × 3 3/4"	1/4.0~1/2.6	1' 1 3/16"~10 3/4"	1.8(1)
8	EB + EL	7 1/2" × 11 3/16"~3 11/16" × 5 1/2"	1/7.9~1/3.9	1' 9 7/8"~1' 1"	1.4(0.5)
		~7 3/16" × 10 3/4"	~1/7.6	~1' 9 11/16"	

Extension Tubes (f = 58mm)

Combination No.	Combination of Tubes No.	Photographic Range	Magnification Rate	Distance from Subject to Film Plane	Exposure Multiple
1	EB + 1 + 2 + 3 + EL	1" × 1 9/16"~ 1/8" × 1 5/16"	1/1.1~1.1	9 1/16"~ 9"	4(2)
2	EB + 2 + 3 + EL	15/16" × 1 11/16"~1" × 1 9/16"	1/1.2~1/1.1	9 1/8"~ 9 1/16"	4(2)
3	EB + 1 + 3 + EL	1 3/8" × 2" ~ 15/16" × 1 11/16"	1/1.4~1/1.2	9 1/4"~ 9 1/8"	3(2.5)
4	EB + 3 + EL	1 5/8" × 2 3/8"~1 3/8" × 2"	1/1.7~1/1.4	9 5/8"~ 9 1/4"	3(1.5)
5	EB + 1 + 2 + EL	2" × 3" ~1 5/8" × 2 3/8"	1/2.1~1/1.7	10 1/16"~ 9 5/8"	2(1.0)
6	EB + 2 + EL	2 5/8" × 3 15/16"~2" × 3"	1/2.8~1/2.1	11 7/8"~10 1/16"	2(1.0)
7	EB + 1 + EL	4" × 5 15/16"~2 5/8" × 3 15/16"	1/4.2~1/2.8	1' 2 5/8"~11 7/8"	1.7(1.0)
8	EB + EL	8" × 1' 1/16"~4" × 5 15/16"	1/8.5~1/4.2	2' 7/16"~1' 2 5/8"	1.3(0.5)
		~7 5/8" × 11 7/16"	~1/8.1	~1' 11 7/16"	

Extension Tubes (f = 100mm)

Combination No.	Combination of Tubes No.	Photographic Range	Magnification Rate	Distance from Subject to Film Plane	Exposure Multiple
1	EB + 1 + 2 + 3 + EL	1 11/16" × 2 9/16"~1 7/16" × 2 1/8"	1/1.8~1/1.5	1' 5 1/2"~1' 4 1/2"	3(1.5)
2	EB + 2 + 3 + EL	1 3/4" × 2 7/8"~1 5/8" × 2 3/8"	1/2.2~1/1.7	1' 5 5/8"~1' 4 7/8"	2(1.0)
3	EB + 1 + 3 + EL	2 5/16" × 3 3/8"~1 13/16" × 2 11/16"	1/2.4~1/1.9	1' 7 1/8"~1' 5"	2(1.0)
4	EB + 3 + EL	2 3/4" × 4 1/8"~2 1/8" × 3 1/8"	1/2.9~1/2.2	1' 8 7/8"~1' 6 3/16"	2(1.0)
5	EB + 1 + 2 + EL	3 3/8" × 5 1/8"~2 7/16" × 3 11/16"	1/3.6~1/2.6	1' 10 15/16"~1' 7 1/2"	1.7(1.0)
6	EB + 2 + EL	4 9/16" × 6 13/16"~3 1/8" × 4 11/16"	1/4.8~1/3.3	1' 11 5/8"~2' 1/4"	1.6(1.0)
7	EB + 1 + EL	5 7/8" × 10 1/16"~3 7/8" × 5 13/16"	1/7.1~1/4.1	2' 11 13/16"~2' 1 9/16"	1.4(0.5)
8	EB + EL	1' 1 1/2" × 1' 8 1/4"~5 1/2" × 8 3/16"	1/14.3~1/6.8	5' 3"~2' 8 1/8"	1.2(0)
		~9 1/4" × 1' 1 7/8"	~1/9.8	~4' 3/8"	

The Minolta Extension Tube Set II consists of a set of two rings and three tubes of varying lengths. The tubes are made of lightweight aluminum and finished in matte black. The two chrome-plated rings are equipped with bayonet mounts for attachment to the camera and lens. Eight different tube and ring combinations are possible, which permit closeup photography of objects as close as 8⅜ inches from the film plane and as small as 1″ × 1½″. If extension tubes are used with a Rokkor 55mm lens, magnification ratios from 1:8 to life-size can be achieved and more than one set of tubes can be combined for even greater magnification.

No compensation for closeup exposure is necessary when extension tubes are used with SR-T cameras; however, the stop-down exposure measurement method must be employed, since there is no coupling pin on the extension tube set. Focusing and composing are done with the lens set at its widest aperture. Then the lens is closed down to the aperture at which the picture is to be taken.

Fitting the tubes and rings together is a simple process. The tubes are marked No. 1, No. 2, and No. 3 and are threaded at both ends. The rings are marked "EB" and "EL." The "E" on both rings stands for *extension.* The "B" stands for *body,* indicating that one end of the EB ring fits into the camera body. The "L" stands for *lens,* indicating that the EL ring accepts Rokkor lenses. One end of the EB ring is threaded to accept any one of the tubes or the EL ring. One end of the EL ring is threaded to fit into any of the three tubes or into the EB ring, depending upon the length of extension desired. The other end has a standard Minolta bayonet mount that accepts any Rokkor lens.

When all three tubes are used, it makes no difference in what sequence they are mounted. The determining factor is the amount of magnification desired. If the area of coverage is 1⅛″ × ⅝″ and the lens is the 55mm MC Rokkor *f*/1.7, you will need all three tubes to give you the desired magnification.

To attach the EB ring to the camera body, align the red dot on the ring with the red dot over the camera lens mount, and turn clockwise until the ring locks into position. The tubes are screwed into the EB ring; the EL ring is screwed into the last tube; and the lens is then mounted to the EL ring by aligning the red dots of the lens and the ring and turning the lens clockwise until it locks into place.

To remove the lens from the EL ring, depress the small release catch located on the EL ring to the left of the red dot. To remove the EB ring from the camera body, follow the same procedure you would use to remove a lens.

The selection of the proper extension tube depends upon the image size needed. The tables for the 55mm, 58mm, and 100mm lenses which accompany this section will help you determine the extension tube and ring combination required to achieve a particular degree of magnification. The tables also provide the exposure factors for each combination so that you can make the correct adjustment in your final exposure setting if you are using a hand-

held meter and time exposures. They also include ranges in values, which are the variations that result from focusing the lens from infinity to its closest focusing point.

Bellows

Like extension tubes, bellows have no lenses; they fit between the lens and the camera body, and they are ideally suited to all serious macrophotography and closeup work. Within the limits of the bellows extension, an infinite number of magnification ratios can be obtained; moreover, magnification ratios and extension can be read directly from scales engraved on the bellows rails. In combination with a slide copier, these units allow you to extend the range of your photographic work even further.

Bellows can also be used in combination with extension tubes for even greater magnification. If you use, for example, the Auto Bellows I, fully extended, the complete Minolta extension tube set, a reverse ring, and the 50mm macro lens, you can get a $4.9\times$ magnification. The proper order for using extension tubes with bellows is as follows: (1) camera, (2) bellows, (3) EB ring, (4) extension tubes, (5) EL ring, (6) lens.

In tables accompanying this section you will find standard magnification ratios, bellows extensions, focusing ranges, distances between film and subject, and, in the event that you choose to use a hand-held meter, exposure multiples.

AUTO BELLOWS I. This deluxe, double-track bellows provides calibrated extension between the lens and film. It features an automatic diaphragm coupling device, and when used with the standard 55mm Rokkor Lens, permits continuous magnification from $0.7\times$ to $2.9\times$.

The bellows rides on two rails, one of which is engraved with a magnification scale and the other with an extension scale. This unit is mounted on focusing rails, which have an accessory holder and a distance setting chain.

Although it is possible to hand-hold the Auto Bellows I if you use the Auto Bellows Rokkor lens, most of your closeup photography will be done with the bellows mounted on the focusing rail, which in turn should be mounted on a firm tripod. The shutter should be released with either the self timer or a cable release.

Any of the following lenses can be used with the Auto Bellows: the standard 55mm and 58mm lenses, the 50mm macro lens, and the 100mm, 135mm, and 200mm telephoto lenses. Lenses are attached to the bellows in the same way they are attached to the camera: Align the red dots and, with the lens facing you, turn it clockwise. To attach the bellows to the camera, align the red dots and mount it as though it were a lens.

To attach the focusing rail to the bellows, simply engage the front part and then tighten with the attachment screw at the back. (See Fig. 8-6.) Use the special socket on the focusing rail to attach the Auto Bellows to a tripod. This socket is placed so that the camera will be properly balanced and as steady as possible. Do not use the tripod socket on the base of the camera, or you will throw the camera–bellows combination off balance.

121

If you use a lens with an automatic diaphragm, expose with the stop-down method. Once you have advanced the film and properly composed and focused, push the depth of field button. Turn the diaphragm ring of the lens to align the indicator needles in the viewfinder. With your exposure set, push the depth of field button again, which will open up the diaphragm so that you can make a final check on focus. When you press the shutter release, the lens will automatically stop down to the correct aperture.

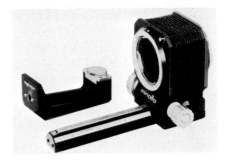

Fig. 8-4. The single rail extension bellows for Minolta SR cameras. The unit permits magnification up to 2.8× life-size with a 55mm Rokkor normal lens.

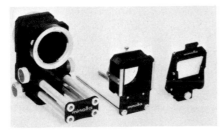

Fig. 8-5. The Minolta Auto Bellows I shown with the slide copier attachment.

Fig. 8-6. The Minolta Auto Bellows I shown with the focusing rail, distance setting chain, and slide copier unit.

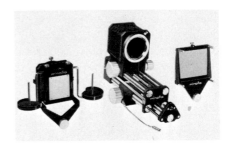

Auto Bellows I (f = 55mm)

Magnification Rate	Bellows Extension	Photographic Area	Distance from Subject to Film	Exposure Multiple
0.7	$1\frac{1}{8}''$	$1\frac{5}{16}'' \times 2''$	$8\frac{11}{16}''$	3
0.8	$1\frac{3}{4}''$	$1\frac{3}{16}'' \times 1\frac{3}{4}''$	$8\frac{1}{2}''$	3
1.0	$2\frac{3}{16}''$	$\frac{15}{16}'' \times 1\frac{3}{8}''$	$8\frac{3}{8}''$	4
1.2	$2\frac{5}{8}''$	$\frac{13}{16}'' \times 1\frac{13}{16}''$	$8\frac{7}{16}''$	5
1.4	$3''$	$\frac{11}{16}'' \times 1''$	$7\frac{7}{8}''$	6
1.6	$3\frac{1}{2}''$	$\frac{9}{16}'' \times \frac{15}{16}''$	$8\frac{7}{8}''$	7
1.8	$3\frac{15}{16}''$	$\frac{1}{2}'' \times \frac{13}{16}''$	$9\frac{1}{8}''$	8
2.0	$4\frac{3}{8}''$	$\frac{15}{32}'' \times \frac{11}{16}''$	$9\frac{1}{2}''$	9
2.2	$4\frac{13}{16}''$	$\frac{7}{16}'' \times \frac{5}{8}''$	$9\frac{13}{16}''$	11
2.4	$5\frac{1}{4}''$	$\frac{3}{8}'' \times \frac{9}{16}''$	$10\frac{3}{16}''$	12
2.6	$5\frac{11}{16}''$	$\frac{3}{8}'' \times \frac{9}{16}''$	$10\frac{5}{8}''$	13
2.8	$6\frac{1}{16}''$	$\frac{3}{8}'' \times \frac{11}{16}''$	$10\frac{7}{8}''$	14

Auto Bellows I (f = 58mm)

Magnification Rate	Bellows Extension	Photographic Area	Distance from Subject to Film	Exposure Multiple
0.6	1⅜″	1⁹⁄₁₆″ × 2⅜″	9⁹⁄₁₆″	3
0.8	1⅞″	1³⁄₁₆″ × 1¼″	9¹¹⁄₁₆″	3
1.0	2⁵⁄₁₆″	¹⁵⁄₁₆″ × 1⅜″	8¹⁵⁄₁₆″	4
1.2	2¹³⁄₁₆″	¹³⁄₁₆″ × 1¹³⁄₁₆″	9¹⁄₁₆″	5
1.4	3¼″	¹¹⁄₁₆″ × 1″	9¼″	6
1.6	3¹¹⁄₁₆″	⁹⁄₁₆″ × ¹⁵⁄₁₆″	9½″	7
1.8	4³⁄₁₆″	½″ × ¹³⁄₁₆″	9¹³⁄₁₆″	8
2.0	4⅝″	¹⁷⁄₃₂″ × ¹¹⁄₁₆″	10¹⁄₁₆″	9
2.2	5⅛″	⁷⁄₁₆″ × ⅝″	10½″	11
2.4	5⅝″	⅜″ × ⁹⁄₁₆″	10⅞″	12
2.6	6¹⁄₁₆″	⅜″ × ⁹⁄₁₆″	11¼″	13

Auto Bellows I (f = 100mm)

Magnification Rate	Bellows Extension	Photographic Area	Distance from Subject to Film	Exposure Multiple
0.1	2¹⁄₁₆″	9⁷⁄₁₆″ × 1′ 2³⁄₁₆″	3′ 11⁹⁄₁₆″	1.2
0.2	2⁷⁄₁₆″	4¾″ × 7¹⁄₁₆″	2′ 4¼″	1.5
0.3	2⅞″	3³⁄₁₆″ × 4¾″	1′ 10¹⁄₁₆″	2
0.4	3¼″	2⅜″ × 3⁹⁄₁₆″	1′ 7³⁄₁₆″	2
0.5	3⅝″	1⅞″ × 2⅞″	1′ 5⅝″	2
0.6	4″	1⁹⁄₁₆″ × 2⅜″	1′ 4½″	3
0.7	4⁷⁄₁₆″	1⅜″ × 2″	1′ 4³⁄₁₆″	3
0.8	4¹³⁄₁₆″	1³⁄₁₆″ × 1¾″	1′ 3⅞″	3
0.9	5³⁄₁₆″	1¹⁄₁₆″ × 1⁹⁄₁₆″	1′ 3¹¹⁄₁₆″	4
1.0	5⅝″	¹⁵⁄₁₆″ × 1⁷⁄₁₆″	1′ 3⅝″	4
1.1	6″	⅞″ × ⁵⁄₁₆″	1′ 3¹¹⁄₁₆″	5

Auto Bellows I (f = 100mm)

Magnification Rate	Bellows Extension	Photographic Area	Distance from Subject to Film	Exposure Multiple
0.4	1⁹⁄₁₆″	2⅜″ × 3⁹⁄₁₆″	1′ 7½″	2
0.5	2″	1⅞″ × 2⅞″	1′ 5¹¹⁄₁₆″	2
0.6	2⅜″	1⁹⁄₁₆″ × 2⅜″	1′ 4¾″	3
0.7	2¾″	1⅜″ × 2″	1′ 4³⁄₁₆″	3
0.8	3³⁄₁₆″	1³⁄₁₆″ × 1¾″	1′ 3⅞″	3
0.9	3⁹⁄₁₆″	1¹⁄₁₆″ × 1⁹⁄₁₆″	1′ 3¾″	4
1.0	3¹⁵⁄₁₆″	¹⁵⁄₁₆″ × 1⁷⁄₁₆″	1′ 3¹¹⁄₁₆″	4
1.1	4⁵⁄₁₆″	⅞″ × ⁵⁄₁₆″	1′ 3¾″	5
1.2	4¾″	¹³⁄₁₆″ × 1³⁄₁₆″	1′ 3¹³⁄₁₆″	5
1.3	5⅛″	¾″ × 1⅞″	1′ 3⁹⁄₁₆″	5
1.4	5½″	¹¹⁄₁₆″ × 1″	1′ 4³⁄₁₆″	6
1.5	5⅞″	⅝″ × ¹⁵⁄₁₆″	1′ 4⅜″	6

In general, you will find that focusing is easiest if you keep your lens set at infinity. Once you have set your magnification or extension, lock the bellows with the clamp and focus with the focusing rail. When you use a standard 55mm or 58mm lens, or the 50mm macro lens, the distance setting chain is especially handy. Just place the object you intend to photograph at the maximum reach of the chain, and set either the magnification or extension you want on the bellows rails. Although the figures inscribed on the rails are for the 55mm lens, they also give a very close approximation of the values for the 58mm and 50mm lenses, since these lenses are so close in focal length to the 55mm lens.

THE BELLOWS III. This unit can be used with the standard 55mm and 58mm lenses, the 50mm macro lens, and the 100mm, 135mm, and 200mm telephoto lenses as well as with the special bellows lenses. Although it can be hand-held when used with a bellows lens, best closeup results are achieved when the unit is mounted on a rigid tripod and used with a cable release or self timer.

This unit rides on only one rail and has neither a separate focusing rail nor an automatic diaphragm coupling pin. Lenses are attached to the front of the bellows by matching the red dots, and the unit is attached to the camera body in the same way. Extension and magnification scales are engraved on the bellows track.

Since there is no automatic diaphragm coupling pin on the Bellows III, remember to close down the lens aperture manually before you take the picture. In general, you will get the most consistent results if you establish a routine procedure: First, bring your subject into critical focus using the focusing knob; second, close down the lens aperture as far as possible; third, turn the shutter dial until the needles in the viewfinder match; fourth, release the shutter using a cable release or self timer.

Bellows III (f = 50mm Macro)

Magnification Ratio	Bellows Extension	Photographic Area	Distance From Film to Subject	Extra Stops to Open Aperture
0.7	1$\frac{7}{16}$″	1$\frac{5}{16}$″ × 2″	8$\frac{1}{4}$″	1.5
0.8	1$\frac{5}{8}$″	1$\frac{3}{16}$″ × 1$\frac{3}{4}$″	8$\frac{1}{8}$″	2
1.0	2$\frac{1}{16}$″	$\frac{15}{16}$″ × 1$\frac{7}{16}$″	8″	2
1.2	2$\frac{7}{16}$″	$\frac{3}{4}$″ × 1$\frac{3}{16}$″	8$\frac{1}{16}$″	2
1.4	2$\frac{7}{8}$″	$\frac{11}{16}$″ × 1″	8$\frac{1}{4}$″	2.5
1.6	3$\frac{1}{4}$″	$\frac{5}{8}$″ × $\frac{15}{16}$″	8$\frac{1}{2}$″	3
1.8	3$\frac{11}{16}$″	$\frac{1}{2}$″ × $\frac{13}{16}$″	8$\frac{3}{4}$″	3
2.0	4$\frac{1}{16}$″	$\frac{1}{2}$″ × $\frac{11}{16}$″	9$\frac{1}{16}$″	3
2.2	4$\frac{1}{2}$″	$\frac{7}{16}$″ × $\frac{5}{8}$″	9$\frac{3}{8}$″	3.5
2.4	4$\frac{7}{8}$″	$\frac{3}{8}$″ × $\frac{9}{16}$″	9$\frac{5}{8}$″	3.5
2.6	5$\frac{1}{4}$″	$\frac{3}{8}$″ × $\frac{9}{16}$″	10″	3.5
2.8	5$\frac{11}{16}$″	$\frac{3}{8}$″ × $\frac{1}{2}$″	10$\frac{5}{16}$″	4
3.0	6$\frac{3}{16}$″	$\frac{5}{16}$″ × $\frac{1}{2}$″	10$\frac{3}{4}$″	4
3.2	6$\frac{1}{2}$″	$\frac{5}{16}$″ × $\frac{7}{16}$″	11$\frac{1}{8}$″	4
3.4	6$\frac{7}{8}$″	$\frac{1}{4}$″ × $\frac{3}{8}$″	11$\frac{1}{4}$″	4.5
3.5	7$\frac{1}{16}$″	$\frac{1}{4}$″ × $\frac{3}{8}$″	11$\frac{3}{8}$″	4.5

Bellows III (f = 55mm)

Magnification Ratio	Bellows Extension	Photographic Area		Distance from Film to Subject	Extra Stops to Open Aperture
0.7	$1\frac{1}{8}''$	$1\frac{5}{16}''$	$\times\ 2''$	$8\frac{11}{16}''$	1.5
0.8	$1\frac{3}{4}''$	$1\frac{3}{16}''$	$\times\ 1\frac{3}{4}''$	$8\frac{1}{2}''$	1.5
1.0	$2\frac{3}{16}''$	$\frac{15}{16}''$	$\times\ 1\frac{3}{8}''$	$8\frac{3}{8}''$	2
1.2	$2\frac{5}{8}''$	$\frac{13}{16}''$	$\times\ 1\frac{13}{16}''$	$8\frac{7}{16}''$	2
1.4	$3''$	$\frac{11}{16}''$	$\times\ 1''$	$7\frac{7}{8}''$	2.5
1.6	$3\frac{1}{2}''$	$\frac{9}{16}''$	$\times\ \frac{15}{16}''$	$8\frac{7}{8}''$	3
1.8	$3\frac{15}{16}''$	$\frac{1}{2}''$	$\times\ \frac{13}{16}''$	$9\frac{1}{8}''$	3
2.0	$4\frac{3}{8}''$	$\frac{1}{2}''$	$\times\ \frac{11}{16}''$	$9\frac{1}{2}''$	3
2.2	$4\frac{13}{16}''$	$\frac{7}{16}''$	$\times\ \frac{5}{8}''$	$9\frac{13}{16}''$	3.5
2.4	$5\frac{1}{4}''$	$\frac{3}{8}''$	$\times\ \frac{9}{16}''$	$10\frac{3}{16}''$	3.5
2.6	$5\frac{11}{16}''$	$\frac{3}{8}''$	$\times\ \frac{9}{16}''$	$10\frac{5}{8}''$	3.5
2.8	$6\frac{1}{16}''$	$\frac{3}{8}''$	$\times\ \frac{11}{16}''$	$10\frac{7}{8}''$	4
2.9	$6\frac{5}{16}''$	$\frac{5}{16}''$	$\times\ \frac{1}{2}''$	$11\frac{1}{8}''$	4.5

Bellows III (f = 58mm)

Magnification Ratio	Bellows Extension	Photographic Area		Distance from Film to Subject	Extra Stops to Open Aperture
0.6	$1\frac{3}{8}''$	$1\frac{9}{16}''$	$\times\ 2\frac{3}{8}''$	$9\frac{9}{16}''$	1.5
0.8	$1\frac{7}{8}''$	$1\frac{3}{16}''$	$\times\ 1\frac{3}{4}''$	$9\frac{1}{16}''$	1.5
1.0	$2\frac{5}{16}''$	$\frac{15}{16}''$	$\times\ 1\frac{3}{8}''$	$8\frac{15}{16}''$	2
1.2	$2\frac{13}{16}''$	$\frac{13}{16}''$	$\times\ 1\frac{13}{16}''$	$9\frac{1}{16}''$	2
1.4	$3\frac{1}{4}''$	$\frac{11}{16}''$	$\times\ 1''$	$9\frac{1}{4}''$	2.5
1.6	$3\frac{11}{16}''$	$\frac{9}{16}''$	$\times\ \frac{15}{16}''$	$9\frac{1}{2}''$	3
1.8	$4\frac{3}{16}''$	$\frac{1}{2}''$	$\times\ \frac{13}{16}''$	$9\frac{13}{16}''$	3
2.0	$4\frac{5}{8}''$	$\frac{17}{32}''$	$\times\ \frac{11}{16}''$	$10\frac{1}{16}''$	3
2.2	$5\frac{1}{8}''$	$\frac{7}{16}''$	$\times\ \frac{5}{8}''$	$10\frac{1}{2}''$	3.5
2.4	$5\frac{5}{8}''$	$\frac{3}{8}''$	$\times\ \frac{9}{16}''$	$10\frac{7}{8}''$	3.5
2.6	$6\frac{1}{16}''$	$\frac{3}{8}''$	$\times\ \frac{9}{16}''$	$11\frac{1}{4}''$	3.5
2.7	$6\frac{1}{4}''$	$\frac{3}{8}''$	$\times\ \frac{1}{2}''$	$11\frac{1}{2}''$	4

Bellows III (f = 100mm)

Magnification Ratio	Bellows Extension	Photographic Area		Distance from Film to Subject	Extra Stops to Open Aperture
0.4	$1\frac{9}{16}''$	$2\frac{3}{8}''$	$\times\ 3\frac{9}{16}''$	$1'\ 7\frac{1}{2}''$	1
0.5	$2''$	$1\frac{7}{8}''$	$\times\ 2\frac{7}{8}''$	$1'\ 5\frac{11}{16}''$	1
0.6	$2\frac{3}{8}''$	$1\frac{9}{16}''$	$\times\ 2\frac{3}{8}''$	$1'\ 4\frac{3}{4}''$	1.5
0.7	$2\frac{3}{4}''$	$1\frac{3}{8}''$	$\times\ 2''$	$1'\ 4\frac{3}{16}''$	1.5
0.8	$3\frac{3}{16}''$	$1\frac{3}{16}''$	$\times\ 1\frac{3}{4}''$	$1'\ 3\frac{7}{8}''$	1.5
0.9	$3\frac{9}{16}''$	$1\frac{1}{16}''$	$\times\ 1\frac{9}{16}''$	$1'\ 3\frac{3}{4}''$	2
1.0	$3\frac{15}{16}''$	$\frac{15}{16}''$	$\times\ 1\frac{7}{16}''$	$1'\ 3\frac{11}{16}''$	2
1.1	$4\frac{5}{16}''$	$\frac{7}{8}''$	$\times\ \frac{5}{16}''$	$1'\ 3\frac{3}{4}''$	2
1.2	$4\frac{3}{4}''$	$\frac{13}{16}''$	$\times\ 1\frac{3}{16}''$	$1'\ 3\frac{13}{16}''$	2
1.3	$5\frac{1}{8}''$	$\frac{3}{4}''$	$\times\ 1\frac{7}{8}''$	$1'\ 3\frac{9}{16}''$	2
1.4	$5\frac{1}{2}''$	$\frac{11}{16}''$	$\times\ 1''$	$1'\ 4\frac{3}{16}''$	2.5
1.5	$5\frac{7}{8}''$	$\frac{5}{8}''$	$\times\ \frac{15}{16}''$	$1'\ 4\frac{3}{8}''$	2.5

Bellows III (f = 100mm Auto Bellows Rokkor)

Magnification Ratio	Bellows Extension	Photographic Area	Distance from Film to Subject	Extra Stops to Open Aperture
0.1	2¹⁄₁₆"	9⁷⁄₁₆" × 1' 2³⁄₁₆"	3' 11⁹⁄₁₆"	0.5
0.2	2⁷⁄₁₆"	4¾" × 7¹⁄₁₆"	2' 4¼"	0.5
0.3	2⅞"	3³⁄₁₆" × 4¾"	1' 10¹⁄₁₆"	1
0.4	3¼"	2⅜" × 3⁹⁄₁₆"	1' 7³⁄₁₆"	1
0.5	3⅝"	1⅞" × 2⅞"	1' 5⅝"	1
0.6	4"	1⁹⁄₁₆" × 2⅜"	1' 4½"	1.5
0.7	4⁷⁄₁₆"	1⅜" × 2"	1' 4³⁄₁₆"	1.5
0.8	4¹³⁄₁₆"	1³⁄₁₆" × 1¾"	1' 3⅞"	1.5
0.9	5³⁄₁₆"	1¹⁄₁₆" × 1⁹⁄₁₆"	1' 3¹¹⁄₁₆"	2
1.0	5⅝"	¹⁵⁄₁₆" × 1¹⁄₁₆"	1' 3⅝"	2
1.1	6"	⅞" × ⁵⁄₁₆"	1' 3¹¹⁄₁₆"	2

Bellows Lenses

The 100mm Auto Bellows Rokkor f/4 lens has been specifically designed for use with Minolta bellows units. This lens focuses from infinity, giving you the option of hand-holding the bellows and using it as a telephoto for portrait and medium telephoto work. For closeup photography, the bellows should be mounted on a tripod.

The Auto Bellows Rokkor lens has an automatic diaphragm, which means that once you have preset the aperture, you can open up again to check composition and focus if you use it on the Auto Bellows I. If you use this lens on the Bellows III, you must close down the aperture manually before you release the shutter, since the Bellows III does not have a diaphragm coupling pin.

Minolta also manufactured a 135mm Bellows Rokkor f/4 lens, which came with a Leica mount and an SR mount adapter ring and flange tool. This is a manual preset lens. If you use it on one of the Minolta bellows units, open the lens to its widest aperture, compose and focus, close down to the smallest f/stop possible, match needles in the viewfinder, and release the shutter.

A bellows lens lets you work farther from your subject and still get life-size images on your negative or color slide. The Auto Bellows Rokkor, for example, gives you a 1:1 image with the front of the lens seven inches from the subject, whereas the 55mm Rokkor lens must be only two inches from the subject to give you the same life-size image.

The Slide Copier

The Minolta slide copier can be used with either the Auto Bellows I or the Bellows III. When you use it on the Auto Bellows, attach it to the accessory holder at the front of the focusing rail. Make sure that the three accessory

holder rods are all the way into the holes in the front of the rail and secured with the accessory holder clamp. If you use the copier on the Bellows III, attach the copier to the connector and slip the connector onto the bellows track.

The slide copier has a special lens adapter ring, which allows its use with the 55mm $f/1.7$ lens and the 55mm $f/1.9$ lens, the standard lens for the SR-T 100. If you use the copier with any other lens, remember to remove the adapter ring. Choose one of the standard 55mm or 58mm lenses or the 50mm macro lens for slide copying.

With the slide copier mounted on the bellows unit, release the clamps that hold the slide copier bellows and attach the rear of the slide copier bellows to the front of the lens using the lens clamp.

To copy a slide, set the lens at infinity; set the magnification you want on the bellows track; insert a mounted slide into the slide holder, with the emulsion side of the slide toward the diffusor; point the diffusor toward some natural or artificial light source; and focus.

Use the focusing knob on the focusing rail to focus the Auto Bellows I. To focus the Bellows III, move the connector back and forth until the slide is in approximate focus, tighten the screw clamp of the connector, and fine focus with the focusing knob of the bellows unit.

Measure exposure just as you would for macrophotography. Use the stop-down method if you have an Auto Bellows I. If you use the Bellows III, turn the aperture selector ring to the $f/$stop you want before you release the shutter.

You can also make copies of strip film: Simply pull the diffusor down, insert the film, and close the diffusor. Long strips of film can be supported with strip film trays on either side of the diffusor. Remember that if you are copying black-and-white negatives and have your camera loaded with black-and-white film, you will get positive black-and-white transparencies.

You can put positive transparencies in slide mounts and project them just as you would color slides. Mounted black-and-white transparencies make an interesting change of pace in slide shows and let you show your black-and-white work right along with your color slides.

When you make copies of color slides, use a daylight-type film if your light source is daylight and a tungsten-type film (indoor film) if you are using a tungsten light source. The Minolta slide projector, by the way, makes an excellent light source for slide copying: Just turn on the projector and point it at the diffusor.

The 50mm MC Macro Rokkor $f/3.5$ Lens

The 50mm MC Rokkor $f/3.5$, an extremely versatile lens, has a long focusing range of nine inches to infinity. It can be used not only for closeup photography but for general photography as well. Many professional photographers use the macro lens in place of a normal lens for just this reason. At its closest focusing point, the lens by itself provides a magnification ratio of 1:2 and, with the intermediate ring supplied with the lens, a magnification ratio of up to 1:1.

The MC Macro Rokkor is particularly convenient to work with in closeup photography. For one thing, it is equipped with automatic diaphragm operation so that the lens remains at maximum aperture until the instant of exposure and returns to maximum aperture after exposure. This allows the photographer to view his subject with the viewfinder at its maximum brightness level. This lens also couples to the through-the-lens metering system of the SR-T 101 and SR-T 100, eliminating the need for you to compute exposure information: You simply match the needles in the viewfinder.

The lens barrel of the MC Macro Rokkor has special markings, which help you determine magnification ratios, exposure factors, and effective apertures for macrophotography. Thus, the lens eliminates the need to refer to complicated formulas and tables.

As you turn the focusing ring of the lens, the barrel will extend and expose the magnification ratios and exposure factors, which are engraved in white and orange. Refer to the white engraved numbers when you use the

Fig. 8-7. Nature studies often make striking photographs. This picture of a leaf was taken right after a rain. To get this close to the leaf, the photographer used the MC Macro Rokkor lens, which focuses to within nine inches of the subject, providing a 1:2 ratio. Photograph by Robert D. Moeser.

MC Macro Rokkor alone and to the orange engravings when you use the lens in conjunction with the intermediate ring.

At any given focus, the correct magnification ratio will be the number closest to the camera body. Thus, if the lens is focused at a distance of ten inches, the magnification ratio will be 1:3, and the exposure factor will be +1, which means that if you use a hand-held meter, you should open the aperture one full f/stop for correct exposure.

Because magnification ratios are engraved on the lens barrel (1:10–1:2 when the lens is used without the intermediate ring; 1:1.7–1:1 with the intermediate ring), you can set the lens barrel at the particular magnification ratio you want and simply move the camera forward or backward until your subject comes into sharp focus.

When you use the intermediate ring with the MC Macro Rokkor, magnification ratios up to 1:1 are possible within a focusing range of nine inches to eight inches from the focal plane. Adding the lens to the intermediate ring also changes the effective apertures of the lens from f/3.5–22 to f/5.6–32, because of the increased distance between the lens and the film. The intermediate ring permits the lens to be used automatically and to couple to the through-the-lens metering system of the SR-T 101 and SR-T 100. The intermediate ring has f/stops engraved on it in orange. When you use this ring, refer to the orange markings on the lens barrel for magnification ratios and exposure factors.

In addition to the intermediate ring, the lens is supplied with a reverse ring. When the MC Macro Rokkor and the reverse ring are used in combination with a Minolta bellows unit, even greater magnification ratios can be obtained. When the lens is mounted on the reverse ring, however, normal focusing is not possible: You must use the knurled knob on the bellows unit. In addition, the lens diaphragm does not perform automatically, nor does the lens couple into the through-the-lens metering system.

The turnabout of a lens may seem strange. Actually, it serves an important purpose. In the case of larger-than-life reproduction, the distance between lens and film becomes greater than that between subject and lens, which is a reversal of the normal relationship. As soon as the lens is turned around, it is restored to its proper distance relationship, which results in improved performance.

The MC Macro Rokkor lens is available as a single item or in the special Minolta SR-T 101 Macrokit. The Macrokit, designed expressly for photographers who wish to use the MC Macro Rokkor as a normal lens, consists of a Minolta SR-T 101 body, MC Macro Rokkor lens, intermediate and reverse rings, a neck strap, a body cap, a leather case for the MC Macro Rokkor lens, and a compartmented case for the complete Macrokit.

LIGHTING FOR MACROPHOTOGRAPHY

Lighting techniques for macrophotography are similar to those used for general photography. The basic difference is that you must concentrate your

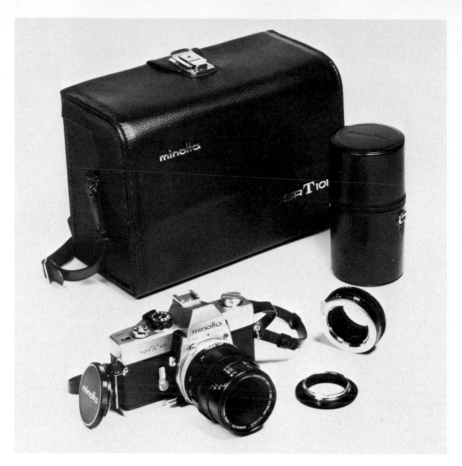

Fig. 8-8. The Minolta SR-T 101 Macrokit.

light on small areas with spotlights, high-intensity lights, or reflectors. The reflectors can be flat or concave mirrors, foil-covered cards, which help to fill in shadows left by the main lights, or even white paper. These improvised reflectors are especially important in this type of work because of the cramped area between the lens and the subject.

Basic lighting patterns include rim or backlight for showing edge detail and filament-like structures, frontlight, sidelight to bring out texture, diffused or shadowless light, and trans-illumination for translucent subjects.

A problem encountered with lighting in closeup and macrophotography is the great heat generated by a number of lights focused on a small area. Heat-sensitive objects and living things will wilt or die if kept under the lamps too long. When you photograph perishable subjects, try to arrange your lighting setup and determine magnification ratios and exposure factors before putting the subject in front of your lens; even then, you will want to work quickly.

SPECIAL REQUIREMENTS FOR MACROPHOTOGRAPHY

There are certain requirements for good closeup and macrophotography besides precision equipment. The first is a solid tripod or base from which to shoot, because the least movement of the camera or support is tremendously exaggerated in this type of work.

When a choice is possible between a horizontal or vertical camera position, choose the vertical; gravity helps stabilize equipment by pulling along the vertical axis. This principle is utilized by the Minolta Copying Stand, which is quite rugged and has a large baseboard measuring 15½" × 17¾".

The copy stand is a rigid camera support designed to afford the maximum stability required for macrophotography. A 24-inch long chrome tube, 2 inches in diameter, provides secure support for the camera and macro equipment. Markings for centering copy are given on a heavy-duty 15½" × 17¾" baseboard.

With any support, a cable release is a must. If you do not use a cable release, the self timer may be used. Another aid to sharp pictures is the use of the highest possible shutter speed consistent with the necessary depth of field. This will always be a compromise.

FOCUSING FOR MACROPHOTOGRAPHY

Although the MC Macro Rokkor remains at maximum aperture to permit focusing through the viewfinder at full brightness, the smallness of the subject often makes a magnifying device desirable. The Magnifier V, an accessory that clips onto the viewfinder frame of the Minolta SR camera and provides 2.5× magnification power, may be helpful. The Minolta Magnifier V has an adjustable eyepiece with a locking-screw to permit focusing for individual eyesight.

When the Minolta copy stand is used in macrophotography, it is sometimes convenient to change the normal viewing position. To make this easier, the Anglefinder V can be used. This device can be turned in a complete circle for viewing with the camera held below the eye or in any other position. The Anglefinder V clips onto the viewfinder frame of the Minolta SR camera and can be focused for individual eyesight.

9

General Photography

The pleasures of photography offer enough variety and challenge to last a lifetime. With enough knowhow and experience, the photographer should be able to take truly exciting pictures. Subjects before the camera can be anything from stars in the sky to electrons in the atom. Although the extremes involve highly specialized photography, the subject matter within the extremes is almost inexhaustible.

Few people buy a camera one day and are ready to earn a living as a professional photographer the next. And although professional photography may certainly be the goal of some, many accomplished workers are content to enjoy photography as a hobby for the artistic and creative outlet it affords. Most begin photographing relatively simple subjects and work up to more difficult levels as their interest and experience grows. This chapter summarizes some of the specific areas in which photographers have shown the greatest interest. Each situation should be attempted and experimented with in a continuing effort to master areas of personal challenge.

SCENIC PHOTOGRAPHY

The grandeur of nature—rolling hills, towering trees, budding flowers, rivers, lakes and oceans, mountains, valleys, and plains—has been, since the beginnings of photography, the most popular subject matter for both the novice and seasoned photographer.

Technically, scenic photography offers the fewest problems. Abundant light, whether in the form of direct sunlight, indirect light from a clouded sky, or open shade in the shadow of a tree or mountain, allows the use of relatively fast shutter speeds and small aperture settings with even the slowest films.

Working outdoors presents situations in which the film will greatly influence the photograph that results. The careful worker can gain considerable experience by paying careful attention to the way different films react under various conditions. For example, shooting outdoors with plenty of bright

132

sunlight would at first seem to be the perfect opportunity to use slow films in the ASA 25 range, which would call for a basic exposure of about $f/8$ at $1/125$ sec. or some other combination with that exposure value.

Unless a particular effect is desired, however, the use of a slow film in bright sunlight would most certainly be disappointing, because the brightest highlights would be overexposed, showing little or no detail, and the shadow

Fig. 9-1. A picture is what you make it. In this instance, the photographer made his picture of a door, and not any door, but an old one, paint-peeled, with broken windows. The picture was taken with a 28mm lens and Tri-X film, rated at ASA 400. Photograph by Robert D. Moeser.

Fig. 9-2. Railroad tracks make for graphically striking pictures. These were taken as the photographer was walking home. It was late evening, and the sun was low on the horizon. By printing on a contrasty grade of paper, the photographer was able to emphasize the lines of track. The picture was made with a Minolta SR-T 101 with the MC Rokkor 100mm $f/2.5$ lens. The film used was GAF's Super Hypan rated at ASA 500. Photograph by John Neubauer.

areas would appear as black patches without detail owing to underexposure. As explained in Chapter 6, Films and Filters, slow films have relatively less latitude for over- and underexposure, which is apparent at either extreme on the brightness scale. Since faster black-and-white and color films have inherently greater latitude for under- and overexposure, they are able to retain considerably more detail in the highlight and shadow areas.

Heavily clouded and overcast days afford flat, dull light. Under these conditions, the brightness range is way down, and it would seem the perfect time

to take advantage of the high-speed films. But the faster films are inherently flat: They lack contrast, and pictures shot with high-speed films on days like these show it. Under these particular lighting conditions, the slower films will produce photographs or slides with increased contrast and more detail.

Adjustments are possible in the darkroom if the photographer processes his own film. He can vary film development times and use printing papers of different contrasts. However, he will usually achieve best results by matching the film to the lighting conditions as the photographs are taken. Keeping in mind the way film affects a photograph, and then trying the different types under a variety of conditions will help the photographer gain control in producing the effects that most please his individual taste. There is nothing that can match the actual experience of shooting with the aim of control in mind and succeeding in getting the intended effect.

Contrast differences between film types should be kept in mind when subject distances are considered. Aerial haze is often encountered when you shoot distant subjects; it has the practical result of reducing contrast. Filters (see Chapter 6, Films and Filters) can give added contrast and separation of tones, and the results will vary depending upon the type of film used. The slower films will, in almost every case, provide the greatest contrast possible with any given filter.

Many photographers settle on one type of film and use that regardless of the situation, and they are very happy with their photographs. It could be, however, that they have settled on one because they have never tried the others. This is unfortunate, because scenic photography offers so many different possibilities for experimentation with everything from basic to highly complicated equipment, as well as with a multitude of films.

CANDIDS IN THE HOME

The greatest number of pictures taken by the amateur photographer are shot in and around the home and at gatherings of family and friends. These pictures are most likely to be candid, or unposed, to capture what can best be described as natural and spontaneous expressions. But capturing such fleeting expressions as appear on children's faces as they quickly turn from smiles to tears takes patience and understanding.

Among his most valuable pictures will be those the photographer takes of his child's first birthday, and if a boy, of his first haircut. They will be of the frustration of a harried neighbor stuck in a long line of traffic; of the excitement in a child's eyes seeing a new toy for the first time; of his grandparents celebrating their fiftieth wedding anniversary; in short, the memories evoked by candid photographs will be of events that happen practically every day. The alert photographer will keep his camera loaded, ready to capture these events as they occur.

A question that often comes up among enthusiastic photographers is "How much can I shoot without being a pest?" The answer is for the photographer to practice his picture-taking skills so that he will be unobtrusive and

also to generate similar enthusiasm among the people he is photographing.

The 35mm SLR is the ideal camera for taking candid photos, because it is relatively small, lightweight, and unobtrusive. Also, it holds a large film supply, which allows uninterrupted shooting as unexpected situations occur. The photographer may have to reel off over a dozen shots just to capture a certain expression or a particularly striking pose.

One of the biggest disappointments suffered by the photographer may result from not exposing enough film. Although no one would advocate indiscriminate shooting, it is generally accepted that if a scene or person is interesting enough, it is worth several frames—if only to provide extra copies should a prized negative or slide be damaged.

Flash units are being used much less frequently than in the past. One reason is that lenses are so fast that they perform very well in available light. Also, the photographer who does use flash often finds himself hampered in candid situations because each firing of the flash draws attention to what he is doing and detracts from the spontaneity of the event.

Natural light candid photography is easily within the range of any lens with an aperture speed of $f/2.8$, or faster. Most photographers find that, as a rule, any room with an illumination level high enough for them to read comfortably the small print of a newspaper offers more than enough light for available light shooting. Faster lenses, of course, allow for easy shooting at much dimmer illumination levels.

High-speed lenses offer further advantages. Where the illumination level is higher than the minimum, a fast shutter speed can be used if the lens aperture is opened wide. People talking, gesturing, or moving vigorously can often be photographed sharply if the photographer anticipates the movements and shoots at what is known as the *peak action.* This is nothing more than releasing the shutter at the instant the action reaches its climax, for example, when an arm is raised, then stops for a moment before it is lowered again. This peak action stopping point can be applied to a child jumping up and down on a bed, as well as a swimmer diving from a board into a pool.

An advantage of the wide aperture in a high-speed lens is the narrow depth of field it provides when used wide open. More often than not there are distracting details in the background that detract from the center of interest. With a shallow depth of field, background details will be thrown so far out of focus that they will make the main subject actually stand out from the rest of the scene. This is known as *selective focus,* and it is as effective in black-and-white photography as it is in color.

The advantages of interchangeable lenses are that they allow the photographer to stand on one side of a room with a long lens, say 135mm, and shoot tightly framed shots of a subject on the other side of the room or to work with a short lens, say 28mm, and shoot wide-angle views in situations where it is impossible for him to back farther away from his subject.

For maximum detail as much of the subject must be included in the 35mm film frame as is practicable. True, it is possible to enlarge a small portion of a negative, such as the head of a subject, to a much larger size. How-

ever, either moving closer to the subject or using a longer lens, which will give the same effect, produces an entirely different photograph. Any extreme enlargement renders detail less distinctly and shows a larger grain structure than a lesser enlargement.

A wide-angle lens used at the same aperture setting and from the same distance as a longer lens delivers a greater depth of field. This is important when activity is taking place over a wide area. A wide-angle lens enables the photographer to take advantage of the increased depth of field, either by setting the focus on the lens so that the depth of focus falls within the area covered by the aperture setting, and by permitting him to focus rapidly, although not quite as accurately as he could if the subject remained static.

With practice the technical aspect of setting the exposure after considering the compromises that must be made between shutter speed and aperture settings becomes easier. One photographer may find he can focus quickly and accurately but has trouble holding the camera steady at slow speeds; another may have the opposite problem; still a third may find that he has no problem at all with candid shooting. After making the necessary adjustments to compensate for his individual weaknesses and strong points, the photographer can concentrate on capturing expressions, poses, and relationships, which is, in the end, his reason for taking candid photographs.

SPORTS PHOTOGRAPHY

Photographing sports is probably the ideal situation for a photographer to develop his sense of timing by learning to anticipate that exact moment to release the shutter. In almost every event, there is but one split second when all action reaches its peak, and the most interesting photographs will result if the photographer can capture that moment. Outdoor sporting events offer the advantage of adequate light over the entire scene of action. But even with his ability to shoot at small apertures for maximum depth of field and at high shutter speeds for action stopping power, the serious sports photographer will quickly discover that the high points are difficult to capture in a dramatic way. Most athletic activity takes place over relatively long distances. Since few photographers are in as good physical condition as the athletes participating in the events, it is difficult to follow the action in a game like football by running up and down the field in order to stay within close shooting range of the players.

A long focal length lens isolates areas of action that would be almost impossible to portray with a normal focal length lens. The focal lengths used may be just barely long enough to show the contestants, or longer and longer to the point where the individual images are so large that the expressions on the players' faces are clearly visible.

When using a longer lens, say a 200mm, it is soon apparent that a shutter speed of 1/250 sec. does not produce as sharp an image as it does when a normal focal length lens is used. This occurs, in part, because the subject or camera motion is magnified on the film plane at the same rate as image

size is increased. A 200mm lens gives an image size four time larger than a normal lens and also increases camera and subject movement four times.

The same is true with focusing. An image only slightly out of focus when shot with a normal lens appears even more out of focus with longer lenses set at the same distance. Although it would seem that longer focal length lenses will produce better sports photographs automatically, it must be remembered that the use of these lenses requires special attention to the basics of steady handling and accurate focus to make possible the fine results of which they are capable.

ANIMAL PHOTOGRAPHY

Photographing pets at home is done in much the same manner as shooting candids of the other members of the family. As is the case with children, good photographs of pets usually result from patience and a good sense of timing. Familiarity with a pet's habits often allows the photoprapher to position himself in advance to capture the picture he has in mind.

Photographing wild animals in the zoo offers almost as much challenge as stalking them in their natural habitats. The aim of the photographer is to portray a natural likeness of the animal, while eliminating the appearance of a caged surrounding. This is another area in which high-speed, long-focal-length lenses can be used to advantage.

Since high-speed lenses with the aperture setting wide open produce a very shallow depth of field both in front of and behind the point of exact focus, they can often be used to throw the animal's cage or bars completely out of focus. Through-the-lens viewing allows the photographer to see the effect that will register on the film. Slight vertical or lateral adjustments in the camera position and pinpoint focusing can be easily and rapidly accomplished.

Almost all animals, whether in the home or the zoo, quickly become accustomed to the presence of humans. When photographed under normal conditions, the animal may appear bored and uninterested, hardly the way in which a photographer would want to portray it. Photographers specializing in work with animals devise some method of producing an unfamiliar sound to attract the subject's attention, such as a quiet whistle, the rattle of keys, or the tinkling of a bell. The result should be a picture of the animal looking squarely at the noise source with its ears, eyes, and bearing giving the impression of alertness.

INFORMAL PORTRAIT PHOTOGRAPHY

We have all seen the formal portrait that bears little resemblance to the person. There are many reasons for this. For one, since the photographer probably did not know the subject personally, he did not have an opportunity to see him in different moods. The studio lights and camera may well have disconcerted the subject. Also, most people feel that for the purpose of having

their portrait taken, they must look either overly somber or too cheerful. Neither of these moods may actually reveal the individual's overall personality.

Informal portraiture is becoming more popular for home and for publication purposes. Informal portraits depict more natural and relaxed expressions, because they are generally taken in surroundings familiar to the subject.

Informal portraits can be broken down into three categories: long, medium, and close views. An example of each would be the full-length shot of a bride in her gown, the medium shot of a child sitting at a table watching her birthday cake candles being lighted, and the close-up of a small baby sleeping. Any of these situations can be photographed under either natural or artificial light.

Portraiture differs slightly from candid photography in that the photographer is primarily interested in capturing a facial mood or expression in a prescribed context. Most informal portraits are taken in the home. If the photographer lives in the same home, or is familiar with the subject's home, he will know that certain areas offer better photographic opportunities than others. Since the most effective photographs are usually the most simple, one of the first things the photographer looks for is an uncluttered setting. As a rule, unless some outside details will contribute to the overall photograph, they can probably best be left out. Distracting items may include pictures on the wall behind the subject, flowers or plants, bookshelves or other furnishings, and light sources, such as table lamps and overhead lights.

The type of lighting under which informal portraits are made will determine, to a great degree, the mood of the finished photograph. There should be sufficient illumination to allow the photographer to work with a comfortable shutter speed and aperture setting. Placing the subject near a table lamp or, better still, near a window should provide enough light. Table lamps covered by shades throw off a soft light that is very flattering. Direct sunlight through a window should be avoided in favor of indirect light.

Direct light falling on a subject sometimes cannot be avoided. Since this type of light is very contrasty because it casts deep, harsh shadows, a reflector of some sort will be helpful in controlling them. Sometimes the surroundings themselves act as reflectors, if they are of a light color or have highly reflective surfaces. If the surroundings are dark, a very effective reflector can be improvised by holding a newspaper, a light colored sheet, or a piece of crumpled aluminum foil in such a way that it bounces the direct light into the shadow areas. These reflectors should be placed close enough to the subject to reflect light into the shadows but not so close that they appear inside the picture area. Trial and error will teach the photographer whether he needs to use reflectors, and if so, how many.

Sometimes the area that affords the most pleasant lighting conditions will have a cluttered background that cannot be eliminated or rearranged. Selective focus helps throw unwanted background clutter so far out of focus that it is barely noticeable, much less objectionable. On the other hand, the photographer may well want to record the entire scene around the subject in sharp detail. In this case, he should back away from the subject to a point

where everything he wants appears inside the viewfinder. Then he can set his lens at the smallest aperture setting compatible with a fast enough shutter speed to allow steadiness during exposure or switch to a shorter focal length lens, which will cover a wider angle of view while providing a greater depth of focus than the longer lenses.

Care should be taken when using wide-angle lenses because they have a great effect on apparent perspective. When held perpendicularly, they will record horizontal and vertical lines accurately, but once they are directed upward, downward, or sideways, an apparent distortion will be noticeable. This same apparent distortion will also be evident if the subject is photo-

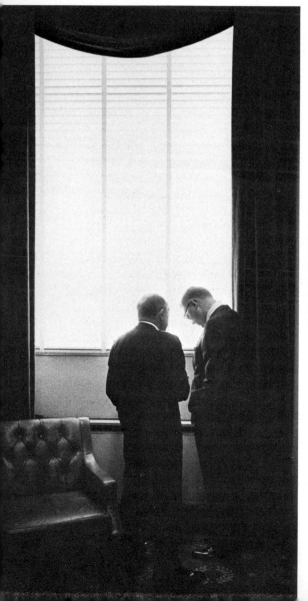

Fig. 9-3. In Washington, D. C., the nation's capitol, mood photographs like this are popular among politicians and lobbyists. For this photograph, the 85mm lens was used. The original exposure was based on the window light, and then the lens was opened two full f/stops in order to render some detail in the face. Photograph by John Neubauer.

graphed at very close range. In a close-up of a face taken with a wide-angle lens, features closest to the camera appear proportionately larger than those even a short distance away. In a straight-on shot, the nose appears very large and the ears very small when compared with the eyes, which are at a point midway between both.

Whereas a great amount of distortion can be tolerated in foreground and background settings, the opposite is true for facial features. To avoid distorting facial features, yet still produce a large image on the negative, a long focal length lens is necessary. Focal lengths in the 85mm to 135mm range will provide the desired image size in most cases. But it should be kept in mind that perspective distortion in the form of flatness of field will result when too long a focal length lens is used.

If black-and-white film is used, it will be relatively easy to locate a suitably illuminated area in which to shoot the informal portrait. An area lit by an electric lamp will serve just as well as one lit by sunlight through a window. Greater care, however, must be taken if the portrait is to be made with color film. Ordinary household lighting will most likely call for the use of a film such as High Speed Ektachrome Tungsten, whereas sunlight through a window will require regular daylight color films, such as Kodachrome II, Kodachrome-X, and Agfachrome CT-18.

Once the location, lighting, lens, and film have been decided upon, the actual shooting can begin. The important thing is to record an image of the subject in such a manner that his expression fits the occasion and purpose of the photograph. Owing to the large film supply in his 35mm camera, the photographer has increased chances of capturing the exact expression that will portray his subject as a unique individual. He should guide the subject along with quiet conversation, suggest poses, and try to evoke the desired expression. Each photographer will handle the situation in his own particular way, drawing on past experience. The best advice is for the photographer to keep the subject in focus and all controls set so that he will be prepared to photograph any expression he feels is typical of the subject.

NEWS PHOTOGRAPHY

Unlike photographers who shoot pictures to please themselves, those who photograph news events must please editors and viewers who want to be informed with accuracy and, if possible, in an entertaining manner. Whereas the photographer shooting for himself only may never pass the stage of producing technically good photographs in a straightforward manner, the competent news photographer begins his work at this point and, through greater skill, innovation, and experience, makes an interesting photograph of a newsworthy event.

The press photographer's life was easier, though probably just as hectic, a generation ago when he primarily used large-format press cameras. Lenses and films were comparatively slow, and most shots had to be made with the aid of flash units. His cameras were heavy, held a limited film supply, and,

with a flashgun attached, drew almost as much attention to the camerman as to the event being photographed. Those early press photographers were a sturdy breed who, without the modern technological advantages, set standards of expertise that are seldom surpassed today.

Press photography has advanced to the point where 35mm cameras and films are almost universally used to cover everything from town hall meetings to beauty pageants. Whereas the photographer of yesterday packed a press camera, a flash unit, and only a few film holders, today's press photographer carries at least two 35mm cameras—one for color and another for black-and-white film—a half dozen lenses ranging from fisheyes to extreme telephotos, a few small electronic flashguns, and enough film for several hundred exposures. High-speed lenses and fast films produce surprisingly good results under miserable conditions, but there are times when lighting conditions will be even worse than miserable. In such cases, a small flashgun can often make the difference between failure and successful coverage.

Lugging a great deal of 35mm equipment for any length of time, if not used, is wasted energy. The aspiring news photographer should learn, through continual practice, what equipment a particular assignment will require.

It is not unusual to encounter news photographers who can set all camera controls in any desired fashion in almost complete darkness while they are on the run. They have learned from experience that news events do not always wait for a photographer to arrive and get set up.

Most people think of news photography in terms of riots, burning buildings, automobile accidents, and twisted trains. These events are certainly news, but few photographs would appear in newspapers and magazines if they had to rely solely on catastrophes. More often than not, they publish photographs of some locally or nationally known dignitary addressing an audience, cutting a ribbon, or congratulating someone; a street scene where an old landmark has been torn down or where some important new structure is about to be built; contest winners; sports events; and so on.

The photographer who wants to practice news photography either full or part time, but has little experience, should first study published photographs. A published photograph that may at first glance appear to be a snapshot might really be the result of careful planning, or sheer luck. Careful planning is something that any serious photographer should do until it becomes a matter of habit, and he must keep his equipment in good working order.

News events have a way of happening in places where the photographer is unable to position himself as close to or as far from the subject as he would wish. The photographer who works with a limited range of different focal length lenses is always at a disadvantage. When he can work to please only himself, the photographer can think about the focal length of lenses in terms of how they will affect perspective. Although this should be a consideration when covering a news event, his attention should be paid primarily to producing a usable image size. Obviously he would not want to take a long shot with a wide-angle lens or a shot at close range with a telephoto lens. Carrying a wide range of lenses will be well worth the effort.

The standard of print quality for news photography is no where near that expected for salon work, but there are limits to what this difference can be. The increased grain that results from forced film development will be barely noticeable when a print is reproduced in a newspaper, but an editor will almost surely reject photographic prints that show fingerprints, dust spots, or scratches. Thus, although the print quality may not be outstanding, neatness of presentation will often result in work getting serious consideration for publication.

The amateur who aspires to break into news photography will have to exercise as much, if not more, imagination in his approach to news events than do the professionals against whom he is competing. When news events not routinely covered by staffers from the local paper occur, the amateur should be at the scene to record them and then show his pictures to the editor. If they are extremely good, or if the event is singularly newsworthy, the editor may use the amateur's pictures. As his experience increases, the amateur may find the editor calling on him to cover certain events. Often, in the event the amateur is a student, the editor may want coverage of a particular school game, or play, or charitable fund-raising campaign. News photography has helped pay the cost of putting many students through college, and it has led many photographers to careers in photojournalism.

PICTURE STORIES

The true picture story has a beginning, a middle, and an end. Whereas the news photographer's goal is to capture the peak action of a particular event, the goal of the photographer who shoots picture stories is to narrate the event in visual terms. He does this by exercising all the controls of his photographic tools: He controls perspective by using a variety of lenses; he isolates his subject by employing selective focus or portrays his subject in its total environment by using a small aperture on a wide-angle lens to keep his picture in sharp focus from foreground to background; he freezes the action of the event by using a high shutter speed or portrays the action as a blur by shooting slow; he manipulates his exposure to produce a high- or low-key effect.

Using one or more of these controls, the photographer seeks an establishing shot, a picture that will give the viewer an idea of what the subject looks like or is all about. Depending upon the subject of the picture story, the establishing shot could be anything from an informal portrait of a person to the wide expanse of a scenic view. The establishing shot sets the tone for the subsequent pictures in the series. The middle of the picture story should be an extremely dramatic view carrying as much visual impact as possible. This picture serves to connect and add meaning to the beginning and end of the story; it must fit in context with the pictures that come before it as well as those that follow. The middle picture establishes the theme for the entire series. The concluding photograph sums up the point of the story: It may be birth or death; an expression of joy or of sadness; the beginning of a day or its

closing. It should have the same effect on the viewer that an exclamation point at the end of a sentence has on the reader. The aim of this photographic approach to a picture series is a visual story, which is one of the hardest things to achieve through photography.

The endless combination of ideas, technical controls, and subject matter makes the taking of picture stories one of the most fascinating areas of photography. It offers the photographer an opportunity to express his ideas visually, for pleasure or for profit, and it limits him only to the bounds of his ingenuity and imagination.

Fig. 10-1. A high camera position and a wide-angle lens turned an ordinary low-light level scene into an exciting visual account of a men's wear buyer at a New York fashion house. The papers reflected overhead ceiling light back onto the subjects. The shutter speed was 1/30 sec., which was not of short enough duration to stop the action of the man's hand at the right. But the motion of his hand increases the excitement of the picture. The exposure was at $f/4$, with the 21mm lens. Photograph by John Neubauer.

10

The Minolta SR-M

No matter how rapidly the photographer is able to handle the standard camera, there will always be times when it will be impossible for him to shoot fast enough. Sporting events, for example, often involve fast moving subjects who perform unexpectedly in less time than it takes to advance the film from one frame to the next. Children playing and people at work provide many routine, but unpredictable, situations in which the photographer often finds himself shooting—and missing—the key moments of action and expression because things just happen too fast.

For situations such as these and hundreds of others like them, Minolta has designed a motorized camera body, called the *SR-M*. It is only slightly larger and heavier than the standard SR-T 101. The SR-M body, which comes in a black finish only, accepts all lenses and accessories that fit the SR-T 101, as well as a number of accessories designed exclusively for it.

The motor drive of the SR-M is enclosed in a housing at the bottom of the camera. This makes the total height from the top of the prism to the bottom of the motor housing 5¾ inches, only an inch or so higher than the SR-T 101. The length and width of the SR-M are identical to the SR-T 101. Body weight for the motor drive model is only 37 ounces.

Power for the motor drive is furnished by eight 1.5-volt AA penlight batteries, which are housed in a handgrip that attaches firmly to the side of the camera body. This handgrip comes with an adjustable leather strap, which can be easily adjusted to fit the user's hand. At the front of the grip, near the top, is the shutter release button. A very light touch on this button is all that is necessary to activate the motor drive for either single or continuous exposures. Directly opposite the shutter release button, on the other side of the handgrip, is the selector dial, which activates the motor drive and sets it for shooting either a single frame at a time or continuously.

The pentaprism housing of the SR-M is a bit smaller and more compact than that of the SR-T 101, because there is no through-the-lens metering system in the SR-M. As an aid to viewing and focusing, particularly during high-speed motor operation, the camera is equipped with an extremely bright,

fixed pentaprism finder. With the normal lens, 94 per cent of the total picture is visible in the viewfinder at life-size magnification.

THE VIEWFINDER

The viewfinder screen is designed for fast, accurate, and precise use. It consists of a microprism center spot for critical focusing surrounded by a groundglass collar for general focusing and an overall Fresnel screen for corner-to-corner brightness. In use with the automatic diaphragm Rokkor lenses, the viewfinder remains open for maximum brightness until exposure. At that instant, the lens diaphragm closes down automatically to the pre-selected aperture for the correct exposure, then reopens automatically for the next.

As with the SR-T 101, an oversized mirror has been built into the SR-M to prevent vignetting, even when telephoto lenses are used. An independent mirror lock-up, visible at the lefthand side of the lens mount as you face the camera, has been included for use in situations where mirror focusing is unnecessary. The mirror lock-up also aids in reducing camera movement by eliminating mirror swing inside the camera. It can be used for shooting still lifes and still subjects with telephoto lenses or for time-lapse photography. To allow complete visibility, even for those with eyeglasses, the viewfinder eyepiece is oversized and slotted to accept various accessories, such as eyepiece corrector lenses, magnifiers, and angle finders.

SHUTTER CONTROLS

The shutter speed dial permits setting speeds in click stops from 1 second to 1/1000 sec., plus a "T-B" setting. When turned to "T-B," the shutter works as "time" when released with the firing switch on the handgrip; it works as "bulb" when the shutter release on the camera is used. Both the

Figs. 10-2A–B. The film cartridge is first fitted securely into the supply chamber; (A) then the film leader is inserted between the slits of the take-up spool. (B) The film properly loaded in the SR-M.

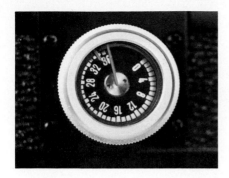

Fig. 10-3. The frame counter in the SR-M shows the number of exposures remaining.

"FP" and "X" synchronization terminals are visible on the righthand side of the lens mount as you face the camera. FP (focal plane) or long burning flashbulbs will synchronize at any shutter speed when connected to the FP terminal. The X terminal allows synchronized firing of electronic flash at a maximum shutter speed of 1/60 sec. or slower.

THE MANUAL FILM ADVANCE

A thumb lever film advance is located on the top of the SR-M camera body, in the same place as on the SR-T 101. This has been provided so the photographer can operate the camera completely manually in the unlikely event that the battery power becomes exhausted while he is still shooting. With a fresh set of eight batteries, more than fifty 36-exposure film cartridges can be exposed in single-frame operation with the motor drive and approximately twenty 36-exposure cartridges when the switch is fired in continuous bursts.

ASSEMBLING FOR MOTORIZED OPERATION

To release the battery container, turn the lock at the bottom of the handgrip in either direction. Then grasp the container by the ends in both hands and twist in opposite directions until it opens in the middle. The top and bottom halves of the container are each divided into four sections. A 1.5-volt AA penlight battery fits in each of the sections as indicated by the symbols + (positive) or − (negative) inside. After inserting the batteries, rejoin the halves to form a single container and place it inside the handgrip in such a way that the words "Minolta Japan" face outward. Finally, reset the container lock.

To attach the grip to the camera body, slide the battery contact shoe over the battery contact bracket on the body. Secure the contact by tightening the knurled knob on the grip lock. Then press the motor drive switch with the S.C. (Single—Continuous) selector dial set at either "S" or "C" to insure that proper contact has been made.

147

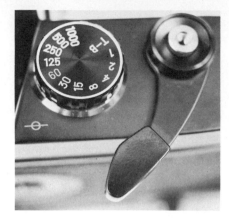

Fig. 10-4. The shutter speed dial and manual film advance lever on the Minolta SR-M.

LOADING FILM

To load film into the SR-M, lift the rewind knob straight up until the back snaps open. Place the film cartridge or cassette in the film chamber, and insert the film leader into any one of the slits on the take-up spool. Then close the camera back securely by snapping it shut.

The film frame counter of the SR-M is on the back of the camera. To set it, pull the outer ring back, then turn it to bring the short red line indicator into line with the number of exposures on the film just loaded—20 or 36. After loading, advance the film three frames, either by hand or by using the motor. The long red line indicator will then show the number of exposures in the film supply. The film frame counter will show the number of exposures remaining as shooting progresses.

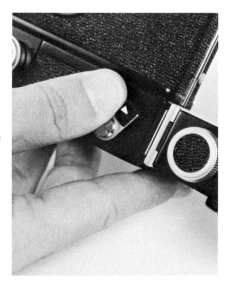

Fig. 10-5. Activate the automatic rewind motor by pushing in the direction of the pointer.

SHUTTER SPEED AND C. S. DIAL SETTINGS

At the "S" (single) setting on the C.S. dial at the top rear of the grip, the shutter speed on the camera can be set at any speed including "T" (time). At the T setting, once the shutter is tripped, it will remain open until the shutter dial is turned manually away from the T position toward any other setting on the shutter speed dial. At the C (continuous) setting, the shutter speed dial must be set at 1/30 sec. or faster, which will enable the camera shutter to recycle fast enough to allow the motor to advance the film at the rate of three frames per second. Speeds less than 1/30 sec. should not be used on the continuous setting. At either setting, C or S, the motor will stop at the "0" position on the film frame counter when all the exposures have been made.

REWINDING FILM

A unique, convenient, and exclusive feature of the SR-M is its motorized film rewind. Film can always be rewound automatically or manually, regardless of the position of the frame counter. The automatic film rewind switch is visible at the bottom, to the right as you face the camera back. To activate it, push the switch to the right as indicated by the white arrow. Winding ceases when the counter stops at the number originally set when you loaded the film. When you rewind automatically, the film leader is not rewound into the magazine. For manual rewind, set the C.S. selector dial at the "Off" position, and rewind with the film rewind crank while holding the film rewind lever in the direction indicated by the white arrow.

Caution: To rewind the film completely by motor, do not at any time change the setting of the frame counter from its original position. If the position is changed, rewinding the film will have to be completed manually.

THE 250-EXPOSURE FILM BACK

A number of accessories for the SR-M add versatility to the Minolta SR-M camera system. Those photographers whose work calls for considerably more than the 36 exposures contained in a regular size roll of film will be interested in one of the major accessories—the 250-exposure film back. This back features the capacity to hold a maximum length of film of 33 feet, which is transported through the camera either by electric motor drive or by hand.

The exposure counter on the 250-exposure film back is backward counting; it stops automatically when the number of exposures for which it has been set have been completed. The same battery grip used for regular operation is attached to the bottom for hand-held use when the accessory film back is in place. Fully loaded and ready for operation, the entire unit, consisting of the camera body, film back, film, and grip, comes to a total weight of slightly more than 46 ounces.

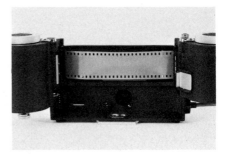
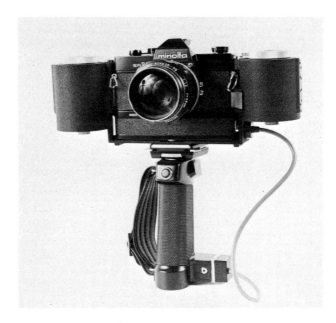

Figs. 10-6A–E. Loading the SR-M with 250-exposure roll. (A) Bulk film supply loaded into the lefthand feed chamber. (B) Bulk film loaded into feed chamber at the left and across the track to the take-up chamber at the right. (C) Loaded 250-exposure film back before the back cover has been put into place. (D) Loaded 250-exposure film back with the back cover in place. (E) Minolta SR-M with fully loaded 250-exposure film back in place and ready for operation.

150

Attaching and Removing the Film Back

Attaching the 250-exposure film back is fast and simple. First, remove the regular SR-M back by opening it and pushing up on the release lever where the back joins the body at the same end as the manual film advance lever. Next, drop this side of the camera into the film back to engage the camera's locking pins with the film back's holding plate. Push the film rewind crank side of the camera in with gentle pressure until it locks securely into position. Finally, engage the safety lock between the camera and film back at the front of the camera on the opposite side.

Attaching and Removing the Battery Grip

To completely remove the 250-exposure film back from the SR-M, simply pull the back cover release knob, at the top left of the camera body, all the way up, after disengaging the safety lock where the body and back join at the front left side.

At the bottom of the film back there is a wedge-shaped foot plate with a removable attaching bracket, which joins the battery grip to the film back. To make the connection, align the pin on the underside of the bracket with the small hole near the connector socket on the grip. Then turn the protruding knurled disk on the bracket until it connects firmly to the socket in the grip.

If you hold the grip with the shutter release button facing you, the narrow end of the wedge-shaped attaching bracket will also face you. With the camera mounted to the film back, and the lens facing you, slide the bracket mounting shoe over the foot plate. When properly seated, the attaching bracket will lock securely onto the film back.

The battery power supply in the grip is fed to the motor drive through the contact bracket attached by a cord to the film back. To make the hook up, connect the film back cord to the battery grip by pushing the contact bracket all the way back into the grip contact shoe. To secure the connection, tighten the grooved knob at the bottom of the grip while holding the contacts firmly in place.

To remove the attaching bracket from the film back foot plate, simultaneously depress both grooved retaining finger releases, which are located on either side of the narrower end of the attaching bracket, all the way and slide the bracket mounting shoe off the foot plate toward the front of the camera.

Opening the Film Back

To open the 250-exposure film back, position the camera so that the lens is facing away and you can look down at the unit. On either side of the film back are large control dials with the words "Open" and "Close" on the top. Turn both control dials so that "Open" on each aligns with the indicator dots on top of the back of the film holder. Next, pull up the lock lever located at the top and extreme right side of the film holder. This lever rises about one-quarter inch to allow for the complete removal of the entire back cover.

Loading the Film Back

The film cartridges must be removed from the film back for loading. To remove the cartridge, set the control dial on the top to "Open," and then pull out the release knob located at the underside of the back beneath the cartridge. Tip the back toward the rear, shaking it slightly if necessary, until the cartridge slides out of the chamber.

To remove the film spool from the cartridge, press the rounded button on top of the cartridge when the name "Minolta" appears. With the button held down, turn the inner shell in either direction until the opening and the retaining projection on the rim of the outer shell are aligned. The cartridge will then separate.

The film cartridges must be loaded manually, in complete darkness. To accomplish this easily, use the Minolta film loader, which can be set to measure automatically film lengths that will provide 50, 100, 150, 200, 250, and any intermediate number of exposures.

Once loaded, the film supply cartridge is ready to be returned to the film back. At this point, the supply cartridge should be in the closed and locked position with a short leader protruding. With the cartridge control dial set at "Open" and the cartridge release knob pulled out, insert the film cartridge into the film chamber at the left side of the back. So that it will slide in easily, align the dot centered at the edge of the film gate on the lower rim of the cartridge with the line on the inside of the chamber bottom. Next, take the film leader and check to be sure that the emulsion (dull) side is facing the lens. Put the end of the leader under the metal retaining clip on the drum of the empty take-up cartridge spool, and wind several turns to secure the film. Place the spool in the outer shell of the cartridge, with the leader projecting through the open gate. After aligning the inner and outer gate openings, insert the inner shell and turn it counterclockwise to close the film gate and lock the cartridge. Place the take-up cartridge in the film chamber at the right side, with the cartridge dot aligned with the chamber line; then push in the cartridge release knob.

To put tension on the film once it is in position, turn the cartridge release knob at the left under the film supply cartridge counterclockwise until you feel firm resistance. Be careful not to turn it so far that it will cause the take-up spool to turn back and disengage the leader end from it.

To replace the film back cover, hold it so that the indented section is in the upward position, with the film pressure plate toward the film. Hold the back plate at about a 90° angle to the film plane, and insert the hinge tongue on the left side of the plate all the way into the groove at the left side of the film supply cartridge opening. Make sure that both the top and bottom guide rails around the film back opening are aligned to fit into the channels around the edges of the back cover. Carefully close the cover and push the right side until the catches engage in the back cover lock.

Use a firm but gentle touch when you replace the back cover. If it should bind or fail to move smoothly and easily into position—stop! Attempting to force the back could cause serious damage to the hinge tongue. If you en-

counter resistance, remove the back completely and repeat the above procedure from the beginning until the cover goes into place properly. With the back firmly in place, turn both cartridge control dials to align with "Close" opposite the respective indicator dots.

Since all operations, except the actual loading of film into the cartridge, are performed in the light, the film should be advanced manually five or six times to move the exposed film leader onto the take-up spool.

The final step is to pull out the cartridge release knob under the frame counter window. Turn it clockwise to set the red indicator mark to the desired exposure number, and push the knob back in. The camera is now ready for operation.

Remember: The motorized film advance automatically stops when the counter reaches 0. This does not necessarily mean that the film supply has been exhausted, but rather that the number of exposures for which the counter was set have been used. When all the exposures have been taken and the counter stops at 0, advance the film manually several times before opening the back to avoid any chance of ruining those last few frames still on the film track.

The Built-In Film Cutter

A film cutter is built into the film back on the same side as the film supply cartridge. This allows the film to be cut at any intermediate point, while leaving the remainder of the unexposed film supply intact.

To take advantage of this feature, close the film gate in the film supply cartridge by turning the cartridge control dial to align with the "Open" indicator dot. Grasp the knurled knob on top of the film holder, which is located just behind the camera strap lugs, and pull up the film cutter the full length of the stroke to cut the film. Next, advance the film several times to move the exposed film into the take-up cartridge. Turn the take-up cartridge control dial to align "Open" with the indicator dot, and open the back cover as explained above.

ACCESSORIES FOR THE SR-M

The Battery Checker

Under many circumstances, it may be necessary to check the battery power supply. A battery check device is available that makes this important test a fast and simple matter. The battery checker must be attached to the power shoe at the bottom of the battery grip. If the grip is being used with the 250-exposure film back, simply disconnect the power cord that connects the back and no further disassembly is necessary. The grip must, however, be disconnected from the camera when it is being used with the regular camera back.

With the battery shoe empty, make sure that the C.S. selector dial is turned from the "Off" position to either the C or S setting. Slide the battery checker bracket all the way into the battery shoe and hold it there. At this point, the test lamp will light if the batteries are still capable of transporting

film at a minimum rate of 2.5 frames per second. If the test lamp does not light, the old batteries should be replaced.

The battery checker must be pushed all the way into the shoe of the battery grip for the checker to function properly. Do not, however, leave the battery checker in this position for more than five seconds at a time, because this drain on the power will weaken the batteries.

Remote Control Cords

The combination of a motor drive and a large film supply opens the door for any number of photographic possibilities. To make the SR-M as versatile as possible, several more accessories have been designed exclusively for it. The least complicated and most useful are the remote control cords, which allow the use of the SR-M from a distance. The cords are available in two lengths: The "S" cord is 3⅓ feet long, and the "L" cord is 16½ feet long. With these, the photographer can easily operate the camera, either in single shots or in continuous bursts, while he remains at a distance.

To set up for use, insert the plug of either the S or L cord into the accessory jack on the front of the battery grip. Be sure the C.S. selector dial is set in the C or R position. Then push the release button on the remote control cord to activate the shutter and film transport. The camera can still be operated from the release button at the top of the battery grip while the remote control cord is attached.

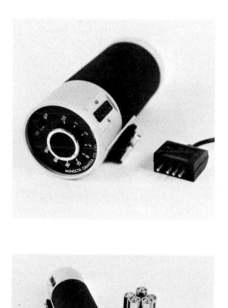

Figs. 10-7A–C. The Intervalometer-PM, which enables automatic shutter trip at intervals from 0.5 second to 60 seconds between exposures (A). At the right is the connecting cord, which joins the Intervalometer-PM to the battery grip of the SR-M. (B) Intervalometer-PM connection cord plugged into the receptacle at the base of the battery grip. (C) The Intervalometer-PM is powered by five 1.5-volt batteries, which fit as indicated by + and − signs inside the battery case. The battery case fits inside the Intervalometer-PM and is held in place by a screw-on retainer, shown at left.

154

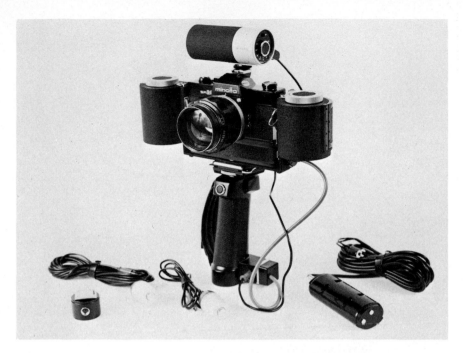

Fig. 10-8. The Minolta SR-M fitted with 250-exposure film back, Intervalometer-PM, and 20-inch connecting cord-S. Accessories shown are the battery checker (left), the remote control-S (behind the battery checker), the remote control L (center), and the power supply cord (right).

The Intervalometer-PM

The Intervalometer-PM is a repeating timer, which trips the camera shutter at regular intervals of 1/2 sec. to 60 seconds between single-frame exposures. The unit is mounted on top of the camera with a shoe, which holds it in place in the accessory shoe; it is connected by a cord to the same outlet as the remote control cable.

Intervals between exposures are limited in part by the length of time required for the camera to recycle at different shutter speeds. With the interval between exposures set at 1/2 sec., the usable shutter speeds are between 1/1000 sec. and 1/15 sec. At intervals of 1 second, the usable shutter speeds are between 1/1000 sec. and 1/8 sec.; at intervals of 2 or more seconds, all shutter speeds between 1/1000 sec. and 1 full second can be used.

The Intervalometer-S

The Intervalometer-S is a more versatile timer, capable of actuating exposure over a broad range of intervals of 0.2 sec. to 10 minutes. This model can be used to make exposures for a series of continuous sequences or a series of single-frame exposures taken during a certain period at regular intervals. It is also suited to ordinary time-lapse photography and motion analysis,

Fig. 10-9. Intervalometer-PM mounted in the accessory shoe on top of the Minolta SR-M.

Fig. 10-10. The battery checker mounted in the connecting shoe, for reading of battery grip.

nature studies of animals and plants, and traffic and meteorological surveys, to name only a few applications.

Connection Cords

Two connection cords are designed to connect either the Intervalometer-PM or Intervalometer-S to the battery grip of the SR-M. They differ in length only. Connecting cord model "S" is 20 inches long, and model "L" is 100 inches long.

A.C. Power Supply Cord

An a.c. power supply cord is designed to fit into the battery grip of the SR-M in place of the battery container. This cord is used with a d.c. rectifier, which permits the SR-M to be operated with normal household current.

STORING THE SR-M

When you plan to store the camera for a long period of time, remove the batteries from the grip and trip the shutter release. Set the distance scale on the lens at infinity and put the camera in the original packaging with a small bag of silica gel, which acts as a drying agent.

11

Minolta SR Accessories

This chapter is a guide to the accessories for Minolta SR cameras produced by Minolta which were not described in previous chapters. Filters, for instance, are considered an accessory item, but since a lengthy discussion of them is contained in Chapter 6, they are not included here. Accessories such as closeup lenses, the Minolta Electroflash, and the Minolta Deluxe Flash Unit III are also discussed in other chapters and will not be referred to here. In this chapter, the reader will find a description of such accessories as the angle finder, magnifier, eyepiece corrector lenses, lens mount adapters, front and rear lens caps, panorama head, copy stand, microscope adapter, microscope photo unit, photo oscilloscope unit, and light meters.

THE MINOLTA LIGHT METERS

There are four light meters currently available under the Minolta brand name. A fifth, the Auto-Professional, was introduced to the American photographic market as this manual was being written. The four meters now available are the Minolta Auto-Spot 1°, the Minolta Viewmeter 9°, the Minolta 3-Color Temperature Meter, and the Minolta Flash Meter. Although production of the Minolta Viewmeter 9° has been stopped, the meter is still available through some photo dealers.

The Minolta Auto-Spot 1°

The Minolta Auto-Spot 1° is an amazing exposure meter, unique in its design and in the accuracy of its readings. This device not only looks different from other spot meters but operates on a different principle. One difference between it and other spot meters is its motor drive exposure dial. Viewing is done through a reflex housing, much like viewing through the SR-T 101, and the exposure dial is visible in the viewfinder. When the button on the front of the meter handle is pressed, the exposure dial turns, and the aperture and shutter speed numbers line up according to the subject area being metered and the speed of the film. As the dial turns, it makes a gentle whirring

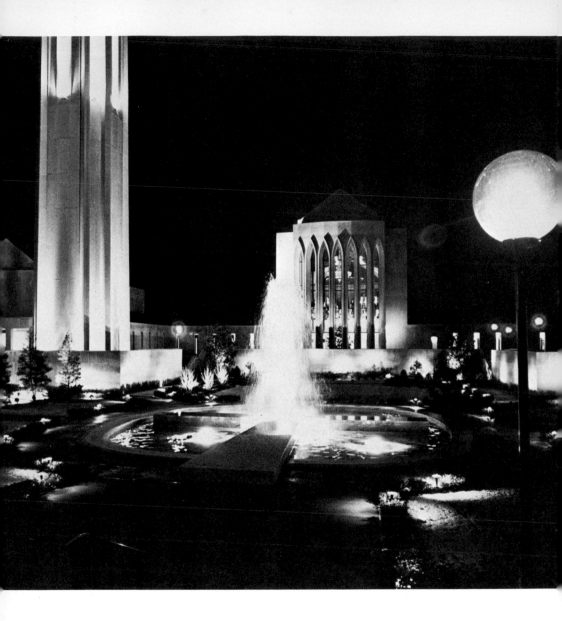

Fig. 11-1. Night photography must be accomplished with the aid of a tripod; otherwise the picture will be spoiled by camera shake. The natural tendency when you attempt to photograph a night scene, hand-holding the camera, is to shoot at as slow a shutter speed as possible and at as wide an aperture as possible. With a firm tripod, you not only need not concern yourself with camera shake, but you can take advantage of a smaller aperture to provide the required depth of field, and you can shoot at a shutter speed as slow as is required for the aperture being used. For this photograph of the National Presbyterian Church in Washington, D. C., the photographer mounted his camera on a steady tripod, and with the aid of a cable release and Tri-X film rated at ASA 400, exposed for one full second at $f/5.6$. Photograph by Robert D. Moeser.

sound, which allows you literally to hear changes in the light conditions being read. When the light conditions are low or when changes in the light conditions are subtle, the whirring sound is a real convenience. The Auto-Spot 1° is so accurate that it reacts to variations in light of less than one-sixth of an f/stop. As an example, meter a person's eye, and have him blink it as you meter.

With other spot meters employing cadmium sulfide (CdS) cells, the accuracy of the reading depends to a great extent on the condition of the batteries, because the movement of these spot meters derives directly from the battery *via* the CdS cells. The Auto-Spot 1°, on the other hand, makes use of a bridge circuit, consisting of a CdS resistor and a variable resistor. These balance and smooth out the power generated by the batteries, providing an even flow of energy and resulting in a greater degree of reading accuracy.

There are nine basic parts to the Minolta Auto-Spot 1° meter: (1) the ASA setting knob; (2) the main switch; (3) the checker lamp; (4) the battery check button; (5) the handgrip, which also functions as the battery chamber; (6) the hood; (7) the lens barrel; (8) the ASA/DIN scale, which also serves as the battery chamber cover; and (9) the eyepiece.

Prepare the meter for use by first adjusting the eyepiece so that the figures on the scale in the viewfinder are in sharp focus. Turn the eyepiece inward (clockwise) or outward (counterclockwise), until the figures appear sharp and clear. Next, extend the hood to shield the lens of the meter from any extraneous light. The hood, which is made of rubber and is collapsible, screws into the lens of the meter. When the meter is not in use, place the lens cap over the lens to protect it.

With the eyepiece adjusted and the lens hood extended, adjust the meter for the speed of the film being used. As you watch the ASA number window in the viewfinder, turn the ASA setting knob until you reach the desired ASA number. To determine the correct aperture–shutter speed combination for the film being used, press the main switch button on the front of the meter. This activates the motor drive and turns the inner scale. Once the inner scale stops turning, the aperture–shutter speed combination can be locked into place by releasing the main switch button.

The Auto-Spot 1° has a total field of view of only 8°, which is what you see when you look through the 300mm MC Rokkor lens on the Minolta SR-T 101. But of the total 8° viewing field, light is measured over an extremely narrow angle of only 1°, which permits you to make highly critical exposure measurements of highlight or shadow areas of distant subjects without having to take closeup readings.

Unlike other spot meters, the Auto-Spot 1° has a focusing lens barrel, which focuses smoothly with a short stroke from 3.3 feet to infinity. Sensitivity ranges for the Auto-Spot 1° are as follows: exposure values, 2–18; ASA 3–25,000; shutter speeds, 30 seconds to 1/2000 sec.; aperture, f/1–45; cine speeds, 8–128 frames per second. This computational and measurement range is considerably more than the range of the Minolta SR-T CLC system.

Power for the Auto-Spot 1° is provided by a nine-volt Mallory M-1604

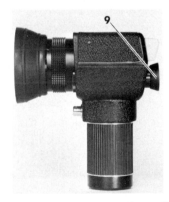

Figs. 11-2A—E. The Minolta Auto-Spot 1° Meter, front (A), three-quarter (B), back (C), bottom (D), and side (E) views.

1. ASA setting knob
2. Main switch
3. Checker lamp
4. Battery check button
5. Grip and battery chamber

6. Hood
7. Lens barrel
8. ASA/DIN scale and battery cover
9. Eyepiece

Fig. 11-3. The Auto-Spot 1° Meter viewfinder.

1. EV pointer
2. Luminance guide number
3. Measuring area (1°)
4. f/number
5. Frame speed
6. Shutter speed
7. ASA number

In use, set the ASA value of the film being used by turning the ASA setting knob until the correct number appears in the ASA number window in the viewfinder. Determine the correct aperture–shutter speed combination by pressing the main switch button on the front of the meter. This activates the motor drive and turns the inner scale. Any combination of aperture and shutter speed that lines up once the inner scale stops turning will produce a correct exposure.

battery or its equivalent. A 1.5-volt AA penlight battery is used for illuminating the scales in the viewfinder. The batteries are housed in the handgrip. The red light at the rear of the meter is for checking on battery conditions. Below the red check light is a button, which is depressed simultaneously with the main switch button. The red light signals that the condition of the batteries is still good. If it does not light, the batteries should be replaced. To replace the batteries, remove the cover at the bottom of the handgrip by unscrewing

it in a counterclockwise direction. You must remove the snap cover on the nine-volt battery before the battery can be taken out of the battery chamber. Then set the snap cover in place on the new nine-volt battery. The 1.5-volt battery will come out when the cover is removed.

An ND (neutral density) filter is available for extending the measuring range when a high-speed film is used outdoors under extremely bright light. Since the meter reads the scene directly through the lens of the Auto-Spot 1°, you can screw the ND filter into the meter without having to make an adjustment in the ASA setting.

The Minolta Viewmeter 9

The Minolta Viewmeter 9 is a reflected-light meter that incorporates several innovations in CdS exposure meter design. These are a narrow angle of acceptance of 9°, an eye-level viewfinder, and a color-corrected CdS cell. Although not offering as narrow an angle of acceptance as the more sophisticated Minolta Auto-Spot 1°, the Minolta Viewmeter 9 angle of acceptance is much narrower than that of most other reflected-light meters. Most reflected-light meters have an angle of acceptance of 30°, which is too wide for taking accurate readings of distant objects. The 9° angle of acceptance allows you to stand farther from your subject and to take accurate readings of subjects in backlighted situations.

The Viewmeter 9 has a sensitivity range that includes an EV range from -3 to $+22$, an aperture range from $f/1$ to $f/64$, a shutter speed range from 1/8000 sec. to 2 hours, and a cine film speed range from 8 frames per second to 128 frames per second. Power for the Viewmeter 9 is supplied by a 1.3-volt mercury battery. The CdS cell of the Viewmeter 9 has a special filter over it which automatically compensates for changes in color temperature, such as those that occur between early morning and midday. Since the latitude of color film is not as great as that of black-and-white film, the addition of the filter over the CdS cell provides a greater degree of measuring accuracy than if the filter were not used.

There are eight basic parts to the Minolta Viewmeter 9: (1) eye-level viewfinder; (2) indicator needle lock button; (3) light intensity scale; (4) light intensity transfer scale window and range selector switch; (5) ASA/DIN scale; (6) shutter speed, f/stop, and cine film speed scale; (7) battery chamber; and (8) battery check button.

Using the Viewmeter 9 is not much different from using the Auto-Spot 1°. First, you must set the ASA/DIN speed of the film being used by turning the raised dial on the front of the meter. Then set the light intensity scale to the appropriate table. To do this, flip the range selector switch up or down. The light intensity scale has two sets of numbers. With the range selector switch in the down (forward) position, the low-level scale (1–9) is brought into view. When the indicator needle lock button is pressed, held for a moment, and then released, the indicator needle will be locked in position for the correct light intensity value number. For example, if the indicator needle comes to rest at 15, turn the outer ring of the front dial to bring the same number into

Fig. 11-4. The Minolta Viewmeter 9.

1. Light intensity scale
2. Indicator needle lock button
3. ASA/DIN film speed scale
4. Shutter speed–*f*/stop scale
5. Light intensity transfer scale window

view in the light intensity transfer scale window and position the number over the arrow according to the way the indicator needle falls across the number on the light intensity scale. With the number properly set in the light intensity transfer scale window, you can read the correct setting on the shutter speed–*f*/stop scale.

To provide a check on the condition of the battery, the battery check button is depressed at the same time the indicator needle lock button is pressed. The battery is still good if the indicator needle rests at any position on the red dash on the light intensity scale. The red dash is on both the low-light level and the normal light-level scales. To check on the indicator needle, remove the battery and press the indicator needle lock button. If the indicator needle drifts toward the black area of the scale, it is functioning properly. Return the meter to the Minolta Service Department if, for some reason, the indicator needle malfunctions.

The Minolta 3-Color Temperature Meter

This is a new type of meter designed to measure the precise color temperature of any light source—daylight, studio floods, fluorescent lights, or household incandescent lamps. It is capable of measuring simultaneously the color temperatures of different types of light emanating from a single source or from a combination of sources. It gives direct readings for light balancing or color correction (CC) filters.

The Minolta 3-Color Temperature Meter employs blue silicon cells, rather than cadmium sulfide or selenium cells. Since blue silicon cells are generally more sensitive than CdS or selenium cells, they react faster to changing light conditions.

The Minolta 3-Color Temperature Meter measures blue, red, and green

163

Fig. 11-5. The Minolta 3-Color Temperature Meter.

1. Incident-light receptor
2. Function indicator window
3. Battery check zone
4. LB filter scale
5. Main color temperature-LB filter index
6. Illuminance scale
7. Mired scale
8. Color temperature range scale
9. Film-type index
10. Color temperature/film-type selector knob
11. Battery check button
12. CC filter scale
13. Color temperature scale
14. CC filter index dial
15. Main index dial
16. Strap attachment lug

color temperatures by means of a 180° flat receptor, which takes into account all surrounding conditions that affect or contribute to the color temperature of the light at the subject position. The meter provides a particularly high degree of accuracy in its readings by dividing its broad measuring capability into four ranges. It reads color temperatures ranging from 2500 K to 12,500 K.

Red, blue, and green detectors are incorporated into the light receptor,

Figs. 11-6A–B. Setting the zero adjustment. (A) To check the zero reading, depress the reading button. (B) If the needle rests on zero on the mired scale, no adjustment is necessary. If the needle is to the left or right of the zero line, turn the screw (with a coin) until the needle rests at zero.

which has a spectral response similar to that of color films. A fourth detector measures incident light for the built-in, illumination intensity meter, a feature that permits the use of the Minolta 3-Color Temperature Meter for taking ordinary meter readings and for determining illumination levels for other purposes.

The Minolta 3-Color Temperature Meter has 23 basic parts: (1) incident-light receptor; (2) function indicator window; (3) battery check zone; (4) LB (light balancing) scale; (5) main color temperature-LB filter index; (6) illuminance scale; (7) mired scale (a mired is the contraction of micro-reciprocal degrees. The mired value of a light source is the color temperature in units Kelvin divided into one million); (8) color temperature range scale; (9) film type index; (10) color temperature–film type selector knob; (11) battery check button; (12) CC filter scale; (13) color temperature scale; (14) CC filter index dial; (15) main index dial; (16) strap attachment lug; (17) neck strap; (18) zero adjustment screw; (19) reading lock button; (20) function selector lever; (21) battery compartment cover; (22) illuminance range selector; and (23) battery compartment.

Before you use the meter, in fact even before you put batteries in the meter, check and set the zero adjustment. To do this, depress the reading lock button and check to see that the meter needle rests exactly on zero on the mired scale. If the needle does not rest exactly on zero, turn the zero adjustment screw on the back of the meter right or left to bring the needle into the correct position. As you do this, press the reading lock button. Turn the zero adjustment screw only a little at a time; otherwise the needle will shift too far from its correct zero position, and bringing it into place will require considerable time and care.

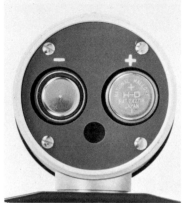

Figs. 11-7A–B. Installing batteries. (A) Remove the battery compartment cover. (B) Insert five PX-625 batteries into the two chambers. Replace cover.

Batteries for the Minolta 3-Color Temperature Meter are installed in the battery compartment. Five PX-625 batteries are required. To install the batteries, first remove the battery compartment by unscrewing it counter-clockwise. Minus (−) and plus (+) signs are marked inside the compartment to indicate the position in which you should place the batteries. With the batteries in place, replace the battery cover by aligning the pin inside the cover with the hole in the battery chamber and then turning the cover clockwise until it is securely in position. To check the condition of the batteries, the reading lock button should be depressed at the same time as you press the battery check button. If the needle falls into the battery check zone at the right end of the illuminance scale, the batteries are functioning properly. If the needle registers outside the battery check zone, all the batteries should be replaced simultaneously.

To use the meter, you must first adjust the smallest center dial to the correct measuring position of T1, T2, D1, or D2. This is determined by the light source under which the meter is to be used. T1 is for measuring 2500 K to 3330 K; T2 is for measuring 2750 K to 3800 K; D1 is for measuring 3700 K to 5880 K; and D2 is for measuring 5560 K to 12,500 K. Each measuring position has a definite click stop. To set the meter for the correct measuring position, align the index mark in the dial opposite the designation for the color temperature of the light source involved.

Next, set the meter for the type of film being used. The types of film are Type B (tungsten), which is balanced for light sources having color temperatures of 3200 K; Type A, which is balanced for light sources having color temperatures of 3400 K; Type F, which is balanced for light sources having color temperatures of 3800 K; and daylight type, which is balanced for light sources having color temperatures of 5500 K. The meter can be set to inter-

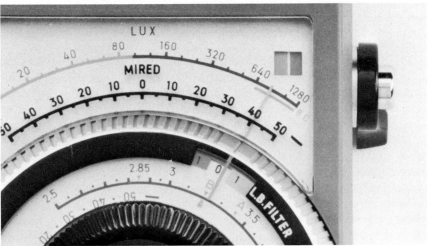

Figs. 11-8A–B. Checking batteries. (A) Depress the reading button and battery check button simultaneously. (B) If the indicator needle stays within the red battery check zone at the right end of the illuminance scale, the battery is functioning. If outside the B.C. zone, replace all batteries.

mediate values for films balanced for other color temperatures expressed in units Kelvin. To set the meter, lift and turn the center dial knob until the small red triangular film index pointer is opposite the letter "B," "A," "F," or "D" (daylight), according to the type of film being used.

Determining the level of the light intensity is the next step. The Minolta

Fig. 11-9. To set the meter for light sources, turn the knurled knob of the small center dial to align the index with the designation of the range that includes the color temperature of your light source.

3-Color Temperature Meter has been designed so that color temperatures can be measured over a broad range of light intensity levels, which means that distance from the light source—as long as the light intensity of the light source does not fall below a minimum level of 9.3 foot candles—is not a determining factor. Changes in distance from the light source do not affect accurate color temperature readings.

To determine the level of the light intensity, set the function selector lever, which is located on the side of the meter by the reading lock button, so that the dot on the lever aligns with the letter "I." Then point the receptor at the light source, and depress the reading lock button. If the needle indicator registers within the black portion of the illuminance scale above the mired scale, it means that there is enough light to permit an accurate measurement of the color temperature.

With the meter set for the light source in use, the film type programmed into the meter, and the level of the light intensity determined, the next step is measuring the color temperature of the light source. First, turn the function selector lever to the "B/R" (blue/red) position, point the receptor toward the light source, and depress the reading lock button. When the needle stops moving, remove the pressure on the release button. This locks the needle into position. Then rotate the main index dial until the red index line on its grooved rim aligns with the needle. Take readings directly off the scales for color temperature and light balancing (LB) filter reference numbers. With

Fig. 11-10. To set the meter for film type, lift the center knob to disengage it; turn it until the small red triangular film index pointer is set on the letter for the type of film being used.

these numbers in mind, refer to the conversion table on the back of the meter to convert the LB filter reference number to an actual filter indication. For example, if the B/R LB reference number is 5.5, filters needed for proper color balance would be one No. 82 and one No. 82C.

G/R (green/red) ratio readings are taken when you are photographing in color under fluorescent lighting or mixed lighting conditions, such as fluorescent and daylight. When you take G/R ratio readings, set the function selector lever at the "G/R" setting. Depress the reading lock button, and then release it to lock the needle in place. To obtain the G/R readings, refer to the mired scale. Rotate the grooved black CC filter index dial to align the red index to the plus or minus value indicated by the needle. The scale with the plus and minus values is located on the same silver dial surface as the color temperature scale. The CC filter reference number appears on the magenta or green scale immediately beneath the red CC index mark. A reading in the clear "0" portion of the scale indicates that no CC filter is needed. Refer to the table on the back of the meter when converting the CC filter reference number to the actual filter indication.

Fig. 11-11. To check light intensity, set the function selector lever so that the dot is aligned with the letter "I." Point the receptor at the light source and depress the reading button. If the needle indicator registers within the black portion of the illuminance scale, there is sufficient light to permit accurate color temperature measurement.

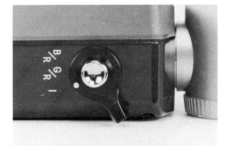

For best results with the Minolta 3-Color Temperature Meter, it is recommended that no more than two filters be used in combination. The single filter that comes closest to the reference number indicated is the filter to use,

Fig. 11-12. When making intensity readings, be sure the illumination range selector is set at its "×1" position.

rather than two separate filters, which when combined provide approximately the same results. However, when the reference number exceeds 4.5 on the blue scale or 5.3 on the yellow scale, there will be no choice but to combine two filters to attain the degree of filtration required. To keep the number of filters required for color correction to a minimum, use the film nearest in response to the units Kelvin of the light source you are working under.

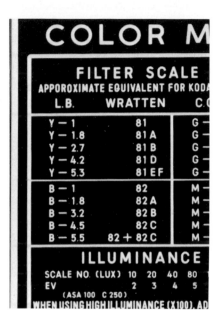

Fig. 11-13. LB and filter reference chart, on the back of the meter.

Fig. 11-14. CC filter reference chart, on the back of the meter.

Figs. 11-15A–B. The Minolta Flash Meter back (A) with batteries (B).

THE MINOLTA FLASH METER

The Minolta Flash Meter is an exposure metering system for determining the correct aperture and shutter speed combination for a particular film when the light source is electronic flash or flashbulbs. The meter can also be used to determine the correct exposure setting under available indoor or outdoor light.

Like the Minolta 3-Color Temperature Meter, the Minolta Flash Meter makes use of a blue silicon cell rather than a CdS or selenium cell, because of its quicker response capabilities and greater sensitivity to changing light

171

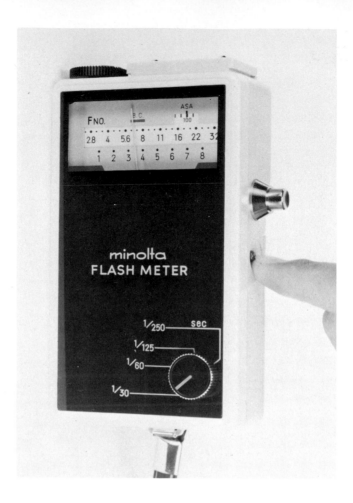

Fig. 11-16. If the indicator needle is outside the red B.C. zone when the battery check button is depressed, replace all the batteries.

conditions, in this case, the short duration of electronic flash and flashbulbs.

The Minolta Flash Meter system consists of the meter itself, a compact, lightweight, hand-holdable unit, which provides direct f/stop readings. This eliminates the need for the photographer to convert guide numbers to aperture settings. The system also includes a detachable spot metering head, flat and dome incident light discs, a long-line fiber optics probe and a long-line flat disc probe, a flash connecting cord, neutral density filters, and a neutral density mask.

The meter itself has 18 basic parts: (1) accessory bracket; (2) ASA number scale; (3) f/number scale; (4) reference numbers for accessories; (5) measuring range limit marks; (6) measuring button; (7) battery check button; (8) battery check mark; (9) ASA number setting knob; (10) indi-

cator needle; (11) measuring range limit marks; (12) shutter speed measuring times; (13) shutter speed–measuring time selector; (14) incident-light receptor; (15) ASA number scale lock; (16) battery chamber cover release button; (17) synch terminal; and (18) synch cord jack.

The detachable spot metering head consists of a combination cell window and reflected-light receptor–viewfinder. Sighting is done through the tinted eye-level viewfinder, which contains a bright-line circle showing the exact area covered by the 10° angle of acceptance of the meter. A center spot pinpoints the subject for extremely critical measurement. Viewing through the spot metering head is similar to viewing through the Minolta Viewmeter 9.

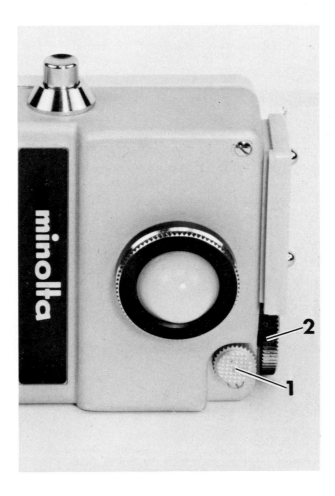

Fig. 11-17. To set the ASA film speed, loosen the ASA scale number lock button (1) by turning it counterclockwise. Turn the ASA number setting knob (2) to the required number on the scale on the front of the meter. Lock it with the ASA number scale lock button (1).

To measure flash exposure with the Minolta Flash Meter, first set the ASA film speed number by turning the ASA number setting knob until the correct number appears in the ASA number scale window, and lock it into position by turning the ASA scale number lock button clockwise. Then set the shutter speed at which the camera is to be used by turning the shutter speed–measuring time selector until the index mark on the selector knob appears opposite the desired shutter speed. If an incident-light reading is to be taken, use the Minolta Flash Meter without the spot metering head. You should use the spot metering head when a reflected-light reading is to be taken. For spot readings, plug the flash cord of the flash unit being used into the standard PC connecting terminal on the bottom of the Minolta Flash Meter. For incident-light readings, which are taken from the subject position, use the accessory flash connecting cord that comes with the Minolta Flash Meter System. This permits you to separate the flash meter and light source up to 20 feet.

Fig. 11-18. To set the shutter speed, simply set the measuring time selector on the front bottom side of the meter to the desired value.

To activate the flash meter, depress the measuring button. As this is done, the light source—electronic flash or flashbulb—is automatically triggered, and the correct f/stop appears on the f/number scale. Hold the measuring button down until you have read the correct f/number. As soon as you release the measuring button, the indicator needle will return to its neutral position at the left of the f/number scale.

The Minolta Flash Meter can also be used to measure available light coming either from sunlight or an artificial source, such as flood lamps, spotlights, and so on. To use the flash meter in this manner, program the ASA film speed into the meter, and set the appropriate shutter speed. Then point the meter at your subject, if you are taking a spot reading, to obtain a direct f/stop reading. If you want an incident-light reading, take the reading from the subject position with the incident-light receptor pointed toward the camera position.

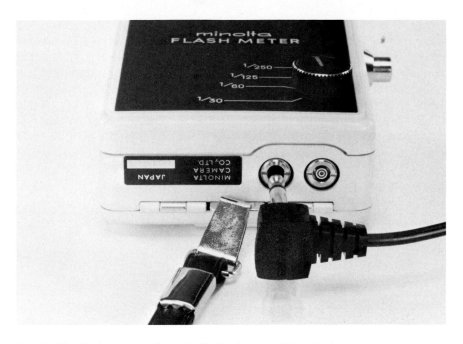

Fig. 11-19. Flash gun synch cord attached to synch terminal.

Fig. 11-20. Flash meter accessory synch cord plug attached to jack.

The Minolta Flash Meter System includes two disc attachments for measuring incident light. The flat incident disc is for measuring light coming from a single direction over a 180° field, as well as for obtaining illumination values. The dome, or spherical disc, measures light coming from more than one direction. Both discs screw clockwise into the light-sensing window of the incident-light receptor.

For measuring illumination levels, when the objective is to balance out the intensity of various light sources, you should use only the flat disc. Two additional accessories available for the flash meter are the 1H micro-disc

Fig. 11-21. Flat and spherical diffusers, to be attached to receptor ring at the top of the back side of the meter.

Fig. 11-22. Reflected-light receptor—viewfinder in position in the accessory bracket.

Fig. 11-23. Pinpoint receptor cord being placed in the connector at the side of the slide accessory connector shoe.

receptor and the 2H micro-disc receptor. These are used for measuring light too weak to be measured with the incident-light receptor of the meter. The micro-disc receptors fit onto the accessory bracket of the meter. When the micro-disc receptors are used or when illumination levels are being measured, refer to the following table. The figures represent luxes. A lux is an international unit of illumination and is equal to the illumination per square meter of a surface at a distance of one meter from a point source of one candela. It is not necessary, however, to remember this definition when using the flash meter. To obtain lux seconds from the following table, divide the number of luxes by 30.

Reference Numbers (in luxes)

Receptor	1	2	3	4	5	6	7	8
Flash meter with flat diffuser	660	1,320	2,640	5,280	10,560	21,120	42,240	84,480
Micro-disc 1H receptor	41.3	82.5	165	330	660	1,320	2,640	5,280
Micro-disc 2H receptor	20.6	41.3	82.5	165	330	660	1,320	2,640

To measure illumination levels, the shutter speed measuring time is set at 1/30 sec. and the reference number indicated on the indicator needle on the reference number scale is used to determine lux seconds. Lux seconds are arrived at, using the figures in the table, by dividing by 30.

The 1H and 2H micro-disc receptors are, respectively, 4× and 5× more sensitive than the incident-light receptor on the flash meter. When they are used, you should adjust the ASA number an appropriate number of steps lower than that of the ASA of the film being used to obtain a correct measurement.

Other accessories for the Minolta Flash Meter are a pinpoint receptor, a neutral density filter, and a neutral density mask. The neutral density filter and neutral density mask are used in closeup work or with high-speed films.

177

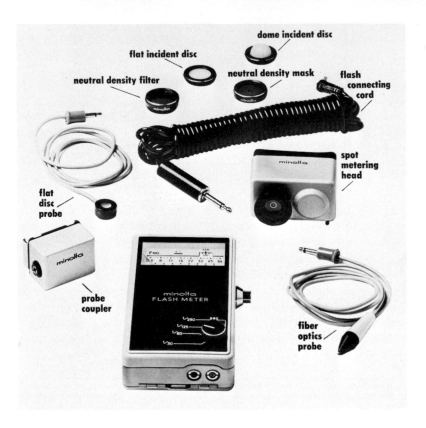

Fig. 11-24. The Minolta Flash Meter System.

For incident-light readings, the neutral density filter is used along with the incident dome or flat disc. For spot readings, the neutral density mask is used in conjunction with the detachable spot metering head. In both instances, you must use a neutral density filter on your lens to obtain the correct exposure as determined by your meter reading. The ND filter and mask for the flash meter have an exposure factor of 4, which means that the ASA number for the film being used should be divided by 4, or the 4× factor should be computed in with the indicator needle setting shown on the f/stop scale. (See Chapter 6, Films and Filters.)

The pinpoint receptor is used primarily to check subject light distribution on the groundglass when you are using a large-format camera, such as a view camera. To use the pinpoint receptor, slip the unit into the accessory bracket, and plug the cord that comes with it into the jack on the receptor. Then place the probe on the end of the receptor cord on the groundglass at the point of the subject area being measured. Press the measuring button, and instead of reading the f/stop number, read the reference number scale and refer to the conversion table supplied with the receptor. A second cord is available for

the pinpoint receptor. Instead of a pointed probe, it has a flat disc probe. This cord permits measurement of light in generally inaccessible situations, such as occur in medical and dental photography and in macro- and microphotography.

MISCELLANEOUS ACCESSORIES

The Minolta SR Angle Finder V is an auxiliary finder, which attaches to the eyepiece frame of Minolta SR cameras and is used principally to allow waist-level viewing. The angle finder permits you to see the image right side up and unreversed. It can be used in candid photography to permit you to face the camera at a 90° angle so that the subjects you are photographing are not aware that you are taking their picture. The angle finder also has applications in closeup and macrophotography when waist-level viewing is desired. The unit is useful for doing copying work with the Minolta Copy Stand II and for long telephoto work when the camera is set at a low angle on a tripod. To use the Angle Finder V, simply insert it into the right and left grooves of the eyepiece frame of the camera. You should adjust the angle finder to your own vision requirements. To do this, set the lens at infinity and focus the eyepiece of the angle finder until the image in the viewfinder appears sharpest. The eyepiece of the angle finder can be adjusted from −4.5 diopters to +2.5 diopters, allowing its use by a nearsighted or farsighted person.

The Minolta SR Magnifier V, another auxiliary finder, attaches to the eyepiece frame of Minolta SR cameras. It can be used only for eye-level viewing and magnifies images 2.5×. An extremely useful tool for critical

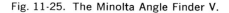

Fig. 11-25. The Minolta Angle Finder V.

179

focusing, it is especially helpful in photomacrography, copying, or taking distant telescopic views. The Magnifier V has an adjustable eyepiece, which you can use to adjust the unit to your own eyesight.

Fig. 11-26. The Minolta SR Magnifier V.

As focusing aids for near- and farsighted persons, there are nine different eyepiece corrector lenses. These snap directly into the eyepiece frame of the camera. Eyepiece Corrector Lenses No. 1 to No. 5 are for farsighted persons; Eyepiece Corrector Lenses No. 6 to No. 9 are for nearsighted persons. The table shows the correct eyepiece corrector lens to use to compensate for near-sightedness or farsightedness.

DIOPTER TABLE

	Lens Number	Diopter	Compound Diopter with Camera
	1	+0.5	−0.5
	2	+1	0
For Nearsightedness	3	+1.5	+0.5
	4	+2	+1
	5	+3	+2
	6	−1	−2
For Farsightedness	7	−2	−3
	8	−3	−4
	9	−4	−5

To determine which eyepiece corrector lens to use, first choose the two eyepieces nearest in value to the eyeglasses you use. Sight through each eye-piece corrector lens, holding it about 3.3 feet from your eye, and choose the

one that provides you with the sharpest viewing. Then mount the corrector lens on your camera, set the lens of the camera at infinity, and view the subject at long range. If the subject is perfectly sharp, you have chosen the correct eyepiece corrector lens. If the subject is not quite as sharp as you would like, choose the next higher corrector lens. If the corrector lens does not fit tightly enough into the rectangular frame of the eyepiece, apply a small amount of glue around the edges of the frame, fit the eyepiece corrector lens firmly into the frame, and let it sit for several minutes before you use the camera.

Fig. 11-27. Minolta Eyepiece Corrector Lenses.

The Minolta Panorama Head, which fits between the camera base and the tripod support, is capable of photographing a horizontal landscape in several divided sections, which may be subsequently joined together to make a sweeping panoramic photograph. To use the panorama head, set the camera in a perfectly horizontal position. This is accomplished with the help of a level. The panorama head rotates a full 360°. One graduation of the head covers 12°. There are click stops at every two graduations, *i.e.*, 24°. Generally, it is best to use a 100mm lens when you take a panoramic photograph. A wide-angle lens is not recommended since there may be some problem with distortion when you join sections together. To produce a panoramic photograph, you must take a certain number of exposures if the entire horizon is to be shown. The table below shows the number of exposures required to photograph an area a full 360° in scope according to the lens used. The table also shows the picture angle of the lens used, the number of graduations involved for the various lenses, and the amount of overlap.

Fig. 11-28. Principle of the Minolta Panorama Head as **C**, the lens, is moved, **AB**, the object to be photographed, will move to **A'B'**, and **ab**, the image, will move to **a'b'**. By observing the center of the image, and the movement of **a** to the position of **a'**, it may be clearly noticed that the size of the image, as explained above, is enlarged.

Lens Used	Picture Angle Against the Long Side	Graduations Used of Panorama Head	Number of Times Required for Photographing 360°	Overlap Yield (in percentages)
35mm	45° 26'	3 (36°)	10	about 34
55mm	36° 14'	2 (24°)	15	33
58mm	33° 24'	2 (24°)	15	28
100mm	20° 24'	1 (12°)	30	40
135mm	15° 10'	1 (12°)	30	20

Fig. 11-29. The Panorama Head is fitted between the camera and tripod. It turns in a 360° circle at marked intervals of 12°, allowing you to shoot up to a 360° panoramic view in overlapping sections.

In panoramic photography, the camera is moved with the lens as an axis, as indicated in Fig. 11-28. Objects in the peripheral (outer edge) portions of the entire view appear slightly larger than those in the central portion. Thus,

182

in joining the divided sections, it is advisable that the picture angles comprising each of the sectionally photographed pictures be equally divided (refer to D...d' in Fig. 11-28) so that the magnifications of the images in the peripheral portions may be made equal in joining the picture sections. If this system is used, there will be no major problems of overlapping.

A variety of lenses manufactured by companies other than the Minolta Camera Co., Ltd., can be fitted to Minolta SR camera bodies by means of Minolta lens adapters. The adapters are available for Leica, Praktica, and Exakta lenses. With the adapters, lenses of these manufacturers can be fitted securely to Minolta SR bodies. The adapters permit the use of Praktica and Exakta lenses as preset lenses at all distances, including infinity. Leica mount lenses, because they have a different back focus, can be used only for close-ups and copying.

Fig. 11-30. Minolta Lens Mount Adapters.

The Minolta Copy Stand II is a rigid camera support, which assures maximum stability for photomacrography or for copy work involving flat or three-dimensional materials. The copy stand has a heavy-duty baseboard, 15½" × 17¾", as well as a chrome tube, 24 inches high, onto which the camera is secured. An arm on the chrome tube can be adjusted to shift the camera to the center of the easel or to any corner of it.

The Minolta Mini 35 II Slide Projector is a very small, lightweight unit, which can project an image onto a 35-inch screen, completely filling it, from a distance of only seven feet. The projector has a 75mm f/2.5 Rokkor projection lens and a condensor system for extra bright, evenly lighted images. Optical accessories for the unit include an auto-changer, a tele-wide conversion lens, a blower device for extra cooling power for long showings, and a strip film carrier.

For advanced technical photographic applications, Minolta also makes

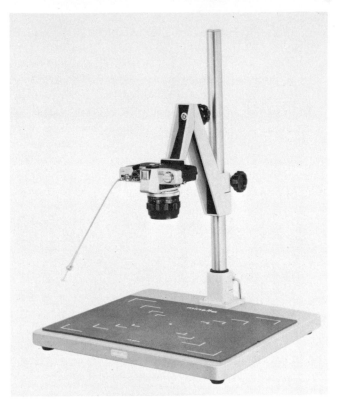

Fig. 11-31. The Minolta Copy Stand II.

Fig. 11-32. The Minolta Mini 35 II Slide Projector.

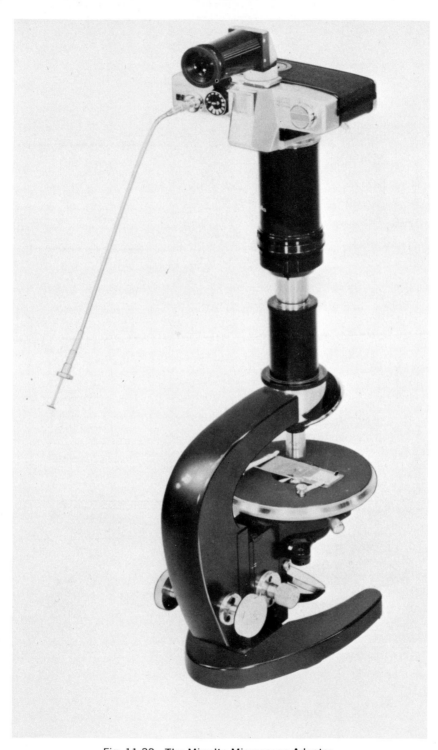

Fig. 11-33. The Minolta Microscope Adapter.

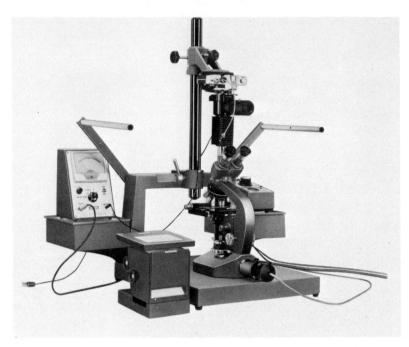

Fig. 11-34. The Minolta Microscope Photo Unit II.

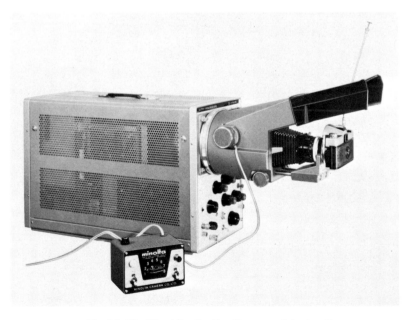

Fig. 11-35. The Minolta Oscilloscope Adapter II.

the Microscope Adapter, the Microscope Photo Unit II, and the Photo Oscilloscope Unit II.

The Microscope Adapter is a two-piece device used to connect an SR camera body to a microscope. One section bayonets into the camera body in place of the lens, and the other end fits into the ocular adapter tube section of the microscope. Taking photomicrographs with the Microscope Adapter is convenient for the photographic technician because it permits him to follow moving specimens up to the precise moment of exposure.

The Microscope Photo Unit II is more versatile than the simple Microscope Adapter; it can be used with most interchangeable lens cameras and most microscopes. It has a number of major features. For one thing, viewing and focusing are accomplished by a $5.6\times$ eyepiece with a sliding eyepoint clamp that holds the chrome support tube in its best corner-to-corner viewing position. Exposure determination is done by means of a half-mirror prism. The unit has a built-in color temperature meter, which provides precise color filtration information. The bellows and exposure system are mounted to provide the greatest degree of freedom from vibration. The through-the-lens exposure meter is of the semi-spot type and measures an area equivalent to $7 \times 9mm$ in the center of the film, whether it is 35mm or 16mm in format.

The Minolta Photo Oscilloscope Unit II is designed principally for academic and industrial research. It is used to accurately record the electric waves emitted from Braun tubes and oscilloscopes. Incorporated in the adapter are an oversized finder for ease of observation and a data recording device.

Index